Life's Pleasures

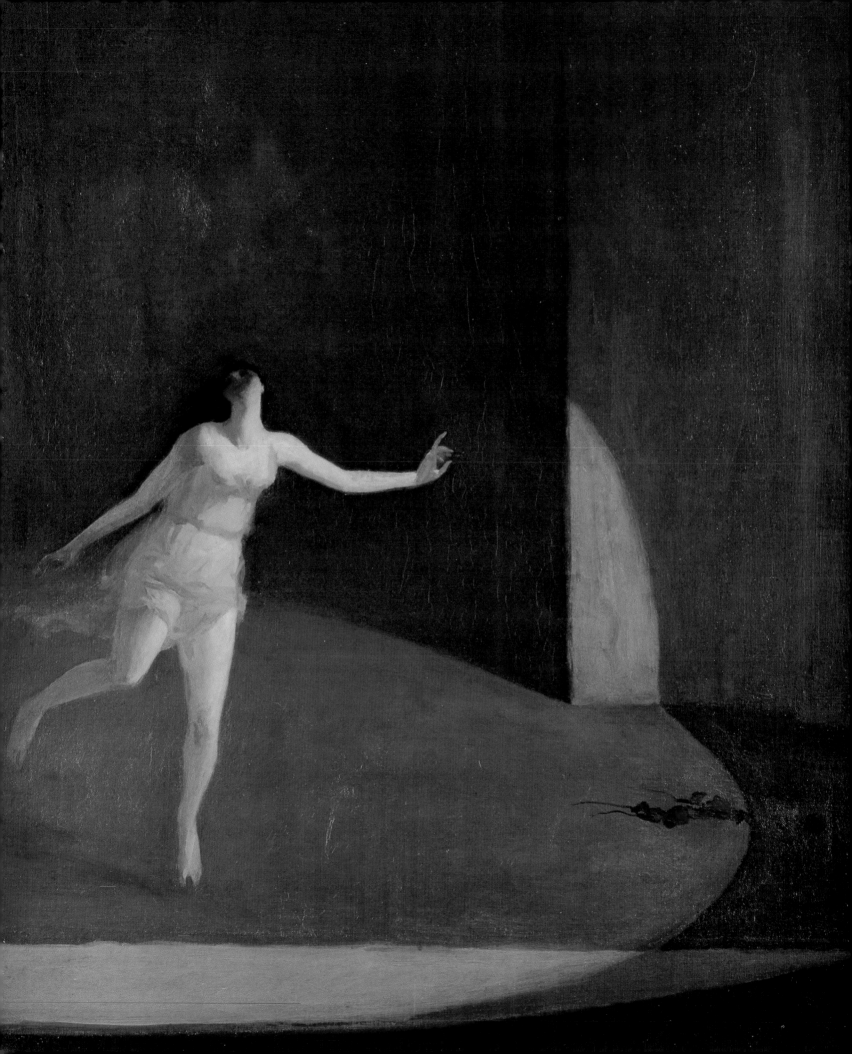

James W. Tottis
Valerie Ann Leeds
Vincent DiGirolamo
Marianne Doezema
Suzanne Smeaton

with contributions from
Michael E. Crane
and Kirsten Olds

Life's Pleasures
The Ashcan Artists' Brush with Leisure, 1895–1925

**Detroit
Institute
of Arts**

MERRELL
LONDON · NEW YORK

First published 2007 by
Merrell Publishers Limited

Head office
81 Southwark Street
London SE1 0HX

New York office
49 West 24th Street,
8th Floor
New York, NY 10010

merrellpublishers.com

in association with

Detroit Institute of Arts
5200 Woodward Avenue
Detroit, Michigan 48202

dia.org

Published on the occasion of
the exhibition *Life's Pleasures:
The Ashcan Artists' Brush with
Leisure, 1895–1925*

The exhibition was organized
by the Detroit Institute of Arts

Exhibition itinerary:
Frist Center for the Visual Arts,
Nashville, 2 August–28 October 2007

New-York Historical Society,
18 November 2007–10 February 2008

Detroit Institute of Arts,
2 March–25 May 2008

A catalogue record for this book is
available from the Library of Congress.

British Library Cataloguing-in-
Publication Data:
Life's pleasures : the Ashcan artists'
brush with leisure, 1895–1925
1. Ashcan school of art 2. Manners
and customs in art 3. National
characteristics, American, in art
I. Tottis, James W. II. Detroit
Institute of Arts
759.1'3

Hardcover:
ISBN-13: 978-1-8589-4384-8
ISBN-10: 1-8589-4384-1

Softcover:
ISBN-13: 978-1-8589-4385-5
ISBN-10: 1-8589-4385-X

Produced by Merrell Publishers
Limited
Designed by James Alexander
at Jade Design
Copy-edited by Matthew Taylor
Proof-read by Barbara Roby
Indexed by Hilary Bird

For the Detroit Institute of Arts
Director of Publications:
Susan Higman Larsen
Editors: Stephen Robert Frankel,
Tracee Glab, Judith Ruskin

Printed and bound in China

Contents

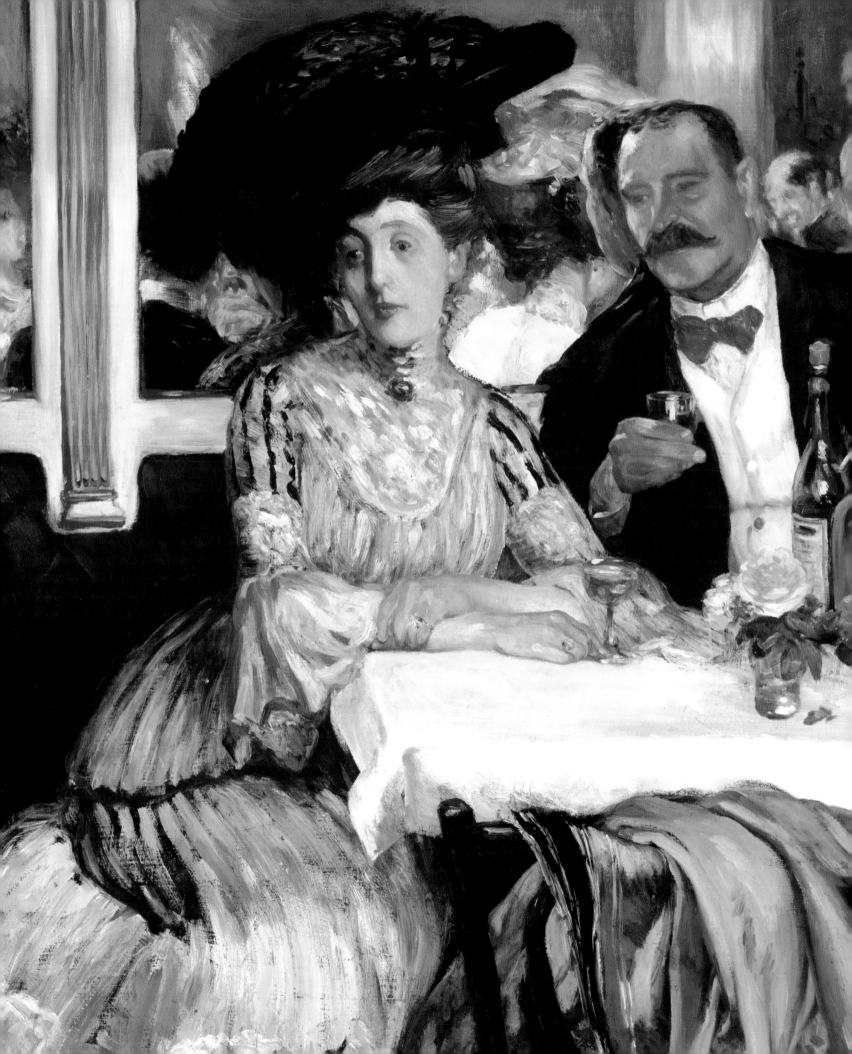

Foreword

The individuals who exhibited as The Eight in 1908 were a disparate lot whose paintings covered a wide range of subjects—a fact quickly obscured by the fuss made over those images depicting scenes of the lower social levels of New York's teeming population. And although the sobriquet "Ashcan" was not bestowed on them for a number of years, the fact that it stuck is a clear indication that this was the area in which Robert Henri, John Sloan, George Luks, and others were seen to have marked themselves out as different from their immediate forebears of the Aesthetic and impressionist movements. In particular, Henri's calls for muscular American painting related most easily to these street scenes, with their attention to the underdog, and the generalization of these artists as primarily painters of New York's underbelly carried the day until fairly recently.

In fact, the Ashcan artists truly were painters of American urban life and took for their subject matter scenes from everyday life, which inevitably showed a wider range of social strata than is indicated by the circle's nickname. This volume focuses on the diametrical opposite of hardship and slum life, showing people from many walks of life at leisure, spending precious free time and discretionary money on an array of different activities in a wide range of places: in bars, cafés, and theaters; in parks, on beaches, and at sporting events. The overall picture is one of zest for life and delight in the pleasures of modern urban America—very different from the grim and grimy images of downtrodden immigrants usually associated with the Ashcan circle. These artists took pride and pleasure in the world they depicted. This is typified in my mind by John Sloan's statement that, "Had all the saloons been conducted with the dignity and decorum of McSorley's, prohibition would never have come about."

The idea for the exhibition celebrated in this book came from James W. Tottis, Associate Curator of American Art at the DIA, and in the exhibition he has brought together nearly eighty works that forcefully illustrate his theme. I am grateful for the time and effort he brought to this task. I would also like to thank the authors of this book: Michael E. Crane, Assistant Curator of American Art at the DIA; Vincent DiGirolamo, Assistant Professor of History at Baruch College in New York City; Marianne Doezema, the Florence Finch Abbott Director at the Mount Holyoke College Art Museum in Massachusetts; Valerie Ann Leeds, independent scholar; Kirsten Olds, independent scholar; and Suzanne Smeaton, Gallery Director at Eli Wilner and Company. I would also like to extend thanks to Susan Edwards and Mark Scala, Director and Curator, respectively, of the Frist Center for the Visual Arts, Nashville, as well as Linda Ferber, Director, and Kimberly Orcutt, Assistant Curator, at the New-York Historical Society, whose enthusiasm for this project enabled its U.S. tour. Finally, of course, I am deeply grateful to those private collectors and institutions whose generous agreement to loan their works of art has made the exhibition possible.

Graham W. J. Beal
Director, Detroit Institute of Arts

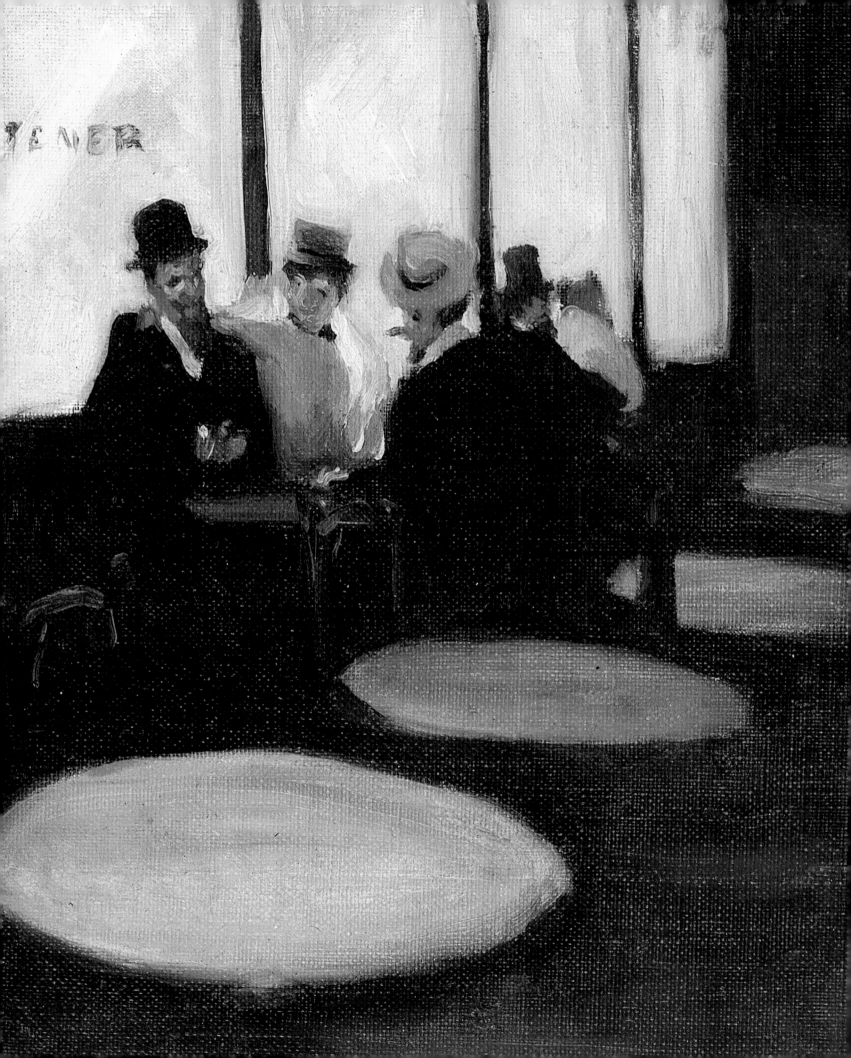

Bars, Cafés, and Parks: The Ashcan's *Joie de Vivre*

James W. Tottis

The greatness can only come by the art spirit entering into the very life of the people, not as a thing apart, but as the greatest essential of life to each one. It is to make every life productive of light—a spiritual influence.
—Robert Henri, 1923[1]

The celebration of leisure is an oft-ignored subject in traditional and even in recent discussions of the work of the Ashcan school—the circle of artists that formed around Robert Henri in the last years of the nineteenth century and early 1900s. Instead, the school's members are generally remembered for their canvases depicting the lower levels of the socioeconomic scale, the raw, unvarnished people who lived and toiled in turn-of-the-century New York. While this material comprises one aspect of these artists' oeuvre, it is not representative of the entire spectrum of their work or of their overall approach to painting. With the nearing centennial of the seminal exhibition "The Eight"—the highly publicized and somewhat controversial show that Henri, Arthur B. Davies, William Glackens, Ernest Lawson, George Luks, Maurice Prendergast, Everett Shinn, and John Sloan held in February 1908 at the Macbeth Galleries in New York—a reassessment of the Ashcan school's representations of everyday city life reveals an abundance of leisure scenes both within and beyond the urban confines.

In addition to concentrating too closely on the artists' interest in some of the more murky aspects of society, discussion of the Ashcan school over the past hundred years has been largely limited to five Philadelphians belonging to The Eight: Henri, Glackens, Luks, Shinn, and Sloan (fig. 1). However, the school can be seen as incorporating a far wider range of artists than that. Indeed, the scholar Robert Hunter correctly defined it as having both a first and a second generation.[2] And when discussing the group, Stuart Davis distinguished between "the founders Henri, Luks and so on," and "the generation after the founders," referring specifically to Glenn Coleman and George Bellows, and by implication their contemporaries.[3]

What all the members of this more expansive group shared was a set of ideas and an approach to painting learned from Robert Henri. It is these ideas and this approach that truly make up the Ashcan school. Henri, the prime mover behind the exhibition of The Eight, was among a group of artists who had become dissatisfied with the practices of the National Academy of Design in New York, its aesthetic constraints, and its antiquated jury

system. These artists wished to demonstrate their belief in artistic independence. Adopting the mantle of a true leader, Henri wrote in an open letter of 14 March 1907 of his dissatisfaction with the academy, its jury process, and its decision to reject works by progressive artists, specifically citing those by Davies, Lawson, and Jerome Myers. This letter signifies the moment of conception of the infamous exhibition held the following year at the Macbeth Galleries.

Henri's was the strongest voice in the exhibition, and it was he who was responsible for selecting the other artists on show. But alongside him and the seven artists whose work he included in the exhibition, there were several others who embraced his approach to painting and who—for varying reasons—were not invited. Sloan wished to include his friend Myers, for example, but Henri blocked the idea, believing Myers's work too sentimental.[4] Henri also wrote of two other artists whom he considered for the exhibition:

> The two men who might have been of the "8" had one of them been younger or the other older [were] A.P. Ryder and George Bellows.... The only time I met Ryder he expressed himself as strong for the "8" and spoke with enthusiasm of several members of the group.... George would naturally have been of the group but it antedated him. Many people now believe he was a member.[5]

Davies also suggested Rockwell Kent as a potential candidate for inclusion, although—much like Bellows—youth did not play in his favor.[6]

Most of the newspapers focused on the rebellious artists, the gang that set up the independent exhibition. They were right to point out that the exhibition did not mark the birth of a homogeneous artistic *style*. The *New York Times* provided this historically accurate assessment: "The showing made by their paintings is both varied and surprising. With the exception, perhaps of Prendergast, the pictures reveal little that is new in direction or treatment to that with which the knowing in art have become

famil[i]ar."[7] In sum, neither the work nor the artists were revolutionary; what was revolutionary was the independent exhibition itself.

Despite the variety of stylistic approaches on show, there was something that gave the exhibition coherence. The critic for the *New York Sun*, James Gibbons Huneker, proclaimed of the participating artists: "Disparate as are their aims and execution, one thing binds them together—an absolute sincerity. With the solitary exception of Davies, they are painters of contemporary life in its varying phases.... They are realists inasmuch as they paint what they see."[8]

It was this sincerity, this candid realism, that Henri sought above all to inculcate through his teaching, and these traits, more than anything, characterized the Ashcan school, as it came to be known.

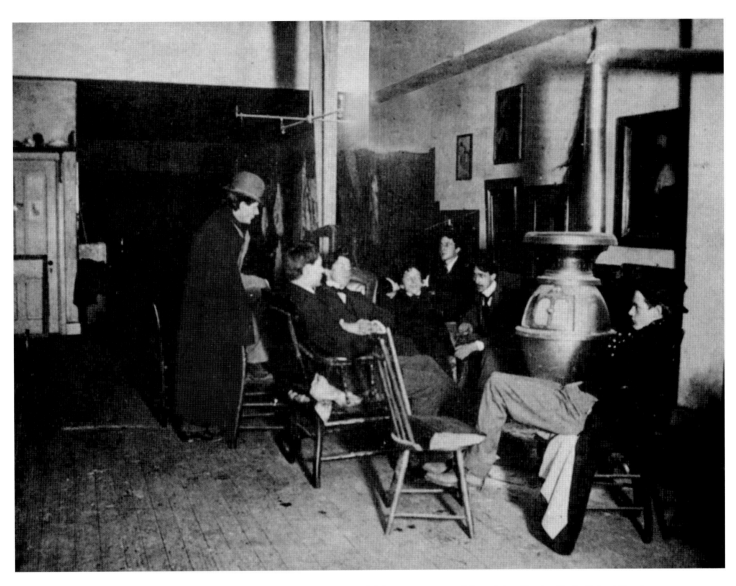

Fig. 1. Robert Henri and friends in the studio at 1717 Chestnut Street, Philadelphia, ca. 1893–94 (left to right: Charles Grafly, Robert Henri, illustrator F.R. Grunger, William Glackens, John Sloan, an unidentified friend, and Everett Shinn)

The Henri Students

The work of the art student is no light matter. Few have the courage and stamina to see it through.
—Robert Henri, 1923[9]

Henri's influence was at its most powerful between 1902 and 1912, first at the New York School of Art (formerly the Chase School) and then at his own school. At both institutions, Henri, a charismatic teacher, created through his instructional approach an atmosphere that was extraordinarily unusual at the time. His discussions were open, encouraging, and as much about life as about the application of paint. Sloan wrote, "In my student days there was a great deal of emphasis on inspiration, self-expression, wit, and pictorial beauty."[10] Henri consistently urged his students not to paint as he did, but to develop their own styles. The unifying factor for the Ashcan school, and for Henri, was not style but approach.

Henri advocated "a realism" derived through the inspiration found in the artists' immediate world, and he encouraged each artist to pursue his own individual objectives. He exhorted his students and followers to use as subject matter the world as they found it, thus absorbing "the great ideas native to his country." Among the subjects addressed were the multitude of leisure pursuits available to the citizenry of varied social strata, those vibrant and diverse activities experienced and observed by members of the Ashcan school.

Henri challenged the impressionist to leave the "garden" and to paint what was real. He abhorred artifice in any form, but especially in fancy, finicky, over-studied works, escapist paintings, and over-precious, sentimental canvases. "After all," he claimed, "the goal is not making art. It is living a life. Those who live their lives will leave the stuff that is really art. Art is a result. It is the trace of those who have led their lives."[11]

Henri's followers took hold of these ideals, incorporating them into their painting. Absorbed in Henri's philosophical approach—which emphasized painting the world the artist knew, embracing it with a joy of life—Sloan

wrote that Henri instructed his students to "Paint what you feel. Paint what you see. Paint what is real to you."[12]

Henri rejected the *fin-de-siècle* idea of art for art's sake in favor of art for life's sake.[13] As he put it, "the object is not to *make art*, but to be in the wonderful state which makes art inevitable."[14] The Ashcan painters followed the creed "never feel that you are making a work of art," a reference to the excesses born of the cult of "art for art's sake" popularized by James McNeill Whistler.[15] Henri admired the work and the artistic endeavors of Whistler and William Merritt Chase, yet he resented their effete nature, artifice, and lack of grounding in reality. Rather, Frans Hals, Diego Velázquez, and Edouard Manet represented the artistic trinity for the members of the Ashcan school, who held these three painters in the highest esteem, constantly using their work as a reference point.

Focusing on Henri's expectations, Guy Pène du Bois recalled: "The student of art must be a man first, with a good strong conscience and the courage to live up to it. Art could come later."[16] Henri formed a camaraderie in the studio that was not found elsewhere. Pène du Bois noted: "He did not expect the artist to be a normal man, of which there are always too many. He expected him to be a real man, of which there are always too few. Art and manhood was [sic] thus compounded into one—an incredibly healthy unity for that time."[17]

Henri did not view his role merely as teaching a group of artists to paint. He chose to mold them, creating the archetypal citizen artist, becoming a mentor and infusing his students with the "art spirit," generating a group of followers who would bring art into the American life and life into American art. Pène du Bois's description of his student years with Henri reads like the memoirs of a collegiate fraternal organization:

For four or five years until 1905 I was the monitor of that rough-riding class. I use this term advisedly, for its members delighted in the Rooseveltian contribution to the color of the period: the word "strenuous." They took up boxing, handball, all sorts of gymnastics, chinning

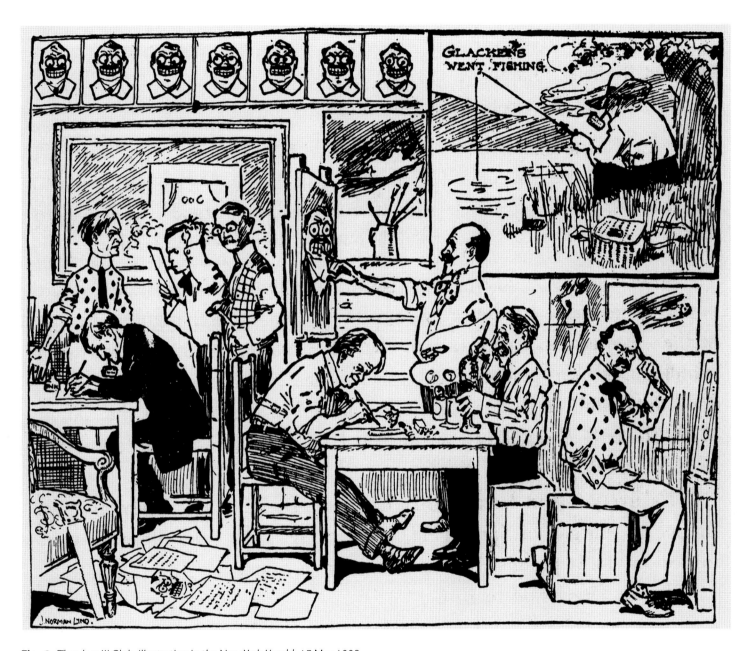

Fig. 2. *Theodore III Club*, illustration in the New York *Herald*, 17 May 1908

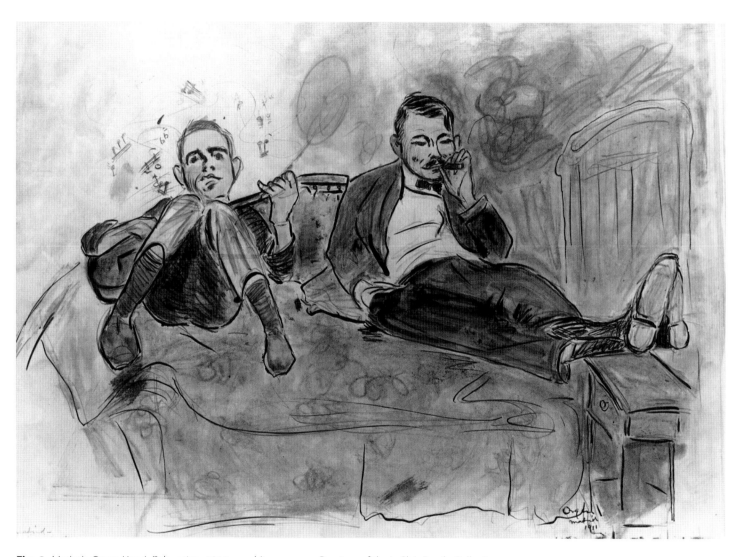

Fig. 3. Marjorie Organ Henri, *Relaxation*, 1911, graphite on paper. Courtesy of the LeClair Family Collection

themselves with the lightest finger grips over all the door lintels. Their baseball team was always victorious even against those of such larger art schools as the National Academy of Design and the Art Students League further west on 57th Street. They had physical encounters with the students of the League, which were presumably proscribed by the academic teaching of Kenyon Cox. The brawls occurred in the school buildings. Police reserves were called to stop an exceptionally violent one at Chase's. Here were art students who could glory in bloody noses, point with pride to the black eye of an evangelical dispute with blacker academicism. This class disintegrated naturally enough afterward, but for a time it was [an] almost miraculously inspired closely knit unit.[18]

Henri, true to form as an innovator, created America's first counterculture fraternity. The Ashcan painters, following him, rejected the effete nature often associated with art. Thus, with democratic zeal they defined the American artist of the twentieth century not as something separate from society, but as an integral part of it.

This fraternal sense is demonstrated in an illustration of Shinn's from the spring of 1908. That year there was speculation that Teddy Roosevelt might seek a third term as president. Like most of the Ashcan painters, Shinn intended to support Roosevelt, a progressive Republican, and came up with an enterprising business venture.[19] To promote Roosevelt's candidature, he established the "Theodore III Club" (fig. 2), leading the press to believe that it was a project of The Eight, who at the time were enjoying a certain amount of celebrity. Not all members of the group felt the press coverage appropriate, resulting in a certain amount of dismay on the part of Lawson and, in particular, Henri.[20] The objection was not to the fraternal association, but more to the use of celebrity for a political purpose, even one they supported.

Informality was the norm among the Ashcan artists. Marjorie Organ Henri, the artist's second wife, captured such moments in *Relaxation*, a drawing depicting Henri

(on the right) and Glackens (fig. 3). The group's subjects often reflect personal relationships and show an interest in specific activities. Such works as Henri's *Portrait of George Luks* (cat. 43) and Sloan's *Yeats at Petitpas'* (cat. 11) or *McSorley's Bar* (cat. 12) exemplify the personal nature of their subjects and the camaraderie enjoyed by these painters. When Henri depicts his friend and fellow painter Luks in an informal moment, dressed in a bathrobe with cigarette in hand, the intimacy of this image attests to the artists' close relationship. In *Yeats at Petitpas'*, Sloan records a leisurely social dinner, in which he includes himself among the admirers surrounding the famed Irish painter John Butler Yeats. A slightly different interpretation of his life follows in *McSorley's Bar*, an establishment that Sloan and his fellow artists frequented. In this instance, his inclusion is as the unseen viewer.

As young art students, many of the group traveled abroad, often to Paris and its environs. Their experiences there served not only as subject matter, but also as a model for an adopted lifestyle. Once back on American shores, they introduced habits learned abroad, recording such events in their canvases, which depict, for example, the evolving dining experience, from the formal affair of the early years of the twentieth century to the more casual event of the 1920s. Entertainment in its many forms also played a prominent role in the lives of the Ashcan artists. They celebrated the performance, the performer, or the audience through their canvases. In some cases, the artist makes the viewer a complicit accomplice in the voyeuristic act of watching the audience watch the performance. The Ashcan painters documented celebrities with whom they associated, among them Isadora Duncan (cat. 30); Katharine Cornell, "the first lady of the theater" (cat. 32); and famed dancer Ruth St. Denis (cat. 18). As men of the "American Century," the members of the Ashcan school also embraced various aspects of popular sports and recreation with gusto. From the physical violence of boxing to the peaceful pleasures of fishing, these artists celebrated some of America's greatest pastimes and documented the nascent stages of the nation's joy of athletics.

New York and its surroundings, especially Central Park, supplied further inspiration for the Ashcan artists, who recorded the use of the park by an ever broader public, from the predominantly well-to-do in the early years of the twentieth century to a more diverse populace in the 1920s. Washington Square and Battery Park offered other parkland escapes from the city (fig. 4). For those who did not live near a park, fresh air and relaxation might be found in courtyards or on piers and tenement stoops (fig. 5), all spaces these artists addressed in their work. They took to the beaches, not to capture the effect of light that attracted an earlier generation, but to depict friends and others seeking respite from the heat. Traveling outside the city, the Ashcan painters portrayed people escaping the congestion of urban life. Leon Kroll explored such a theme with *In the Country* (cat. 62), depicting Bellows and his family at their summer residence in Maine. This intimate portrait underscores the idea of Ashcan painters at leisure, and through the inclusion of the Bellows family, Kroll admits the viewer to their inner circle. This, once again, demonstrates that the Ashcan artists painted life as they found and experienced it.

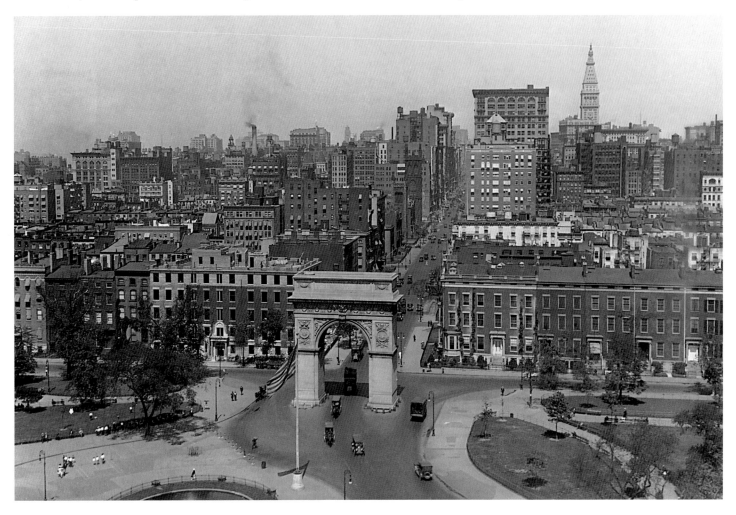

Fig. 4. *Washington Square, New York*, ca. 1900–20. Library of Congress, Gift, State Historical Society of Colorado, 1949

Fig. 5. George Luks, *St. Botolph's Street*, ca. 1910, oil on canvas. Private collection, Washington, D.C.

The Naming of the Ashcan

Many of the first-generation Ashcan artists began their careers as newspaper illustrators, recording facts and, at their editors' pleasure, embellishing characteristics. This experience, along with Henri's exhortations, led them to interpret the gamut of turn-of-the-century life, embracing all levels of the social strata through a myriad of activities, from work to leisure. At times, as we have seen, they depicted a quiet park scene or a group of friends at dinner, while occasionally they adorned the characters with expressive qualities intended to amuse or lampoon. This aspect of their work exemplifies the manner in and zeal with which they embraced life. The work of their most productive and innovative years—those in which they depicted the broadening leisure opportunities that helped define the American experience—provides a refreshing approach to painting, a democratization of subjects, and an expansion of those deemed important enough to paint.

In the minds of many, however, the Ashcan artists continue to be predominantly associated with images of gritty urban reality. The label "Ashcan school," in fact, first appeared in print in 1916 in an attack by Art Young on the art of some of his fellow contributors to *The Masses*.[21] The socialist magazine was near insolvency when Sloan joined the board in 1913. Sloan and four other artists from the Henri circle, most notably Bellows, enlivened the publication with their illustrations.

For the most part, this small group's work consisted of quick sketches drawn in a heavy manner with crayon, often depicting the more tawdry aspects of the lower socioeconomic set—bums, drunks, and prostitutes. To the displeasure of the literary editors and some of the more political artists, Henri's followers appeared to show an obvious delight in depicting such subjects, demonstrating a less sympathetic, more aloof attitude, one not embracing the moral socialist position desired by those loyal to the cause. Members of staff, including Young, were offended by the perceived callous attitude of this group. Favoring a more positive depiction of the downtrodden, Young wrote:

Fig. 6. George Bellows, *Disappointments of the Ash Can*, illustration in the *Philadelphia Record*, 25 April 1915

The dissenting five artists were opposed to "a policy." They want to run pictures of ash cans and girls hitching up their skirts in Horatio Street…. For my part, I do not care to be connected with a publication that does not try to point out the way out of a sordid materialistic world. And it looks unreasonable to me for artists who delight in portraying sordid and bourgeois ugliness to object to a policy.[22]

Young was referring to work of the second generation of Henri followers and specifically to Bellows's drawing *Disappointments of the Ash Can*, which accompanied a piece published in the *Philadelphia Record* on 25 April 1915 (fig. 6). The drawing (of hoboes removing food from a garbage can), the picture's title, and Young's comments led to the naming of the Ashcan school.[23] Max Eastman, managing editor of *The Masses*, later boasted in his memoirs, "we were coarse enough … to play a role in creating the 'Ash-can School' of art. Indeed George Bellows' revolting drawing of … bums licking scraps out of a refuse can was the ne plus ultra of that school."[24] Rockwell Kent, one of the true socialists in the Henri circle, most accurately characterized his mentor thus: "if Henri turned to labor, underprivileged and dilapidation as the subject or background for a picture it was merely because, to him, man at this level was most revealing of his own humanity."[25]

These comments suggest how these artists' intentions might be misinterpreted, how the members of the Ashcan school could be construed as social activists, on the far left side of the political landscape. Yet such an interpretation is not borne out by the generally apolitical nature of most of the Ashcan artists' work. Indeed, while many of the artists belonging to both the first and second generations of the Ashcan school were for the most part progressives, some of whom dabbled in socialism, this did not translate to their canvases, and there is no indication that most members of the Ashcan school played the role of activists.[26]

Henri taught that painting as a vehicle for political or social commentary was no more valid than "art for art's sake"; the realism he advocated was not to be harnessed to a political agenda. Indeed, such an agenda, he argued, was immaterial to the realism, openness, and honesty that he sought to cultivate in his students. In reality, the Ashcan artists were truly "rebellious" only in rejecting artifice where they found it in American life and in exhibiting this work in a relatively independent manner.

The artists of the Ashcan school were diverse individuals, albeit linked by a philosophical approach to painting. They were not limited to one subject, nor did they adopt the role of social activists. They painted their world, their lives, what they saw, and what interested them. Embracing life to the fullest, they were the type of individuals who defined the "American Century," reveling in camaraderie, entertainment, sports, and general leisure activity. Their paintings did not only represent a *joie de vivre*; they brought that joyful spirit to the United States and embraced it.

Notes

1. Robert Henri, *The Art Spirit* (1923; reprinted. New York, 1984), 189.
2. Lowery Stokes Sims, *Stuart Davis: American Painter* [exh. cat., The Metropolitan Museum of Art, New York] (New York, 1991), 32, 33.
3. Sims 1991, 32, 33.
4. Henri was supportive of Myers's work, the approach of which seemed sympathetic with Henri and the other realists. The public reason given for Myers's exclusion from the show was a lack of space in the gallery. For Shinn's comments on Myers's work, see Bennard B. Perlman, *Robert Henri: His Life and Art* (New York, 1991), 77. For Sloan's comments, see *John Sloan's New York Scene from the Diaries, Notes, and Correspondence*, ed. Bruce St. John (New York, 1965), 185. Although Sloan expressed some reservations about Myers's work, he later reminisced that Myers should have been included, and blamed his omission on Henri. See Grant Holcomb, "The Forgotten Legacy of Jerome Myers (1867–1940): Painter of New York's Lower East Side," *American Art Journal* 9 (May 1977): 83–84; see also William Innes Homer, *Robert Henri and His Circle* (Ithaca, N.Y., 1969), 129.
5. Robert Henri diary, 15 February 1927, Henri Estate, LeClair Family Collection.
6. Arthur B. Davies to Robert Henri (15 January 1908), Henri Papers, Beinecke Rare Book and Manuscript Library, Yale University, New Haven, Conn.
7. "Eight Artists Join in an Exhibition," *New York Times*, 6 February 1908, 6.
8. *Americans in the Arts, 1890–1920: Critiques of James Gibbons Huneker*, ed. Arnold T. Schwab (New York, 1985), 475.
9. Henri 1923 (1984 ed.), 15.
10. John Sloan, *Gist of Art: Principles and Practice Expounded in the Classroom and Studio, Recorded with the Assistance of Helen Farr* (New York, 1939), 6.
11. Henri 1923 (1984 ed.), 198.
12. John Sloan notes, on deposit with the Delaware Art Museum, Wilmington, taken from a manuscript based on this reminiscence.
13. Guy Pène du Bois, *Artists Say the Silliest Things* (New York, 1940), 84.
14. Henri 1923 (1984 ed.), 226.
15. Sloan notes, see note 12.
16. Pène du Bois 1940, 88.
17. Pène du Bois 1940, 88.
18. Pène du Bois 1940, 89.
19. It was a small hand-held game, the object of which was to get two small balls in the eyes of an image of Roosevelt.
20. For a full discussion of the Theodore III Club, see Ira Glackens, *William Glackens and the Ashcan Group: The Emergence of Realism in American Art* (New York, 1957), 107.
21. For an in-depth discussion of the naming of the Ashcan school, see Sims 1991, 35.
22. "Clash of the Classes Stirs *The Masses*," *New York Sun*, 7 April 1916, 6.
23. Sims 1991, 36. To underscore the Ashcan moniker, Max Eastman, managing editor of *The Masses*, related a comment by one of the Henri circle: "Stuart Davis was walking in a downtown street with a friend the other day, and saw some pitiful Belgian of the industrial war making for the interior of a garbage can in search of a bit of food. Look he knows I'm a *Masses* artist!" (p. 37).
24. Max Eastman, *Love and Revolution, New York* (New York, 1964), 19.
25. Rockwell Kent, *It's Me, O Lord: The Autobiography of Rockwell Kent* (New York, 1955), 82.
26. Homer 1969, 78. Homer explains that Henri's progressive ideas had a strong effect on Sloan, yet Sloan was unable to bring Henri into the socialist circle: "he would have little to do with the party or its tenets." Although Henri's circle was progressive, they "revealed little social consciousness of the world around them. Their primary concern was with their own individual struggles to become artists and to live and paint free from academic restrictions."

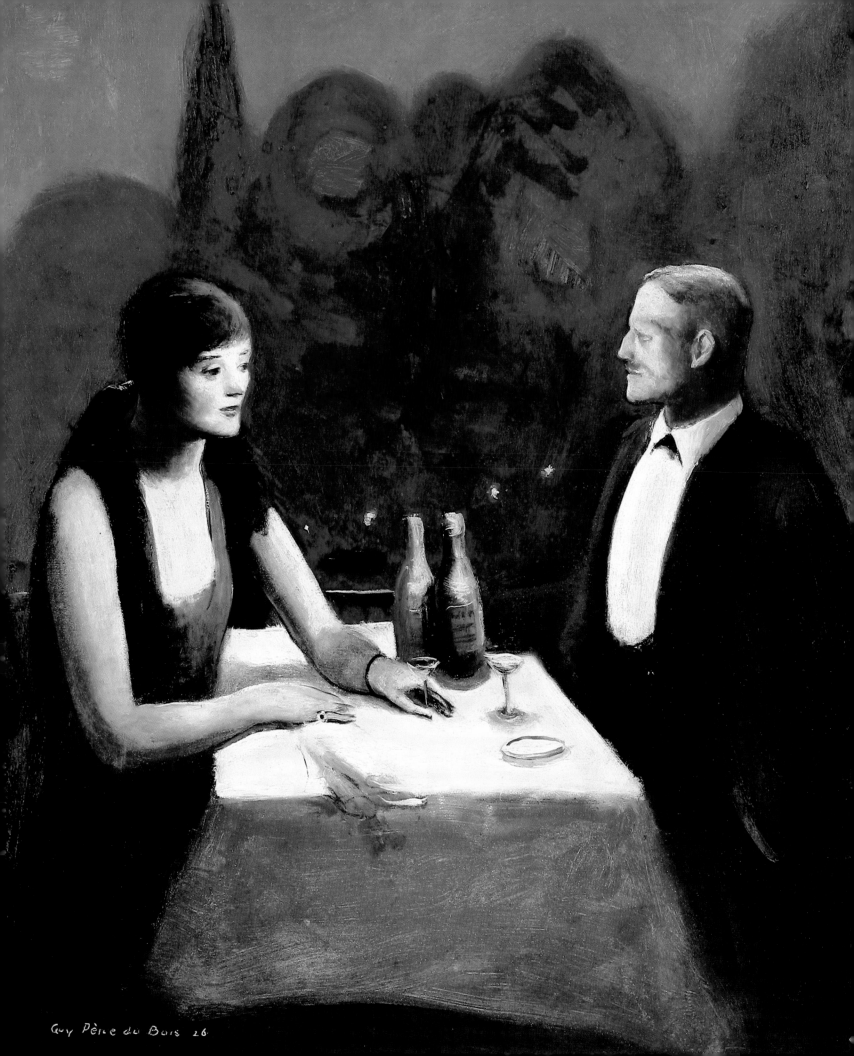

Pictorial Pleasures: Leisure Themes and the Henri Circle

Valerie Ann Leeds

At present [Henri] is the patriarch of the Café Francis crowd, a number of young painters, illustrators and literati who believe in the poetical and pictorial significance of the city crowds and rows of flat houses … we younger men have always looked at Robert Henri as a typification of the new movement in our art.
—Sadakichi Hartmann, 1906[1]

I am always very amused with people who talk about lack of subjects for painting. The great difficulty is that you cannot stop to sort them out enough. Wherever you go, they are waiting for you…. The children at the river edge, polo crowds, prize fights, summer evening and romance … the beautiful, the ugly…. It seems to me that an artist must be a spectator of life; a reverential enthusiastic, [and an] emotional spectator.
—George Bellows, 1917[2]

Work is good, but work is not the only good thing in the world…. He has a twin-sister whose name is leisure, and in her society he lingers now and then to the lasting gain of both.
—Agnes Repplier, 1893[3]

The era surveyed in this volume has been characterized as "The Festive Era," when there was a "cult of gaiety"; by 1904, it was declared that the "average New Yorker" was taking "amusement seriously. It [was] indeed, part of regular life."[4] While this period in the nation's history encompassed such tumultuous events as World War I, the campaign for women's suffrage, and Prohibition, it was also a time in which the pursuit of leisure became an intrinsic part of urban society.[5] Leisure activities and entertainment offerings burgeoned with the decrease in hours in the workweek, the increasing accessibility and affordability of transportation, the advent of electrification, and a boom in entrepreneurial commercialization. It was observed that there was a "'wide-openness' of the city, where the city's people were able to come together to have a good time in public."[6] Although poverty, especially among immigrants, was a pervasive problem in turn-of-the-century New York,[7] a growing middle class with more time and disposable income for leisure pastimes also emerged. These developments are reflected in a significant body of images produced by the Ashcan school artists in the early twentieth century.

In the 1920s, critic Forbes Watson credited Robert Henri and a circle of artists at the beginning of the century with a unifying idea that they took "from the impressionists … the idea of looking at contemporary life and contemporary scenes with a fresh, unprejudiced, unacademic eye."[8] This group of artists, who have been dubbed the Ashcan school—which includes William Glackens, John Sloan, Everett Shinn, George Bellows, Leon Kroll, Jerome Myers, Guy Pène du Bois, and others—has usually been associated with depicting a hardened and unvarnished portrayal of urban existence inhabited by the lower social and economic rungs of working-class life. While such subjects were more often pictured by them than by their predecessors, a thorough review of the work of this group demonstrates that they actually presented a more catholic view of society, showing individuals from all social strata engaged in a broader spectrum of activities than is claimed in much of the existing literature devoted to Henri and the Ashcan circle.[9]

As subjects for their art, in addition to the effects of the evolving industrialization of turn-of-the-century America, the Ashcan artists were attracted to the lighthearted and frivolous pastimes that had become part of modern life. With the emergence of a middle class and the commercialization of entertainment, most of these artists appear to have led bohemian existences and pursued such leisure activities as members of the middle class.[10] Their written legacies illuminate the rich and varied social lives and entertainments they shared.[11] Leisure scenes represent a significant portion of their production, with settings that include bars, cafés, art galleries, and various performances, participation in sports, beachgoing, park scenes, and the countryside, with an emphasis on middle-class people engaged in pleasurable activities. For the most part, these artists depicted the popular new entertainments for the masses, such as vaudeville, musical revues, dancing, circus, and the carnival, but rarely elite cultural pursuits, such as classical-music performances, modern dance, ballet, or opera. In sum, their pictures of everyday city life reveal an abundance of leisure scenes.

At the core of the new informal group were eight artists, led by Henri. They participated in the exhibition "The Eight" at New York's Macbeth Galleries in 1908, in part to express their growing discontent with the overreaching aesthetic constraints of the jury system of the National Academy of Design, but also to assert their overall artistic independence. The critic for the *New York Sun*, James Gibbons Huneker, proclaimed of them: "With the solitary exception of [Arthur B.] Davies, they are painters of contemporary life in its varying phases…. They are realists inasmuch as they paint what they see."[12] Henri had issued a similar pronouncement to his students to paint from life: "I am not interested in any one school or movement, nor do I care for art as art. I am interested in life … let your history be of your own time, of what you can get to know personally… within your own experience."[13]

Henri followed these principles in his own art, deriving subjects from his milieu, although he differed from the other Ashcan artists in his dedication to portraiture. In the early

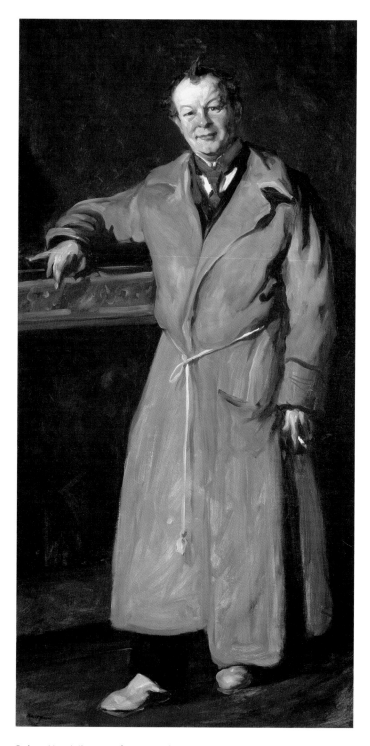

Robert Henri, *Portrait of George Luks*, 1904 (see cat. 43)

years, he frequently painted the people who were closest to him, including his wife and his fellow artists James Preston, Charles Grafly, William Glackens (and Glackens's wife, Edith), John Sloan, and George Luks, the latter represented by a portrait of 1904 (cat. 43). In contrast to Henri's portrait style at the time—in a dark, sober palette filtered through the influence of predecessors Thomas Eakins, Edouard Manet, and James McNeill Whistler—his portrait of Luks is unusual for its casual manner. It shows his friend wearing a bathrobe that suggests an artist's smock, leaning against a picture frame, and smoking a cigarette, as if at work, a relaxed pose that was probably part of Henri's strategy to capture the essence of Luks's irreverent personality.[14]

Glackens, Sloan, Shinn, and Luks came to painting from backgrounds as illustrators and artist-reporters that trained them to record their immediate surroundings and capture the dramatic moment, embellishing scenes to enhance the response of readers to the stories, and they applied these skills as they pursued careers in fine art. Under the leadership of Henri, they and their expanded circle of friends and colleagues were attempting to define a distinctly American art derived from their contemporary world with a new sense of pictorialism.[15]

Cafés, Bars, and Restaurants

As the commercial economy matured, dining and drinking in establishments away from home became a focal point of social interaction in the city. Such socializing often took place in cafés, bars, and restaurants, ranging from working-class taverns to stylish restaurants—places to relax and congregate that offered a respite from the bustle of city streets or the too-still quiet of home. Café scenes by the Ashcan school artists were initially influenced by the French impressionists, although the Americans modified their approach to suit their artistic goals. Like the impressionists, they selected subjects taken from their immediate experience, which resulted in a profusion of middle-class subjects, but with an increasing emphasis on the pictorial narrative. Maurice Prendergast was one of the earliest of this group to spend an extended period in Europe, where he absorbed the latest developments in art and fashion. An early watercolor, *The Band Concert, Luxembourg Gardens* (cat. 10), dating from 1893, depicts a fashionable crowd relaxing with drinks while listening to a concert performed by musicians visible in the background.[16]

The European café scenes of Prendergast, Alfred Maurer, and Guy Pène du Bois highlight the social formality more typical of the late nineteenth century. Café and dining scenes created by other American realists in the first few years of the twentieth century—for example, *Chez Mouquin* (cat. 1), by Glackens, and *The Café Francis* (cat. 3), by Luks—reflect a more modern and realistic ambience, as social constraints relaxed and artists placed increasing emphasis on narrative and characterization. Works from several years later, such as Sloan's *Yeats at Petitpas'* (cat. 11) and *McSorley's Bar* (cat. 12), reflect this progressive transition.

The social nexus for the Ashcan artists revolved around Mouquin's, Café Francis, and Petitpas', which became the common meeting grounds for these artists and other cultural figures of the day.[17] These establishments attracted an eclectic clientele, including a well-heeled middle-class crowd of theatergoers, together with artists, critics, and writers, who carried on into the very late hours.

Fig. 1. Everett Shinn, *Mouquins*, 1904, pastel on cardboard. The Newark Museum, Newark, New Jersey. Collection of the Newark Museum, 49.353

Mouquin's was a frequent destination for the Ashcan artists, memorialized in one of the most recognizable images of the period, Glackens's *Chez Mouquin*, and Shinn depicted the restaurant from the outside in *Mouquins* (fig. 1). Glackens's painting, which evokes café scenes by Degas and Manet, shows James B. Moore—a lawyer and the proprietor of the Café Francis—with Jeanne Louise Mouquin, wife of the proprietor, Henri Mouquin, who was probably too busy to sit for the portrait; Edith Glackens is also visible (from the back) conversing with Charles Fitzgerald, a friend and sympathetic art critic.[18] The painting was included in the exhibition at the Macbeth Galleries, where it elicited praise for its realism and criticism for its perceived vulgarity.[19] Only on rare occasions did Glackens represent the rougher side of urban life for which the Ashcan artists have been stereotyped, instead favoring a brighter optimistic view in "the picnic spirit."[20]

Aside from his paintings of scenes populated with street characters, entertainers, urchins, and harpies, Luks also pictured café subjects, as in *The Café Francis*. This work also portrays James Moore with one of his young female companions. The café was a competitor to Mouquin's for the art and literary crowd, and was advertised as "New York's Most Popular Resort of New Bohemia" until it closed in 1908. It served as a social hub for the Ashcan artists, who were dubbed the "Café Francis School."[21] Glackens's representation of *Chez Mouquin* is more conventional, while Luks's café scene is dynamic and filled with movement, showing Moore attempting to prevent the young woman from striding away. She is glamorously attired in feathers, sequins, and a low-cut bodice that reveals her ample figure and which, with her inviting expression, suggests a loose moral character. In a small window in the background over Moore's shoulder, the bustling ambience of the café is visible behind a costumed guitarist providing entertainment, adding another layer of narrative.

Sloan was an astute chronicler of Manhattan society in the early twentieth century, and his many restaurant and bar scenes are among his most penetrating portraits of everyday urban life. He was adept at translating incisive observations into compelling painted images. Sloan routinely painted the places he knew best, and one of his most personal transcriptions is *Yeats at Petitpas'*, a locale for which he and his circle had particular affection. Petitpas' was a boarding house and restaurant run by three French sisters from Brittany, and was where Sloan's close friend John Butler Yeats (father of poet William Butler Yeats) boarded and routinely held court. On the elder Yeats's death, he was celebrated as "the sage of a little table d'hote restaurant in West Twenty-ninth Street…. As painter, philosopher, poet and friend, he greeted all who came to Petitpas…. Sitting in the chair at the end of the table with two or twenty friends about him, he discoursed on everything from the profound to the humorous."[22]

In the painting, Yeats is seen seated at the table second from the left, next to Sloan's biographer, Van Wyck Brooks. The painting depicts a summer evening at their designated outdoor table and was inspired by a birthday dinner for Dolly Sloan, the artist's wife, but was conceived to honor Yeats, who was close to and very supportive of Sloan.[23] Petitpas' attracted an artistic and literary crowd, and it was said that "almost everybody who dallies with a paintbrush or a pen knows Petitpas'…. Some of the best known were Van Wyck

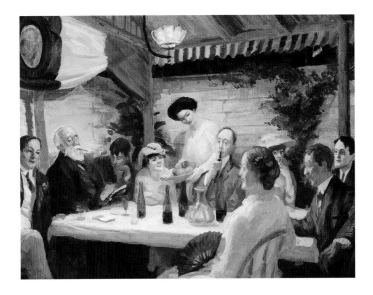

John Sloan, *Yeats at Petitpas'*, 1910 (see cat. 11)

Brooks, Mr. and Mrs. Sloan, Mr. and Mrs. Henri, George Bellows … Mr. and Mrs. Randall Davey, William Carmen Robert, Mary Fanton Roberts, Eulabee Dix Becker … Mr. and Mrs. William Glackens … John Quinn—all intimates of the seer of Petitpas'."[24] The locale was represented in the work of other Ashcan artists besides Sloan, including a watercolor by Luks and a drawing of 1914 and lithograph of 1916 by Bellows.

McSorley's Old Ale House, an Irish working-class bar located on East Seventh Street in Manhattan, provided Sloan with a different sort of establishment to paint. Known as the city's oldest continuously operating saloon (established in 1854), it had a floor strewn with sawdust, no stools, and walls adorned with theater memorabilia, sporting prints, and programs. To this day, the bar maintains the same faded ambience. Among Sloan's best-known works are five depictions of McSorley's, in particular, *McSorley's Bar* (cat. 12) and *McSorley's Back Room* (1912; Hood Museum of Art, Dartmouth College). The light in both compositions is of central importance, as it highlights details that affirm the authenticity of Sloan's representation. Although Sloan's training as an illustrator taught him to capture a slice of life quickly, he made at least six sketches of McSorley's, from which he developed the composition for *McSorley's Bar*.[25] McSorley's was known as a place where men of different classes intermingled; seen here are probably some of the varied regulars imbibing the famed ale as they stand at the bar, while a waiter, with his back turned, and the bartender, Bill McSorley, son of the founder, tend to the patrons. Offering a quiet, all-male environment, where men of all backgrounds could relax in a neutral and comfortable setting, McSorley's earned the sobriquet the "Old House at Home," and Sloan fondly referred to it as the "old standby," and declared that he could not "get away from it."[26]

Guy Pène du Bois, a student of Henri's who became a reporter and illustrator, was a critic as well as a painter. He was an astute observer of society but used his talents for satirical images of the new moneyed class. By the 1920s, he had cultivated a stylized approach that focused on depictions of café society. He painted two versions of his

principal benefactor, Chester Dale, with his wife, Maude, in a café. The first is *Mr. and Mrs. Chester Dale Dining Out* (fig. 2), which shows the couple about to give their order to a waiter in the celebrated dining room of the expensive and fashionable Brevoort Hotel in New York. Located on Fifth Avenue between Eighth and Ninth streets, the Brevoort attracted artists and writers as well as a sophisticated European clientele.[27] An able caricaturist, Pène du Bois achieved effective likenesses of Dale and his wife, although he reported difficulty in finishing the painting.[28] A conflicted relationship with Dale—an investment banker, art patron, and philanthropist—may have contributed to the problems he had; as Pène du Bois noted, Dale's "glories have to be in things money can buy him for they are absolutely not in him. He is one of those forced to stand by his pile of gold in order to have any beauty at all."[29] Two years later, the artist undertook a variation of the composition showing the Dales in a less formal environment, *Café Madrid (Portrait of Mr. and Mrs. Chester Dale)* (cat. 9).[30]

In both scenes, Pène du Bois appears to be also subtly satirizing high society, presenting the Dales with vapid and detached expressions that could suggest some vestige of resentment by the artist toward the wealthy subjects on whom he was financially dependent.[31] In his uniquely mannered style, Pène du Bois recorded an era of cosmopolitan sophistication in American café society, yet many of his images of the upper classes reveal an undertone of contempt. Glackens and Pène du Bois tended to favor café society as subjects, while Sloan was drawn to subjects of less pretension.

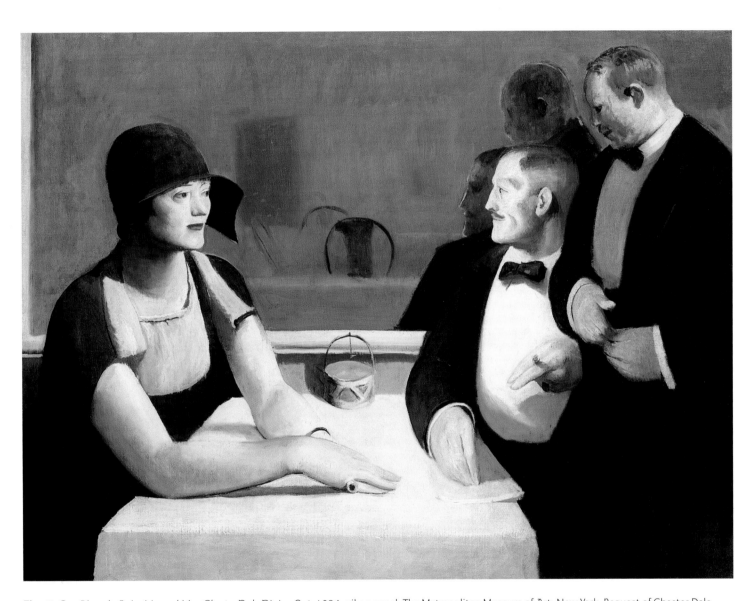

Fig. 2. Guy Pène du Bois, *Mr. and Mrs. Chester Dale Dining Out*, 1924, oil on panel. The Metropolitan Museum of Art, New York, Bequest of Chester Dale

Entertainment, Performances, and Outings

As the social and cultural climate matured, there became available a wider array of commercial cultural venues, such as museums, galleries, theaters, music halls, and movie houses, and these became more actively patronized. Wealthy art aficionados and collectors became interested in attending museums and commercial galleries, especially those for contemporary American art. The Whitney Museum, which began as the Whitney Studio Club on Eighth Street, was an early forum for contemporary American artists as well as art lovers. It was founded by patron and sculptor Gertrude Vanderbilt Whitney, an important supporter of the realists. Visiting such art destinations became a popular pastime.

In a satirically titled work, *The Art Lovers* (1922; private collection), Pène du Bois pictured well-to-do patrons looking at fine art in a gallery or museum reception. He also painted *Juliana Force at the Whitney Studio Club* (cat. 23), a tribute to the adviser and assistant to Gertrude Vanderbilt Whitney at the Whitney Museum, whose loyal support of his work meant a great deal to him.[32]

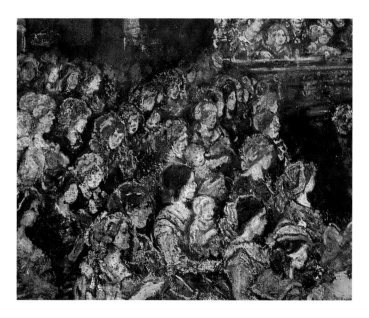

Detail, Jerome Myers, *The Children's Theatre*, ca. 1925 (see cat. 21)

Jerome Myers usually concentrated on depicting a very different segment of society: the city's disadvantaged, in scenes of tenement life on New York's Lower East Side. Myers's portrayals of street life preceded the work of the Ashcan artists, perhaps as early as 1887. Although his artistic outlook seemed compatible with Henri and the realists, and Henri was supportive of his work, Myers was not invited to show with The Eight, largely owing to a perceived sentimentality in his work that some of the group found objectionable;[33] even Myers himself admitted to presenting a romanticized view of tenement life.[34] As a release from the grim, crowded conditions that many immigrants endured, he emphasized the more modest pleasures they were able to find, as in *The Children's Theatre* (cat. 21), a humble local theater on Third Avenue in which performances for children were given on summer afternoons. The average Lower East Side family could seldom afford such a luxury, but a rare matinee was a favored form of entertainment, which Myers conveys through the expressions of pleasure on the faces of the audience, principally women and children.[35] Recalling the nostalgia he felt for such performances as he grew up in similar circumstances, he observed, "It is a far cry from the Paris Opera house, Degas and his ballet girls.... Many days I spent absorbing this simple subject [which] brought back my childish love for the play, giving it the quality of real illusion."[36]

Many of the subjects represented by these painters are middle-class popular amusements, but more refined pastimes, such as classical music, were also occasionally portrayed, as in Arthur B. Davies's *The Horn Players* (cat. 15). Of the Ashcan artists, Luks was particularly interested in music, and featured musicians in several mostly single-figure compositions. *Three Top Sergeants* (cat. 20), a multifigure composition, was inspired by an impromptu visit from three neighbors, whom Luks posed with musical instruments. Even though none of the models had any musical training, the authenticity and immediacy of the work are so convincing that music appears to emanate from the subjects.[37]

Everett Shinn devoted a significant portion of his oeuvre to the theater, depicting the spectacle as well as the

audience. He had an enormous regard for Degas, whom he called "the greatest painter France has ever turned out."[38] Like Degas, Shinn also often worked in pastel, executed dance and theatrical subjects, and employed contrasts in lighting and unusual vantage points. And, like the other realists, Shinn emphasized light popular entertainment for the masses, preferring dance-hall shows and musical revues. After an extended trip to Europe, he produced fewer of the gritty cityscapes he had produced in the 1890s, and began to favor theatrical subjects. By the early years of the twentieth century, he was producing scenes especially of the honky-tonk New York establishments. He most often relished picturing the vaudeville and circus entertainers and their spectators, as in *Theatre Scene* (cat. 27), *Theatre Box* (cat. 26), and two works entitled *The Orchestra Pit* (cats. 25 and 28).

The Orchestra Pit paintings are typical of the manner in which Shinn emphasizes the drama of such performances, using an angled perspective to show the stage performer bowing from the pit. In a move that helped establish his reputation as a painter of theater subjects, Shinn entered the oil painting (cat. 25) in The Eight exhibition in 1908 at the Macbeth Galleries. The theater depicted is probably Proctor's Theater, which opened in 1900 at Broadway and Twenty-eighth Street and was the leading venue in establishing vaudeville in the theater district. In *Theatre Box*, Shinn reverses the vantage point, looking out on to the audience from backstage of a vaudeville performance. The audience's middle-class status is affirmed by their very presence, which required a sufficient disposable income.

Hammerstein's Roof Garden, at Forty-second Street and Seventh Avenue in New York, was opened by impresario Oscar Hammerstein, who was instrumental in making the Times Square area a center for theatrical entertainment. It was an even more favored venue for popular middle-class entertainment than Proctor's Theater, as the open-air setting was cooler and it presented more varied summer entertainment. In *Hammerstein's Roof Garden* (cat. 16), Glackens, like Shinn, focuses on both performers and audience, but adds dramatic tension by featuring a female tightrope walker shown midway across the tightrope.

The scene is segmented by the suggestion of strong horizontals, with the audience constituting the bottom third. The audience members are more carefully defined than in Shinn's scenes; although their generic dress and comportment suggest middle-class status, some commentators regarded them as lacking refinement, and one cultural observer declared that the entertainment offered was dull and vulgar.[39] The scene derives from a *Harper's Bazaar* magazine illustration from 1900 and is an unusual subject for Glackens, who was inclined to represent outdoor scenes filled with activity.

Although Shinn often emulated Degas in portraying dance themes, he rarely pictured the ballet, preferring popular dance performances and vaudeville. Maurice Sterne, although not in Henri's circle of realists (and known primarily as a modernist sculptor), shared Shinn's admiration for the work of Degas, which he had seen firsthand in Europe. *Entrance of the Ballet* (cat. 33) stands out within Sterne's oeuvre as a painting in an early formal style, paying homage to Degas's ballet scenes. In showing a more refined cultural activity, Sterne departs from the preponderance of popular entertainments in the work of the realists.[40]

In the early years of the twentieth century, scenes depicting lighthearted—and more affordable—pastimes, such as the circus, carnival, and movies (a recent innovation), were more widely introduced into the visual lexicon of artists. Besides Shinn, such artists as Sloan, Gifford Beal, and Bellows represented circus and carnival subjects; more than any of the other realists, Beal devoted a significant part of his oeuvre to such themes, as in *Waiting for the Show* (cat. 13).

Bellows credited Henri with mentoring his artistic development and urging him to draw subjects from his immediate surroundings.[41] In the summer of 1912, a circus came to Bellows's hometown of Montclair, New Jersey, and his wife, Emma, observed that it "played to capacity audiences and was lots of fun but financially a big flop…. I always said George got more out of it than anyone else."[42] The event inspired two important canvases in 1912: an

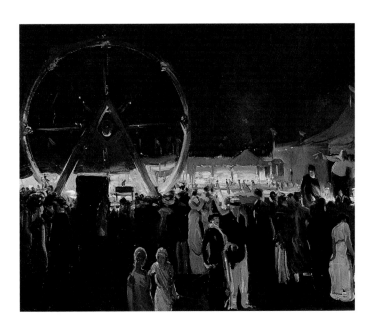

Detail, George Bellows, *Outside the Big Tent*, 1912 (see cat. 14)

indoor scene depicting the big ring, *The Circus* (fig. 3), and *Outside the Big Tent* (cat. 14). Both compositions exhibit dramatic lighting and design, with the audience in the foreground. *Outside the Big Tent* shows a varied, well-dressed, middle-class crowd milling around, with a carnival act in the distance. Although it was composed with a strong underlying geometric framework, utilizing an aligning grid of angles, horizontals, and verticals, as in other works of this period, Bellows elicited a feeling of spontaneity in the scene. Both Bellows and Sloan were introduced to rational compositional and color theories by Henri, and readily adopted such strategies.

Sloan's representations of entertainment included a broad range of democratic subjects that surpassed in scope those of any of the other Ashcan painters. In 1919, at Henri's suggestion, Sloan first visited Santa Fe, New Mexico, a place for which he developed a strong connection and where he returned almost every year for an extended period.[43] The region, with its distinctive environment and diversity of people, offered him a rich new source of subject matter. *Traveling Carnival, Santa Fe* (cat. 31) is reminiscent

of the type of street-life genre that Sloan had painted of New York a year earlier. He reported to his sister, Marianna: "A show came to town with carousel and Ferris wheel and I made one of the best things I've ever done with it as a subject."[44] The lights and movement inspired by the merry-go-round are at the core of the composition, with observers in the foreground. Later Sloan reminisced: "These collapsible and portable entertainments, when permitted by the city authorities to flaunt their charms are a tremendous success with the people. Indian, Spanish, and Anglos ... enjoy the agreeable change from the flickering films."[45]

Movies were another popular form of entertainment that captivated Sloan. In 1907, he executed one of the earliest representations of the movies on canvas, *Movies, Five Cents* (1907; H.A. Goldstone Collection), in which he surveys the interior of the movie house from the back looking toward the screen, showing a black-and-white moving picture. In late June 1907, Sloan noted in his diary: "Went into a five cent show of Kinematograph pictures on 6th Avenue. Think it might be a good thing to paint."[46] Introduced in 1895, the cinematograph was an all-in-one camera, film projector, and developer that was used to present moving pictures. In the same year that Sloan executed this scene, the first color movie with sound was presented in the United States. Within a short time, "nickel madness" had overtaken the city and become a new form of mass entertainment. Movie houses attracted a cross section of the populace, especially immigrants and working-class people, owing to their affordability and accessibility; they also drew courting couples, who were able to attend without a chaperone.[47]

Henri was an avid devotee of many types of cultural events but tended not to be very interested in the vaudeville and popular entertainments frequently depicted in the work of his contemporaries, instead favoring theater, movies, and especially dance. He sought acquaintance with noted dancers of the day, including Isadora Duncan, Roshanara (Olive Craddock), and Ruth St. Denis. In May 1909, in rapid succession, Henri produced two full-length portraits of a model dressed as the title role in *Salome*, Richard Strauss's

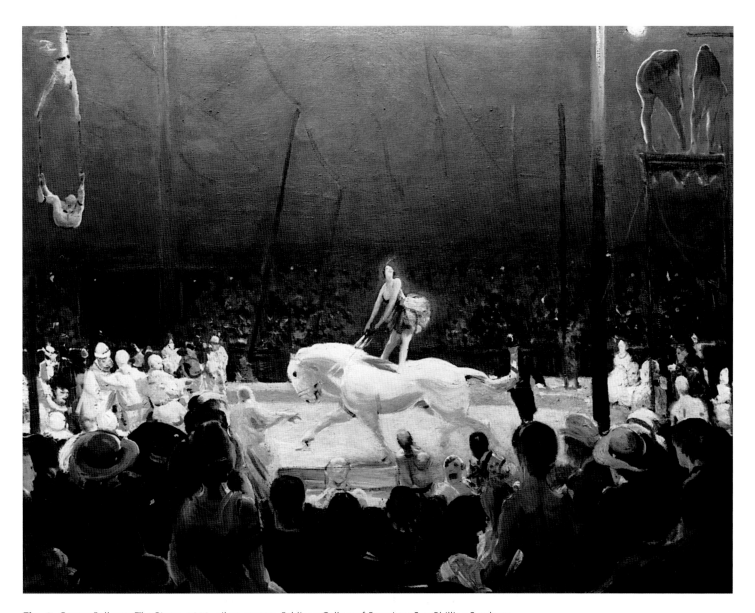

Fig. 3. George Bellows, *The Circus*, 1912, oil on canvas. Addison Gallery of American Art, Phillips Academy, Andover, Massachusetts, Gift of Elizabeth Paine Metcalf

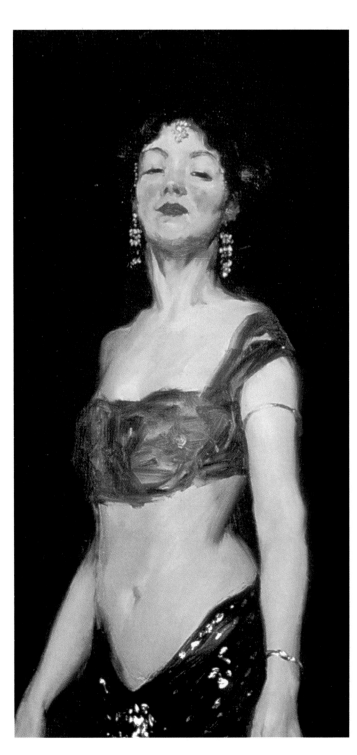

Detail, Robert Henri, *Salome*, 1909 (see cat. 17)

opera of 1905 based on Oscar Wilde's scandalous play of the same name from 1891. At its debut in New York at the Metropolitan Opera House in 1907, the opera was extremely controversial and, owing to the explicit sexual and violent nature of the material and the interpretation, was canceled after the first performance. Henri and his wife saw the opera performed at Hammerstein's Manhattan Opera House (which was in competition with the Metropolitan Opera House) in February 1909, with the soprano Mary Garden in the lead role. Garden was notable for her overtly sensual interpretation and passionate acting, and for performing the opera in Wilde's original French. The musical high point of the opera is "The Dance of the Seven Veils," the subject of Henri's Salome portraits. In most stagings of the opera, a trained dancer and not the singer of the lead role performed the dance, but Garden performed it herself, wearing a tantalizing pink body stocking. For these paintings, however, Henri found a professional model or dancer to pose, noting her name in his record book as Mademoiselle Voclezca.[48] The first version of *Salome* shows her in what appears to be a flirtatious and self-possessed stance (cat. 17), with her head thrust back and eyes half-closed.[49] She holds a white scarf or drape, suggesting the last remaining veil, with which she appears to be dancing, but which was eliminated in the second version (see Doezema essay, this volume, fig. 6). The costume, quite revealing for the day, exposes the model's midriff and legs through chiffon pantaloons and is highly decorated with embroidery, sequins, and beads. The first version was rejected from the National Academy annual in 1910, but was shown at the Exhibition of Independent Artists in the same year; the second version was not exhibited during Henri's lifetime.[50]

One of Henri's few late works depicts Ruth St. Denis, who, along with Isadora Duncan, was a pioneer of American modern dance. St. Denis was deeply influenced by mysticism and Eastern culture, which inspired her famous solo composition "The Legend of the Peacock," the subject of Henri's *Ruth St. Denis in the Peacock Dance* (cat. 18), a masterpiece. Henri began the monumental full-length portrait in February 1919 and was still working on it in April,

an unusually long gestation period for him.[51] When it was shown at the 1919 Portrait Association exhibition, one critic noted, "His joy in the freedom thus accorded him appears in the flexible easy painting. The modeling of the flesh, spontaneous, vital, and calm is remarkable even for an artist in such complete control of his brush as Mr. Henri."[52] In May of that year, Henri wrote to *Vanity Fair*'s editor: "Why can't we suggest a mighty propaganda for a theatre for such great artists as Isadora Duncan, and … Ruth St. Denis … and Roshanara … to give their best in … dance is too great an art for us to miss."[53]

Sloan shared Henri's enthusiasm for dance, but it was Isadora Duncan who earned his unreserved admiration.[54] Henri also sketched Duncan, although no image of her by him has ever been located. Unlike Henri's dance portraits, which are posed portraits remote from the act of dancing, Sloan depicted Duncan performing. He painted *Isadora Duncan* (cat. 30) in 1911, after seeing her dance several times. The first time was in November 1909, after which he wrote in his diary: "We saw Isadora dance. It's positively splendid! I feel that she dances a symbol of human animal happiness as it should be, free from the unnatural trammels. Not angelic, materialistic—not superhuman but the greatest human love of life.… she dances away civilization's tainted brain vapors, wholly human and holy—part of God."[55] He began the painting after seeing her dance on 2 March 1911, but had difficulty in attaining the desired effect; he scraped the canvas and reworked it several times, until 14 March, when he expressed satisfaction with it.[56] Sloan's representation of Duncan dancing on a bare stage, while clad in a diaphanous tunic, with her head thrown back and an arm extended in an unrestrained pose, captures a sense of the physical abandon and expressiveness she was able to convey in her performances.

Eugene Speicher, though not one of Henri's early intimate circle, took a life-drawing class with him, aspired to similar goals, and eventually became one of his closest friends. Firmly associated with the realist tradition, and academically trained, Speicher is most identified with portraiture, although he also executed figurative, landscape,

and still-life compositions. He won the Proctor Portrait Prize from the National Academy of Design in 1911, and in ca.1925-26 painted a portrait of a fellow Buffalonian, actress Katharine Cornell (cat. 32), which was hailed as a "great achievement" by fellow artist Charles Burchfield.[57] Speicher usually painted three-quarter-view seated likenesses, but produced a full-length grand-manner portrait of Cornell, shown in a confident pose in the title role of George Bernard Shaw's play *Candida*, written in 1894. Shaw wrote the character as a strong, assertive figure, intended as a rejoinder to the character of Nora in Henrik Ibsen's play *A Doll's House*, of 1879. The role of Candida contributed to Cornell's growing reputation as one of the country's leading stage actresses, a status that she retained for several decades.

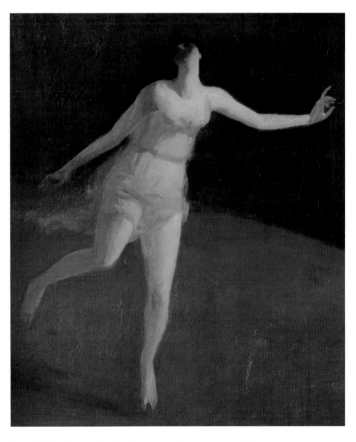

Detail, John Sloan, *Isadora Duncan*, 1911 (see cat. 30)

Sports and Recreation

One of the best prizes with which life rewards successful work is the leisure and means to play out-of-door games.
—David Gray, 1911[58]

[W]ho can say … that the quickened pulse, the healthy glow, the honest self-respect of honest sport have not served in part to steady and inspire a new Americanism for a new century?
—Frederic L. Paxson, 1917[59]

Filling Americans' increased time for leisure were various recently introduced recreational activities. Noted economist and social critic Thorstein Veblen declared in his treatise of 1899 on the leisure class: "Addiction to athletic sports, not only in the way of direct participation, but also in the way of sentiment and moral support, is … a characteristic of the leisure class; and it is a trait which that class shares with lower-class delinquents … a dominant … trend."[60] Sporting themes depicted by the new generation of realist artists extended beyond the typically masculine sports of hunting, fishing, rowing, and boxing, which had been popular with many nineteenth-century artists. Such upper- and middle-class leisure entertainments as polo, horseback riding, horse racing, tennis, and skating were more widely seen as subjects for art in the Henri circle—recreational pursuits that the working class could not afford, and to which they had no access.

At the time Henri executed *Portrait of Miss Leora M. Dryer in Riding Costume* (cat. 42) in 1902, he remained torn between painting landscapes and portraiture. That year, feeling the need to focus on a single genre to gain recognition and establish his reputation, he chose portraiture, with some regret.[61] After he made his decision, his work assumed a new sense of assurance and maturity, with the production of several notable full-length portraits that were imposing in their dark, monochromatic palettes. Created for submission to public exhibitions, these compositions were intended to stand out. The portrait of Miss Dryer—one of the few portraits by Henri showing a subject engaged in or prepared for a particular activity—was the first of these to be completed, and it was accepted and exhibited at the National Academy of Design annual in 1903. Riding was a pastime of the wealthier leisure class, an unusual subject for Henri. He executed the painting in his New York studio in three sittings.[62] Henri had no qualms about altering a picture for an artistic effect, which did not deter critics from associating him with a new brand of artistic realism; this is exemplified by one critic who noted that "Mr. Henri does not hesitate to adjust the parts of his picture, even, at some individual sacrifice, in order to secure a general truth."[63]

In a departure from the Henri circle's depictions of upper- and middle-class sports activities, Sloan painted a group of men engaged in urban fishing, a working-class pastime, in *Fishing for Lafayettes* (cat. 48). Sloan happened upon some locals trying to catch small fish called lafayettes, and sketched the composition from direct experience. Here, he has captured such details as the fishing gear resting on the pier and the motley characters, clad in varying attire, who suggest the shared democratic pursuit of a common goal.[64]

Sloan periodically delved into pointed social criticism, especially of the affluent, although he was wary of expressing his strong leftist political views in his art. One of his most sharply satirical works is *Gray and Brass* (cat. 47), which represents the "pomp and circumstance that marked the wealthy group in the touring car."[65] The idea came to him while walking in Manhattan's Madison Square, as he saw cars with flashing trim pass by on Fifth Avenue, carrying people whom he characterized as "brass-trimmed, snob, cheap" and "nouveau riche," corpulent, overdressed, wealthy types ripe for caricature.[66] In contrast to them, Sloan also depicted a group of less well-off people gathered under a tree, gawking at the flamboyance of the vehicle and its passengers. At the time, ownership of a car was a novelty, and a joyride was an exceptionally rare leisure activity exclusively for the affluent.[67]

Bellows, like Sloan, painted subjects from all walks of life, although his overall subjects comprise a more balanced

view of society. In 1910, Bellows's new patron, Joseph Thomas, arranged for him to visit the George Gould estate in Lakewood, New Jersey. Lakewood was a destination in the late nineteenth century for patrician society, such as the Vanderbilts, Rockefellers, Astors, and Goulds, where the sport of polo was played. Polo had gained popularity among well-to-do Americans by the late 1870s and quickly became a favored recreational pursuit of the privileged. At Lakewood, Bellows was swept up in the visual display of the environment, the game, and the spectators, as he recounted: "I've been making studies of the wealthy game of polo as played by the ultra rich. And let me say that these ultra rich have nerve tucked under their vest pocket.... The players are nice looking, moral looking. The horses are beautiful.... It is a great subject to draw, fortunately respectable."[68] After returning home, he produced two oils, *Polo at Lakewood* (cat. 35) and *Polo Game* (private collection), and a third variation on the theme later that year. He considered *Polo at Lakewood* his best oil to date.[69] The work emphasizes the sparring conflict, power, and movement of the horses and

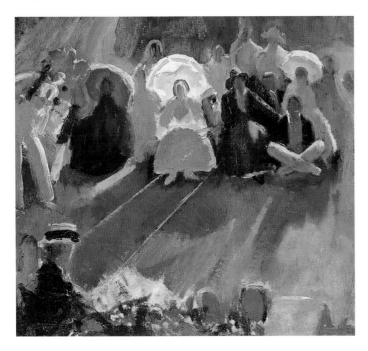

Detail, George Bellows, *Tennis at Newport*, 1920 (see cat. 37)

riders, and Bellows won praise for the other version for its convincing representation when it was submitted to the National Academy of Design winter annual of 1910: "[*Polo Game*] is not merely the rattle and rush of the subject ... [A] conscious elongation of the figures of the onlookers, a stilting up of the ponies' legs beyond natural proportions show that Mr. Bellows is not merely retinal, but is seeking an expression as well for the elegance as for the animation of this theme."[70] John Grabach and Walt Kuhn also undertook themes of similar recreational pastimes involving horses, typically associated with high society.

Along with polo, tennis became popular with the sporting set; introduced in America in the mid-1870s, it soon gained widespread attention when, in 1881, the United States National Lawn Tennis Association held the first national tournament, in Newport, Connecticut.[71] An athlete himself, Bellows played tennis frequently;[72] he depicted the sport in *Tennis at Newport* (cat. 37) after spending the summer of 1919 just a few miles from Newport, in Middletown, Rhode Island, with family and his close friends Eugene and Elsie Speicher. In Newport, he composed sketches of tennis tournaments from which he produced four oils, at least one drawing, and two lithographs.[73] Unlike the naturalism and animation of his polo scene, Bellows's tennis composition has a contrived and static appearance, and employs a distorted perspective. The scene pictures a doubles lawn-tennis tournament overseen by observers from the sidelines, and the staid atmosphere of the restricted club society is transmitted through the poses and attire of the spectators, who display the requisite social decorum. Newport offered Bellows another window into the leisure pastimes of the social elite.

Roller-skating, ice-skating, and croquet were other sporting activities that attracted a democratic range of participants and became subjects for several Ashcan school painters. Roller-skating was introduced to America in 1863; within twenty years, public rinks had opened in many major cities.[74] Glackens was particularly attracted to pictorial genre scenes and, in addition to roller-skating, depicted sledding, ice-skating, and baseball. *Skating Rink, New York*

City (cat. 39) was inspired by an outing by Glackens, Henri, Ernest Lawson, James Moore, and May and James Preston in April 1906. The particular New York rink that Glackens depicted is not known, although the scene presents the skaters in suits and long dresses and hats, indicative of their economic status. Roller-skating particularly attracted youthful, middle-class participants and became popular among both sexes, as the "tools of the game were cheap; skill was not hard to acquire … [and] roller skates became part of the education of the child."[75]

Ice-skating had initially been a sport in vogue for the wealthy, but by the turn of the century, it had become a pastime enjoyed by middle-class participants of both sexes, as is evident in Glackens's *Skaters, Central Park* (cat. 40), a panoramic view with many figures. New York's Central Park became a meeting ground for all classes, but the skating rink largely drew middle-class enthusiasts, who were able to afford skates.[76]

Like tennis and skating, croquet was a craze that swept the country. From its introduction in the 1860s, it gained popularity and, "like roller skating, its paraphernalia was simple and readily set up anywhere, and as a courting game few have surpassed it."[77] The little physical exertion it required made it acceptable for women to participate, without the difficulties presented by tennis, polo, and horse racing, where women were generally relegated to the role of observers. Although it was an unusual subject for an artist known for his radical socialist politics, Rockwell Kent depicted a charming pastoral scene of young girls engaged in a friendly game in *Croquet (The Beach Party)* (cat. 44). Though not formally associated with the Ashcan school, Kent was initially part of a group of closely allied promising younger artists who studied with Henri. He was a favorite of Arthur B. Davies, who suggested Kent as a potential candidate for The Eight exhibition in 1908.[78] As with Bellows, however, space limitations and his young age ultimately kept him from participating. He left the Henri coterie around 1910 on account of artistic disagreements over the organization of the Exhibition of Independent Artists and their conflicting egos.

The more strenuous types of sports, such as wrestling and boxing, lured especially middle- and upper-class male spectators into a highly charged environment. Luks produced one of the best-known images of wrestling, *The Wrestlers* (cat. 46), forceful in its blunt power and directness, underscored by the isolation of the two wrestlers on the floor, who are shown without an audience. With muscles taut, the two men—foreshortened so that only a tangle of limbs is visible—push against each other to the limit of their endurance. The painting, featuring a challenging subject to represent, was singled out by critic James Gibbons Huneker, who appreciated the raw power of the image when he saw it at Luks's solo exhibition at the Macbeth Galleries in 1910:

> There is but one example in the gallery that can be called brutal. It is the "Wrestlers," an almost academic exercise if compared with some pugilistic illustrations we have lately reviewed. Besides, a wrestling match is not precisely a harp recital as much as the extension and contraction of legs and arms resemble arpeggios … his two giants roll and clutch; you hear the gasp of wind that is squeezed bellowwise from the chests, and the squeak and crackle of their strained muscles. It is a monstrous design … that it may be called gentle art we doubt, but it is alive, every inch of it; and we are spared the sight of blood.[79]

Sloan also praised the painting, calling it "a magnificent picture—one of the finest paintings I've ever seen," and noted that Luks had painted it to vindicate Henri in his fight for him against the National Academy juries.[80]

Bellows, who was also fascinated by the spectacle of physical competition, chose the more violent and combative sport of boxing—a theme that came to be the one with which he is most closely identified. Glackens was the first Ashcan artist to depict boxing, in illustrations he did for a story in *Cosmopolitan* magazine in the spring of 1905, but his images do not capture the dramatic tension and physicality of Bellows's representations. At the time Bellows made his

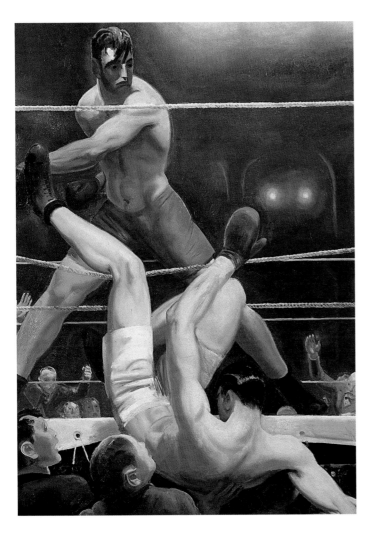

Detail, George Bellows, *Dempsey and Firpo*, 1924 (see cat. 38)

crowd observing the match. Bellows also made boxing illustrations for a short story in 1913 and six lithographs in 1916 representing different aspects of the sport but displaying a more low-key dramatic pitch than in the earlier compositions. A lithograph of 1917, *A Stag at Sharkey's*, however, recaptures the level of vigorous corporeality of the earlier boxing works.

During the 1920s, Bellows produced several boxing lithographs and drawings and one last oil devoted to the subject, *Dempsey and Firpo* (cat. 38). Bellows had been commissioned by the *New York Evening Journal* to cover the match in September 1923 at the Polo Grounds in New York between the favored fighter, Jack Dempsey, and Luis Angel Firpo, the first Hispanic challenger for the world heavyweight title. Bellows captured the event at its high point, when Firpo unexpectedly knocked Dempsey from the ring; but Dempsey, after a long (and disputed) slow count to nine, was able to knock out Firpo in the second round to win the title.[81]

The sport had become popular and mainstream by the mid-1920s, and the brighter light and smoothly stylized interpretation of this action scene lacks the raw force, visceral immediacy, and brutal verisimilitude of Bellows's earlier boxing works, even though Dempsey supposedly landed right in front of the artist when he was knocked out of the ring.[82] To some extent, by the 1920s, Bellows's overall approach tended to lack the emotional vigor and dramatic intensity of his more youthful endeavors, as he became increasingly caught up in the structure and geometry of his paintings.

first boxing picture, boxing in public was still illegal (the law was repealed in 1911); bouts took place in underground clubs that had an illicit ambience. Bellows did a pastel drawing in 1907, soon followed by three major paintings: *Club Night* (cat. 34), *Stag at Sharkey's* (1909; Cleveland Museum of Art), and *Both Members of This Club* (see DiGirolamo essay, this volume, fig. 6). Each of Bellows's early boxing images emphasizes the point of contact between the two opponents, the aggressive exertion of power, and the raucous masculine energy of the

Parks

*The truest value of public pleasure grounds for large cities
is in the rest they give to eyes and mind, to heart and soul,
through the soothing charm, the fresh and inspiring influence,
the impersonal, unexciting pleasure which nothing but the
works of Nature can offer to man.*
—Charles S. Sargent, 1894[83]

Parks became an important component of urban living, offering
respite from the pressures of work, urban density, and confining
living quarters for all elements of society by providing a more
harmonious environment and exposure to nature.[84] Park
scenes by Glackens, Prendergast, Shinn, and Kroll most
often picture middle-class people engaged in recreational
activities, reflecting a change that came to include games
of sport taking place in public parks. Of the Ashcan artists,
only Myers depicted the inhabitants of the downtown
tenements and their limited options for seeking outdoor relief.

For the Ashcan painters, Central Park presented a
prime venue and a picturesque setting for leisure subjects.

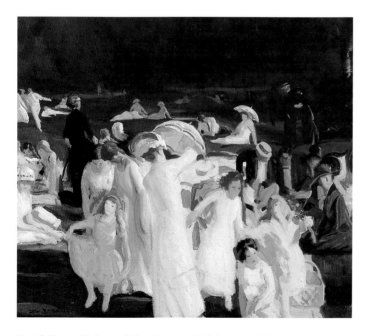

Detail, George Bellows, *A Day in June*, 1913 (see cat. 50)

Besides Prendergast, who was the earliest and most prolific
painter of Central Park scenes, Glackens, Shinn, Bellows,
and Kroll also featured the park in their work. In *Central
Park, Winter* (cat. 55), Glackens pictured sledding, a pastime
that city people attempted even in the modest hills of
Central Park. Here, children are seen sledding under the
watchful eye of some adults; the deep shadows around
the perimeter of the setting establish a winter mood.[85]
Bellows depicted a figurative group enjoying a summer day
on the grass of Central Park in *A Day in June* (cat. 50). He
employed a fluid technique, and the composition appears
graceful and sinuous, even though its construction is
carefully composed on a structured grid.[86] Bellows noted
that his intentions for the painting were principally formal:
"This is a study in which beauty of color and design are
the whole motive."[87] The elegance of the figures in their
long, flowing, white summer outfits with hats and parasols
suggests their privileged social status. Along with his tennis
and polo scenes, *A Day in June* is among Bellows's most
upscale subjects, illustrating the fashionable set lounging
in the meadows of Central Park.

The holiday of May Day was more widely observed
in the early years of the twentieth century than it is
today. In nineteenth-century America, this rite of spring
had a more agrarian orientation, associated by ancient
tradition with fertility and the first spring planting. The
celebration involved anointing a Queen of the May and
dancing around a maypole with intertwined colored ribbons,
signifying the hope for a new love. Prendergast, the first
of the Ashcan artists to depict this holiday scene, painted
no fewer than eleven May Day compositions. Glackens
produced at least two May Day scenes, including *Little May
Day Procession* (fig. 4) and a similar scene, *May Day, Central
Park* (cat. 56), which features the ritual of the maypole;
and Bellows painted at least one picturesque representation
of the procession, *May Day in Central Park* (1905; private
collection, Tennessee). However, none of the Ashcan
artists made any reference in these paintings to May Day
as a commemoration of the workers' struggle to achieve
fair labor practices or as a celebration of the passing in 1884

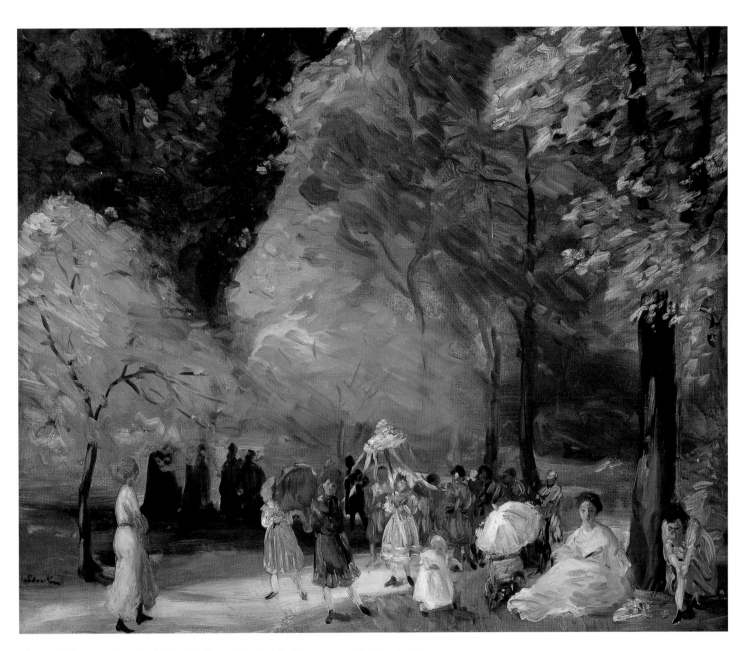

Fig. 4. William Glackens, *Little May Day Procession*, 1905, oil on canvas. Private collection

of the resolution that eight hours would constitute a legal day's work.

Glackens also painted scenes of other park settings, including Battery Park, at the southern tip of Manhattan, as in *The Battery* (cat. 54).[88] Battery Park's grassy unpaved areas and promenade walkways made it a downtown oasis where all types of people gathered. It was also a point of embarkation for the ferry to Staten Island. As seen in Glackens's painting, the park was a leisure attraction, offering open views of the harbor and vessels passing back and forth. The scene focuses on the interactions of figures within the city surroundings, one of several canvases of park and harbor scenes that Glackens produced in the early years of the new century, with fluid and painterly strokes, and using a dark palette that reflects the influence of Henri and Manet.

Shinn, Prendergast, and Sloan were among the artists who painted picturesque Madison Square, which served as a buffer against the encroaching city and its busy commercial district. Sloan, who was often drawn to the bustle of urban streets, represented more pastoral views in scenes of New York's parks and squares, including *Spring, Madison Square* (cat. 73), one of several works on that subject. Sloan resided nearby on West Twenty-third Street, at the southern edge of the Tenderloin district, an area that saw much commingling of classes in its streets and squares.[89] The view here is south across Madison Square toward the Flatiron Building, which Sloan included in other New York views as well. He worked on this painting through 1906 and submitted it to the annual exhibition of the National Academy of Design that year. The bucolic nature of the subject probably helped gain acceptance for the painting, as Sloan often encountered rejection from academy juries.

There were also a few designated public spaces in upper Manhattan that provided a pastoral expanse for uptown inhabitants, including High Bridge Park, which stretches along forty blocks next to the Harlem River. Among the depictions of this park is *Twilight on the Harlem* (cat. 53) by Arthur B. Davies. One of the leading progressive artists of his day, Davies was part of the Henri circle during the first decade of the twentieth century and one of the original Eight. His work had little in common aesthetically with the realists, although they shared the notion of artistic independence. Early in his career, Davies periodically produced realistic scenes, of which this is one, but he became best known for paintings with dreamlike allegories and mythical themes. *Twilight on the Harlem* does, however, exhibit some characteristics of his signature style, including the long, horizontal format with a low horizon line, moody twilight atmosphere, and a friezelike tableau. The painting shows a moonlit idyll that includes small vignettes of children playing, evening strollers, and dogs frolicking. It evolved from several sketches that Davies did on a visit to High Bridge Park,[90] and the distinctive masonry arches of High Bridge crossing the Harlem River at 175th Street, intended to evoke a massive Roman aqueduct, are unmistakable. A vague outline of the city's skyline is visible in the distance, offering a pointed contrast. As one writer of the day remarked:

> There is a different feeling in the air up along this best known end of the city's water-front. The small unimportant looking winding river, long distance views, wooded hills, green terraces, and even the great solid masonry of High Bridge … somehow help to make you feel the spirit of freedom and outdoors and relaxation. This is the tired city's playground. Here is where the city ends and the country begins.[91]

Ernest Lawson and Luks, who lived in the area, also painted scenes of this remote part of Manhattan as a leisure destination. In Luks's *Winter—High Bridge Park* (cat. 65), the park is represented as a winter playland for children; this buoyant and jovial view of the urban existence is a departure from Luks's gritty views of tenement life on New York's Lower East Side.

Myers, from meager circumstances himself, had a particular understanding of the world of the disadvantaged and celebrated that way of life in his art: "My love was my witness in recording these earnest, simple lives, these visions of the slums clothed in dignity, never to me mere slums but

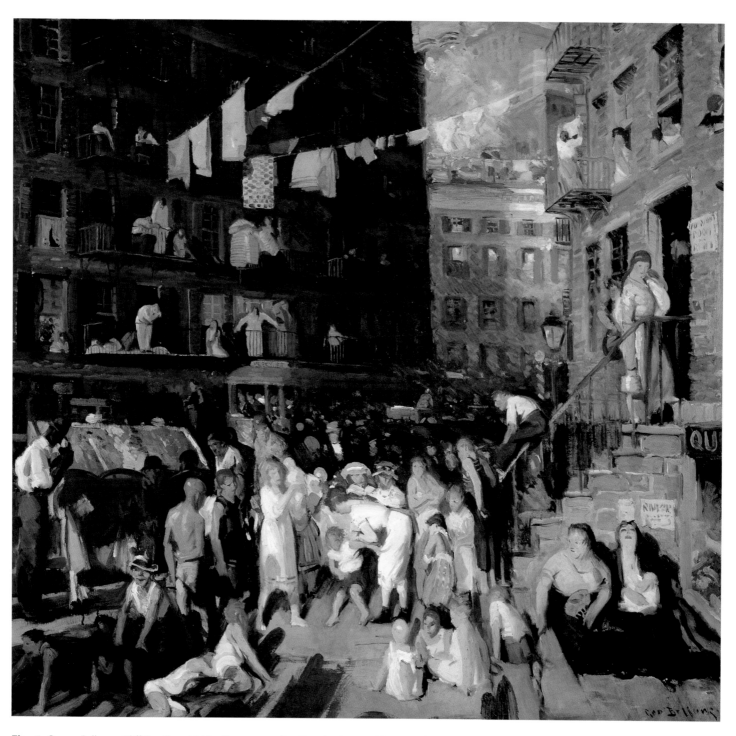

Fig. 5. George Bellows, *Cliff Dwellers*, 1913, oil on canvas. Los Angeles County Museum of Art, Los Angeles County Fund

the habitations of a people who were rich in spirit and effort."[92] These people living in urban tenements sought relief from the summer heat as well as a social outlet, as shown in Myers's *Evening Recreation* (cat. 68).[93] Myers described the "families gathering for the cool breath of the East River, by usage creating a makeshift park of their own. A clearing in front of the ferry house, several brave little trees, a few benches—and the inventive spontaneity of the East Side folk."[94] Such street life was the most common form of recreation among the lower and working classes, as it was free, and they had few options in the pursuit of leisure; moreover, friends and family usually lived close to one another in the tenement districts.[95]

Bellows's *Cliff Dwellers* (fig. 5) also shows residents of New York's Lower East Side tenements spilling on to the streets from the uncomfortable living conditions of their crowded apartments. It is related to a drawing and a series of lithographs with the sardonic title "Why Don't They Go To the Country for a Vacation?" All these works provide a pointed contrast to the light and airy serenity of the wealthy class's privileged summer experience as depicted by Bellows in *A Day in June*.

Few of the artists associated with the Henri circle represented the less fortunate in pursuit of leisure, instead presenting them engaged in everyday tasks, commerce, or work. Robert Spencer, although not affiliated with the Ashcan school artists in a formal way, may have studied with Henri at the Art Students League. He left New York in 1903 and applied himself to genre scenes of the New Hope mill workers and landscapes of the Delaware Valley. He devoted a significant body of work to representing mill workers going about their daily routines, presenting them in an honest, unadorned manner. In his *Courtyard at Dusk* (cat. 75), women are gathered in a tenement courtyard after their workday is over, seeking the cool evening air and social contact within their close community. It is one of the few images by Spencer showing the workers at rest, as that life left little time for leisure.[96]

Beaches

In the mid-nineteenth century, the beach became a leisure destination for all classes. The early twentieth-century realists depicted crowded New York beaches and coastal scenes of New England and Europe, with their focus increasingly diverted from the pristine shoreline to the beachgoers, their activities, and the lively interpersonal interactions.

The work of Prendergast was largely devoted to leisure themes, most often involving coastal views and water, with figures occasionally shown bathing, as in *Low Tide* (cat. 69), but more often standing on the shore. In New York, Prendergast's reputation was established by the works he submitted in 1908 for the Macbeth Galleries exhibition of The Eight. These works included ten small oils depicting the French resort of Saint-Malo, one of which was *Study St. Malo, No. 32* (cat. 71). Prendergast produced many images of this picturesque village on the English Channel in Brittany during an extended stay there. His connection to Henri and the "independents" dates to 1902, when Henri proclaimed that "Prendergast is one of us—a very personal and original painter—quite unlike anyone else."[97] Although he was not associated with the realist aesthetic, Prendergast's artistic independence, individualistic approach, and interest in representing contemporary life led to a natural alliance with the Henri Circle.

Among Glackens's numerous beach and swimming scenes, the best known are those of Bellport, Long Island, a summer resort he frequented annually from 1911 to 1916.[98] Several years earlier, in 1906, Glackens painted a group of noteworthy scenes inspired by travel during his three-week honeymoon in France, including a bathing scene, *Chateau-Thierry* (cat. 57), which depicts a river town that he and his wife, Edith, visited with their friend Alfred Maurer. The picture captures the town's charm and lively ambience, although detail within the painting is vague; however, Glackens included a likeness of himself and Edith in bathing costumes crossing the bridge, and Maurer is depicted in a red bathing suit near the river's edge.[99]

Beach scenes by Bellows and Sloan reflected the growing ease in American society with beachgoing and swimming. Bellows's bathing scenes were an important part of his early recognition; three of his bathing subjects were accepted by National Academy juries: *River Rats* (1906; private collection), *Forty-two Kids* (cat. 49), and *Beach at Coney Island* (ca. 1908–10; private collection). *Forty-two Kids*, like *River Rats*, depicts the quest for fun in the sweltering, overcrowded city. The term "kids" in the title refers to lower-class street urchins but has a less derogatory connotation than "river rats," which suggests hooligans involved in mischievous activities.

Unlike Bellows, Sloan had little popular success until late in life. His noted beach scene *South Beach Bathers* (cat. 74) shows a spot on the eastern shore of Staten Island, a composition that germinated during a day trip Sloan took there in June 1907. Sloan began work on the painting from memory the day after the excursion and worked on it intermittently. He completed it the following summer and entered it in the tour of The Eight exhibition that started at the Art Institute of Chicago in the fall of 1908.[100] South Beach had many amusement parks, arcades, and summer bungalows, and in the early twentieth century was largely populated by Italian American immigrants. Sloan wrote, "Our first visit and we found the place quite to our liking. Reminds one of Atlantic City years ago. It is not so touched by the 'refinements' as Coney Island."[101] He also noted that South Beach was less popular than Coney Island, allowing him a "better opportunity for observation of individual behavior."[102] The composition hinges on his powers of scrutiny and skill as a caricaturist; various vignettes present a sociopsychological cross section of society, showing figures of all ages, some in street attire and the main figure in a chic bathing costume of the day, as Sloan reported,[103] and with the central group smoking cigarettes and eating hotdogs from a makeshift picnic. Most notable is the easy familiarity with which the intertwined figures engage one another, suggesting coarse vulgarity, while the woman and young girl off to the right, fully dressed in pale summer colors, are proper and respectable in comparison.

The evolution of the beach as depicted in American art evolved from the late nineteenth century into the twentieth, as social critic Russell Lynes observed:

Pictures of typical resort beaches crowded with men and women and children … were not the sort of picture that "serious" painters of the nineteenth century thought suitable either to their talents or to the kinds of people to whom they hoped to sell their canvases. Beach scenes of the magazine sort were not pretty or uplifting…. They showed the crowds … somewhat differently from the ways John Sloan … showed them in the early years of [the twentieth] century.[104]

As is evident in *South Beach Bathers*, there was an increasing collision and intermingling of classes and gender—part of a wider city phenomenon of growing heterogeneity that was made possible by advances in transportation that facilitated rapid travel to outlying locales, and by a loosening of social restrictions that made beachgoing a more popular activity.

Detail, William Glackens, *Chateau-Thierry*, 1906 (see cat. 57)

Country

The leisure escape from the city to a more pastoral setting has been a perennial pastime for the urban dweller, and this was particularly true for artists. Although the New York realists were typically identified with city subjects, many artists spent considerable time away in the country, congregating in art colonies or visiting congenial destinations on a quest for inspiring subjects, especially if they had their summer free from teaching commitments. With advancements in transportation, artists traveled to pastoral settings with increasing ease. Henri, Bellows, Sloan, and Kroll were among those who led peripatetic existences, visiting various rustic locales, sometimes for extended periods, which encouraged the production of outdoor leisure scenes.

In the summer of 1902, Henri spent several months in rural northern Pennsylvania. He and his first wife, Linda, and another couple went to Meshoppen, Pennsylvania, on the Fourth of July. *Picnic at Meshoppen, PA* (cat. 60) was inspired by that outing, which he worked up from a sketch.[105] In the early years, Henri periodically executed paintings from memory, although he later largely abandoned this practice in favor of working from life. Here, Henri, interested in

Detail, Robert Henri, *Picnic at Meshoppen, PA,* 1902 (see cat. 60)

the festivity of the occasion, highlighted accents in red, white, and blue, which he used in the attire of the central figures and which may have been a patriotic reference to the holiday. This outdoor park scene may have inspired the later Central Park scenes by Glackens (see cat. 56) and Bellows.

Kroll initially gained recognition for urban scenes of New York, but in the 1910s, he began producing landscape compositions featuring multiple figures, such as *In the Country* (cat. 62). Kroll joined the Henri circle after he was introduced to Henri by Bellows, and soon became part of a larger group of friends that also included Speicher and Randall Davey. In the summer of 1916, Kroll was in Eddyville, New York, when he received a letter from Henri asking him to visit Bellows, who was spending the summer in Camden, Maine, with his family.[106]

At the start of his visit, Kroll made a small painting, *Summer Days, Camden, Maine, The Bellows Family* (Mead Art Museum, Amherst, Mass.), which Bellows disparaged on account of the placement of the tree that bisects the composition.[107] When he started *In the Country,* Kroll amended the composition to include the standing figure of Bellows's wife, Emma, positioned in front of the tree as an artistic retort to Bellows's criticism. In the distance, Bellows is standing with his daughter, Anne, who is on a swing, and Bellows's mother and mother-in-law are also represented. Bellows pronounced the composition "remarkable."[108] Bellows and Kroll often painted together, undertaking similar subjects, as in Bellows's portrait of Emma that summer, *Emma in an Orchard* (fig. 6), in a view from the porch of their summer house, where she is shown wearing the same polka-dot dress as in Kroll's painting.

Henri's philosophy stressed life as the source of art: "Painting is the expression of ideas in their permanent form. It is the giving of evidence. It is the study of our lives, our environment. The American who is useful as an artist is one who studies his own life and records his experiences."[109] His ideas created a legacy and had a profound effect on the Ashcan artists, many of whom elected to paint each other, their surroundings, and their lives—the things they knew best and experienced most intimately.

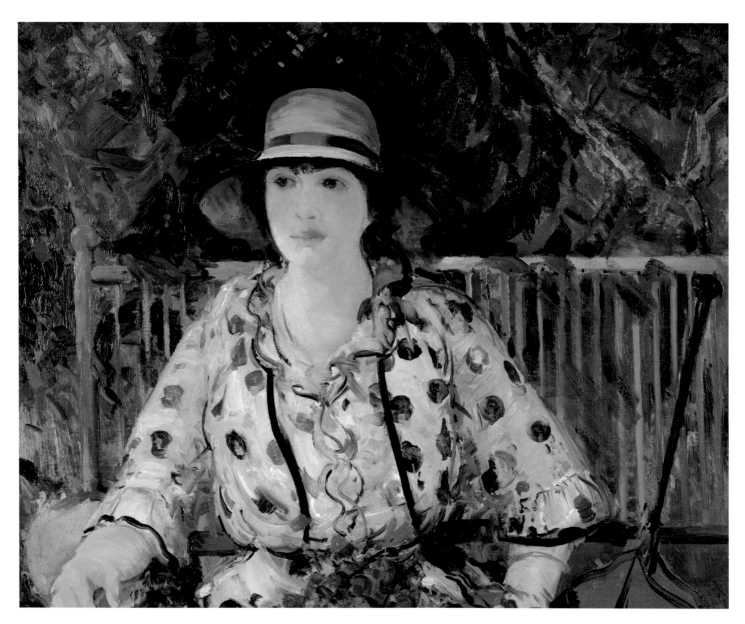

Fig. 6. George Bellows, *Emma in an Orchard*, 1916, oil on canvas. The Cummer Museum of Art and Gardens, Jacksonville, Florida, Museum Purchase with Council Funds, AP1980.1.1

Notes

1. S.H. [Sadakichi Hartmann], *International Studio* 30 (December 1906): 183.
2. George Bellows as quoted in "The Big Idea: George Bellows Talks about Patriotism for Beauty," *Touchstone* 1 (July 1917): 275.
3. Agnes Repplier, "Leisure," *Scribner's Magazine* 14 (July 1893): 63.
4. From *Theatre Magazine* 4 (April 1904), as quoted in David Nasaw, *Going Out: The Rise and Fall of Public Amusements* (New York, 1993), 34.
5. Lloyd Morris, *Incredible New York: High Life and Low Life of the Last Hundred Years* (New York, 1951), 285–316. See also Kathy Peiss, *Cheap Amusements: Working Women and Leisure in Turn-of-the-Century New York* (Philadelphia, 1986).
6. "Wideopenness," editorial, *New York Times*, 28 January 1899, as referenced in Nasaw 1993, 2.
7. Peiss 1986, 11.
8. Forbes Watson, "Introduction," in Robert Henri, *The Art Spirit* (1923; reprint ed. New York, 1984), 8.
9. This characterization has become nearly universal, and much literature devoted to these artists has categorized them as focusing their work on that of the lower classes and on the less refined side of city life. This includes the most recent publications: for example, see Rebecca Zurier et al., *Metropolitan Lives: The Ashcan Artists and Their New York* [exh. cat., National Museum of American Art] (Washington, D.C., 1995). This characterization, however, extends to almost every major historical survey of the period, commencing with Holger Cahill and Alfred H. Barr, Jr., *Art in America: A Complete Survey* (New York, 1934).
10. William Glackens is the most notable exception, as his marriage in 1904 to Edith Dimock, who was from a wealthy family, freed him of financial concerns.
11. Among the publications that best illuminate the spirited activities and social lives of the artists are *John Sloan's New York Scene from the Diaries, Notes, and Correspondence*, ed. Bruce St. John (New York, 1965); Ira Glackens, *William Glackens and the Ashcan Group: The Emergence of Realism in American Art* (New York, 1957); Guy Pène du Bois, *Artists Say the Silliest Things* (New York, 1940); *Revolutionaries of Realism: The Letters of John Sloan and Robert Henri*, ed. Bennard B. Perlman (Princeton, N.J., 1997); Charles H. Morgan, *George Bellows: Painter of America* (New York, 1965); Van Wyck Brooks, *John Sloan: A Painter's Life* (New York, 1955); and Jerome Myers, *Artist in Manhattan* (New York, 1940). See also Henri diary, Henri Estate, LeClair Family Collection; Henri correspondence, Henri Papers, Beinecke Rare Book and Manuscript Library, Yale University, New Haven, Conn.; and Bellows correspondence, Bellows Papers, Amherst College Library, Amherst, Mass.
12. *Americans in the Arts, 1890–1920: Critiques of James Gibbons Huneker*, ed. Arnold T. Schwab (New York, 1985), 475.
13. Henri 1923 (1984 ed.), 218.
14. The portrait of Luks was completed on 28 January 1904 in a single sitting, most likely done in Henri's studio, and he may have supplied Luks with the gray bathrobe, one of the props he kept on hand; Henri record book, Henri Estate, LeClair Family Collection.
15. See, for example, Robert Henri, "What About Art in America?," *Arts and Decoration* 24 (November 1925): 35–37, 75.
16. See Carol Clark et al., *Maurice Brazil Prendergast and Charles Prendergast: A Catalogue Raisonné* (Williamstown, Mass., 1989), 346–47, for related watercolors. One watercolor of this group depicts essentially the same scene and is referenced as Boston.
17. See John Lougery, "The *New York Sun* and Modern Art in America: Charles Fitzgerald, Frederick James Gregg, James Gibbons Huneker, Henry McBride," *Arts* 59 (December 1984): 78.
18. Charles and P.J. Mouquin to the author (13 January 2007); Amy Lyman Phillips et al., "Famous American Restaurants and Some Delicacies for Which They Are Noted," *Good Housekeeping* 48 (January 1909): 23. See also Robert A.M. Stern, Gregory Gilmartin, and John Massengale, *New York 1900: Metropolitan Architecture and Urbanism 1890–1915* (New York, 1983), 225. Mouquin's had French-inspired offerings, an upstairs restaurant, and a cozy basement café that was intended to transport its patrons to Paris, crossing an urban New York establishment with a plush continental one in ambience and accoutrements.
19. See for example, Behrens, "Art Notes," *Cincinnati Commercial Tribune*, 7 February 1909, 9.
20. Forbes Watson, *William Glackens* (New York, 1931), 13.
21. See Hartmann 1906, and Joseph Edgar Chamberlin, "Two Significant Exhibitions," *New York Evening Mail*, 4 February 1908, 6. See also St. John 1965, 109, 114; and diary of Linda Henri, 30 September 1904, 48, Henri Estate, LeClair Family Collection. The location of Café Francis, at West Thirty-fifth Street, was convenient to the residences of a number of artists, as was Mouquin's. Ira Glackens recalled that besides his parents, the Prestons, the Henris, and all their friends were often to be found at one place or the other. See Glackens 1957, 57.
22. James C. Young, "Yeats of 'Petitpas'," *New York Times*, 19 February 1922, 14.
23. See St. John 1965, 444–50. Sloan had trouble with the painting; he began it on 2 August 1910, several days after the birthday celebration, and worked on it intermittently at least through 17 August. See also Brooks 1955, 101–21. In the painting are also likenesses of, from left, Alan Seeger, a young writer; Dolly Sloan; Ann Squire; a self-portrait of Sloan (furthest figure on right); and Fred King, as noted in John Sloan, *Gist of Art: Principles and Practice Expounded in the Classroom and Studio, Recorded with the Assistance of Helen Farr* (New York, 1939), 227.
24. Young 1922, 14.
25. Rowland Elzea, *John Sloan's Oil Paintings: A Catalogue Raisonné*, vol. 1 (Newark, Del., 1991), 117.

26. Sloan 1939, 231; and Brooks 1955, 60, 61.

27. For more on the Brevoort Hotel, see Michael Batterberry and Ariane Batterberry, *On the Town in New York: A History of Eating, Drinking, and Entertainments from 1776 to the Present* (New York, 1973), 226–27. See also Phillips et al. 1909, 23.

28. Diary of Guy Pène du Bois, 3 May 1924, as quoted in Betsy Fahlman, *Guy Pène du Bois* [exh. cat., Corcoran Gallery of Art] (Washington, D.C., 1980), 75.

29. Pène du Bois diary, 4 August 1936, in Fahlman 1980, 75.

30. This painting was shown at The New Society exhibition of 1926; "The New Society: Works in Various Mediums in Its Latest Exhibition," *New York Herald Tribune*, 21 November 1926, sec. 6, 11. Pène du Bois relocated to France in 1926, although he made many trips back to the United States. There were establishments named Café Madrid in both New York and Paris that were the likely source of inspiration for this painting. See also Betsy Fahlman, *Guy Pène du Bois: The Twenties at Home and Abroad* [exh. cat., Sordoni Art Gallery] (Wilkes-Barre, Pa., 1995).

31. George Bellows also had some difficulty in dealing with the Dales. Although he was grateful for the patronage, he did meet with some interference involving commissions. See Morgan 1965, 224–25, 246.

32. Pène du Bois 1940, 189. Force and Whitney were advocates of Pène du Bois's work, exhibiting it and acquiring it for the museum's permanent collection.

33. See Valerie Ann Leeds, *Independents: The Ashcan School and Their Circle* [exh. cat., Cornell Fine Arts Museum] (Winter Park, Fla., 1996), 15–16, for more on Myers's exclusion from The Eight. For Shinn's comments on Myers's work, see Bennard B. Perlman, *Robert Henri: His Life and Art* (New York, 1991), 77; for Sloan's comments, see St. John 1965, 185. Although Sloan expressed some reservations about Myers's work, he later reminisced that Myers should have been included, but blamed his omission on Henri. See Grant Holcomb, "The Forgotten Legacy of Jerome Myers (1867–1940): Painter of New York's Lower East Side," *American Art Journal* 9 (May 1977): 83–84.

34. Myers 1940, 35.

35. Peiss 1986, 143–44.

36. Myers 1940, 246–47.

37. Walter H. Vanderburgh, "The Three Top Sergeants," undated, unpaginated typescript, Detroit Institute of Arts curatorial files. Vanderburgh and the two other sitters were art students who lived in the same building as Luks. See also James Tottis et al., *Forging a Modern Identity: Masters of American Painting Born After 1847, American Paintings in the Detroit Institute of Arts*, vol. 3 (London, 2005), 148–49.

38. Everett Shinn, as quoted in Janay Wong, *Everett Shinn: The Spectacle of Life* (New York, 2000), 41.

39. Mrs. Schuyler [Mariana Griswold] Van Rensselaer, "Midsummer in New York," *Century* 62 (August 1901): 490.

40. For more on Sterne and his painting, see "Maurice Sterne," *American Artist* 5 (December 1941): 5–9, 39; and Maurice Sterne, *Shadow and Light: The Life, Friends and Opinions of Maurice Sterne*, ed. Charlotte Leon Mayerson (New York, 1952).

41. See, for example, George Bellows, "'The Art Spirit,' by Robert Henri," *Arts and Decoration* 20 (December 1923): 25, 87.

42. Emma Bellows to Richard Bassett, Charles Morgan Papers, Amherst College Library, Amherst, Mass., as quoted in *Addison Gallery of American Art 65 Years: A Selective Catalogue* (Andover, Mass., 1996): 323.

43. For more on Sloan and Santa Fe, see Brooks 1955, 153–54. See also chapter 8 of Valerie Ann Leeds, "Robert Henri and the American Southwest: His Work and Influence," Ph.D. diss., City University of New York, 2000, 333–62.

44. Sloan to Marianna Sloan, summer 1924, Sloan Archive, Delaware Art Museum, Wilmington, as quoted in Elzea 1991, 2: 269.

45. Sloan 1939, 275.

46. St. John 1965, 138 (29 June 1907).

47. For more on the movies, early theaters, and the composition of the audience, see Peiss 1986, 145–53.

48. Artist's record book, Henri Estate, LeClair Family Collection. Henri noted the name of the model in the record book, but nothing else about her is known. Where the model may have obtained the costume is also unknown, as Henri's models usually dressed in their own costumes, except for accessories he sometimes supplied. His intention in depicting such a controversial subject was not explicitly stated, although he ardently supported artistic freedom in all art forms; so this theme may be interpreted as a reaction to the uproar about the opera and its subsequent ban.

49. Artist's record book, Henri Estate, LeClair Family Collection.

50. Artist's record book, Henri Estate, LeClair Family Collection.

51. Henri, unusually, completed even major works in only a few brief sittings. He made many sketches for the work in a struggle to get the precise impression. See Henri to his mother (15 February 1919); Henri to Helen Niles (9 April 1919), Henri Papers, Beinecke Rare Book and Manuscript Library, Yale University, New Haven, Conn.; and artist's record book, Henri Estate, LeClair Family Collection. For more on the portrait, see Valerie Ann Leeds, *"My People": The Portraits of Robert Henri* [exh. cat., Orlando Museum of Art, Fla.] (Orlando, 1994), 38.

52. *New York Times Magazine*, 27 April 1919, clipping scrapbook, Henri Estate, LeClair Family Collection.

53. Henri to Frank Crowninshield, 6 May 1919, Henri Estate, LeClair Family Collection.

54. See Brooks 1955, 162–63, for more on the extent of Sloan's worship of Duncan.

55. St. John 1965, 352 (16 November 1909).

56. St. John 1965, 516 (14 March 1911). Sloan did additional drawings and monotypes of Duncan, but this is the only extant oil.
57. *Eugene Speicher: A Retrospective Exhibition of Oils and Drawings, 1908–1949* [exh. cat., Albright Art Gallery] (Buffalo, 1950), 9 [introduction by Charles Burchfield]. The exhibition celebrated the acquisition in 1950 by the Albright Art Gallery of this portrait of Katharine Cornell by Eugene Speicher, both native Buffalonians.
58. David Gray, "Polo, the Best Game in the World," *Collier's Outdoor America* 47 (10 June 1911): 28.
59. Frederic L. Paxson, "The Rise of Sport," *Mississippi Valley Historical Review* 4 (September 1917), as quoted in *The Sporting Set*, ed. Leon Stein (New York, 1975), 168.
60. Thorstein Veblen, *The Theory of the Leisure Class* (1899; reprint ed. New York, 1957), 160. One writer observed that by the first decade of the twentieth century, "ours is a nation which loves not only golf, lawn tennis, and the games of pure skill but the warmer-blooded games of baseball, football, and boxing." See Gray 1911, 15.
61. Henri 1923 (1984 ed.), 115.
62. Robert Henri diary, Henri Estate, LeClair Family Collection. Dryer sat for Henri on 14, 15, and 16 May 1902, and the diary notes that the painting was finished on the third day. She sat for him again on 10 December, although there is only that single extant portrait he executed of her. Henri submitted the painting to the Pennsylvania Academy show of his work in 1902 and to the National Academy of Design annual exhibition in 1903.
63. "Pictures by Robert Henri," *New York Sun*, 31 December 1902, clipping scrapbook, Henri Estate, LeClair Family Collection. This composition signals an occasional practice that Henri followed of outfitting a figure to create a specific impression, although he rarely supplied whole costumes; instead, he would contribute only an article of clothing such as a shawl, shirt, or accessory, for visual interest.
64. St. John 1965, 242 (28 August 1908).
65. Sloan 1939, 215.
66. St. John 1965, 155 (16 September 1907).
67. Paxson in Stein 1975, 164.
68. George Bellows to Professor Taylor, as quoted in Morgan 1965, 115–16. From a middle-class background himself, Bellows was awed by the wealth and luxury of the experience.
69. Morgan 1965, 116.
70. Morgan 1965, 126.
71. John Krout, "Some Reflections on the Rise of American Sport," *Proceedings of the Association of History* (1928), as quoted in Stein 1975, 92.
72. Bellows routinely played doubles with Speicher, Kroll, and Glackens on courts at Ninetieth Street and Park Avenue in New York, and also at his retreat in Woodstock, New York. See Morgan 1965, 245, 248.
73. Bellows's lithograph *The Tournament* (1920) is closely related to the painting *Tennis at Newport*. For more on Bellows's prints, see Jane Myers and Linda Ayres, *George Bellows: The Artist and His Lithographs, 1916–1924* [exh. cat., Amon Carter Museum] (Fort Worth, Tex., 1988).
74. Paxson in Stein 1975, 156.
75. William H. Gerdts, *William Glackens* [exh. cat., Museum of Art, Fort Lauderdale, Fla.] (New York, 1996), 157.
76. Morris 1951, 91–92.
77. Paxson in Stein 1975, 157.
78. Arthur B. Davies to Robert Henri (15 January 1908), Henri Papers, Beinecke Rare Book and Manuscript Library, Yale University, New Haven, Conn.
79. James Gibbons Huneker, "Around the Galleries," *New York Sun*, 20 April 1910, as quoted in Schwab 1985, 522.
80. St. John 1965, 183 (11 January 1908).
81. Firpo, an Argentine fighter, was known as the "Wild Bull of the Pampas." The match was of particular interest as Firpo was sent to the floor seven times before he was able to push Dempsey to the ropes and land a punch that sent the better-known boxer out of the ring. Bellows produced a drawing and two closely related lithographs that depict Firpo unexpectedly knocking Dempsey out of the ring.
82. George Bellows to Louis Pulitzer (7 April 1924), Bellows Papers, Amherst College Library, Amherst, Mass., as quoted in Myers and Ayres 1988, 90.
83. Charles S. Sargent, "Playgrounds and Parks," *Garden and Forest* 7 (6 June 1894): 221, as quoted in Galen Cranz, *The Politics of Park Design: A History of Urban Parks in America* (Cambridge, Mass., 1982), 15.
84. For parks and their design, see Cranz 1982.
85. Glackens reprised the sledding theme some years later, in *Sledding, Central Park* (1912; Museum of Art, Fort Lauderdale, Fla.), although this work has a more impressionistic approach in palette and brushwork, reflecting Glackens's growing infatuation with Renoir and impressionism.
86. The genesis for the painting can be found in a small pencil drawing, but the initial idea of the drawing was fleshed out in a more fully realized pen-and-ink drawing, *Luncheon in the Park* (ca. 1913; Albright-Knox Art Gallery, Buffalo), which preceded the oil painting. *A Day in June* reflects minor adjustments from the drawing in an attempt to achieve a more coherent and harmonious composition in the painting. Bellows followed up this subject three years later in lithographs.
87. As quoted in Myers and Ayres 1988, 29. See also Tottis et al. 2005, 20–21. Bellows entered the painting in a number of important

exhibitions, including the Pennsylvania Academy of the Fine Arts annual of 1917, where it won the Temple Gold Medal.

88. Battery Park was named for the artillery that was stationed there, first by the Dutch and then by the British; the park also has an American fort, which is seen to the right of the composition. The fort was known as Castle Clinton, later renamed Castle Garden, and was built prior to the War of 1812, and named for Mayor DeWitt Clinton. In 1896, the site was transformed into one of the nation's first public aquariums.

89. See William R. Taylor, *In Pursuit of Gotham: Culture and Commerce in New York* (New York, 1992), 72–73. The Tenderloin district was the once seedy heart of New York City that extended from Twenty-fourth Street to Fortieth Street east of Eighth Avenue. It also developed a reputation as the red-light district.

90. The painting was initially titled *An Idyll on the Harlem*. See Bennard B. Perlman, *The Lives, Loves, and Art of Arthur B. Davies* (Albany, N.Y., 1998), 156.

91. Jesse Lynch Williams, "The Water-Front of New York," *Scribner's Magazine* 26 (October 1899): 399.

92. Myers 1940, 48–49.

93. *Evening Recreation* was sent to the National Academy of Design annual exhibtion in 1921.

94. Myers 1940, 218.

95. Peiss 1986, 11, 15, 57–59.

96. Spencer executed an untitled study of the same composition, focusing on the left doorway, in which a male figure stood. In *Courtyard at Dusk*, he appears to have substituted the male figure with a woman. The painting was included in an exhibition at the Saint Louis Art Museum in 1917.

97. Robert Henri to his parents (3 April 1902), Henri Papers, Beinecke Rare Book and Manuscript Library, Yale University, New Haven, Conn.

98. For more on Glackens's beach scenes, see Gerdts 1996, 109–115; Richard Wattenmaker, "William Glackens' Beach Scenes in Bellport," *Smithsonian Studies in American Art* 2 (Spring 1988): 78–94; and Valerie Ann Leeds, *William Glackens: American Impressionist* [exh. cat., Gerald Peters Gallery] (New York, 2003), 18–19.

99. William Glackens to Henri, n.d., as quoted in Glackens 1957, 70.

100. See Judith Zilczer, "The Eight on Tour, 1908–1909," *American Art Journal* 16 (Summer 1984): 45–46.

101. St. John 1965, 137 (23 June 1907).

102. Sloan 1939, 218.

103. Sloan 1939, 218.

104. Russell Lynes, "Changing Perspective on the Beach," in *At the Water's Edge: 19th and 20th Century American Beach Scenes* [exh. cat., Tampa Museum of Art] (Tampa, Fla., 1989), 21–22.

105. Henri diary (4 July 1902), Henri Estate, LeClair Family Collection.

106. Bellows was having difficulty, and Henri thought Kroll could help him overcome an artistic block. Fred Bowers and Nancy Hale, *Leon Kroll: A Spoken Memoir* (Charlottesville, Va., 1983), 43. See also Valerie Ann Leeds, *Leon Kroll Revisited* [exh. cat., Gerald Peters Gallery] (New York, 1983), 13.

107. Charles H. Morgan, Bellows's biographer, to Paul Grigaut (5 January 1963), Detroit Institute of Arts curatorial files. See also Tottis et al. 2005, 132–33.

108. Bowers and Hale 1983, 42.

109. Henri 1923 (1984 ed.), 116.

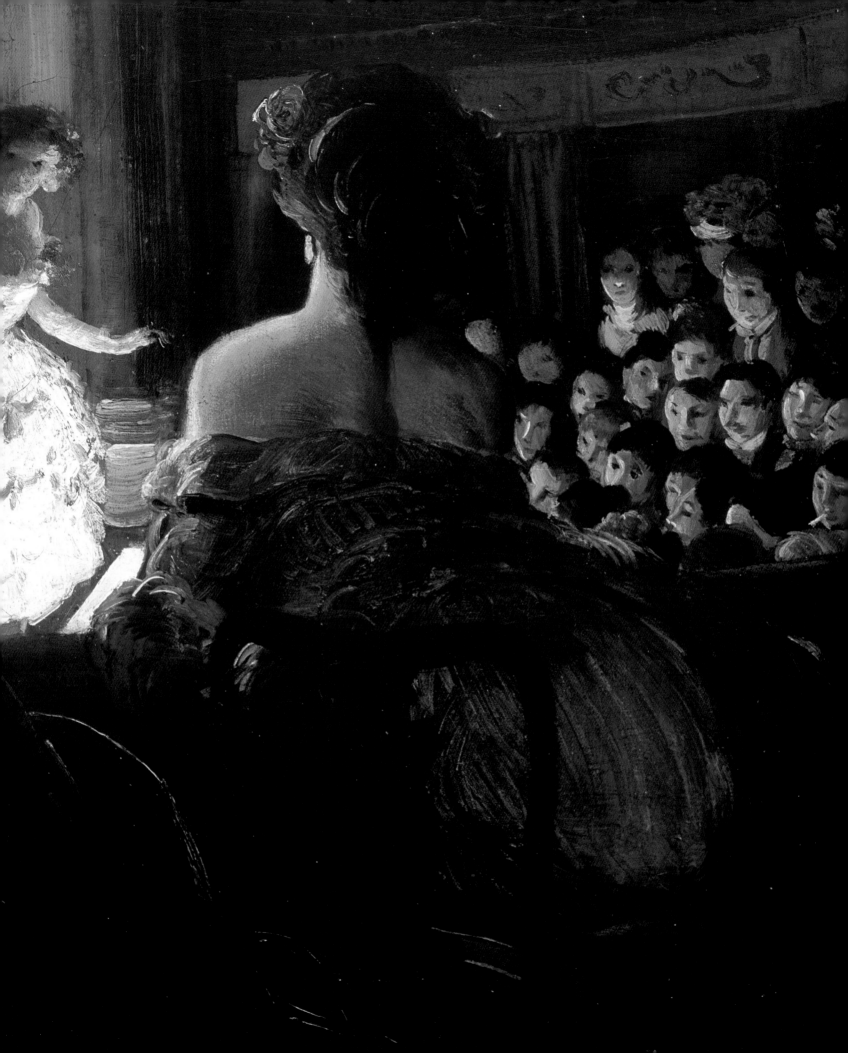

New York in an Age of Amusement

Vincent DiGirolamo

History has been good to the Ashcan artists. Not only have their reputations grown among critics and their prices shot up among collectors, but the value of their work has also appreciated among historians—and not just art historians but also those whose hearts are more likely to race at the sight of a census table than an oil painting. One measure of this heightened esteem is the remarkable number of American history textbooks that feature paintings of the Ashcan school on their covers, particularly paintings of New York City. Students today will find Maurice Prendergast's sunny playground panorama *The East River* (fig. 1) inviting them to open *Major Problems in the Gilded Age and the Progressive Era*, Robert Henri's somber *Street Scene with Snow* (1902; Yale University Art Gallery) setting the mood for *The Unfinished Nation: A Concise History of the American People*, and George Bellows's teeming tenement study *Cliff Dwellers* (see Leeds essay, this volume, fig. 5) raising a ruckus on *Give Me Liberty! An American History*. The list goes on.[1]

To be sure, pictures of presidents, monuments, and flags can still be found on many texts, but the recent preference for Ashcan images is no mere coincidence. Rather, it reflects the historical profession's increased openness to social history—that is, to describing how ordinary people "lived the big changes."[2] There are no great men or grand events depicted on the Ashcan covers, just children playing in sandboxes and swinging on swings, commuters trudging up sidewalks and boarding streetcars, mothers minding babies and gossiping on stoops. Yet these works evoke some of the biggest changes transforming American society a century ago, namely the contested triumph of industrial capitalism, the troubling tidal wave of foreign workers, and the flourishing of a vibrant urban culture offering new patterns of consumption for the masses. No city felt these epochal shifts more intensely than New York, and no group documented them more enthusiastically than the Ashcan artists.

Without the benefit of hindsight (the historian's stock in trade), Ashcan painters intuitively recognized that the whirl and swirl of city life were subjects of immense beauty and importance. Their perspective is indispensable to

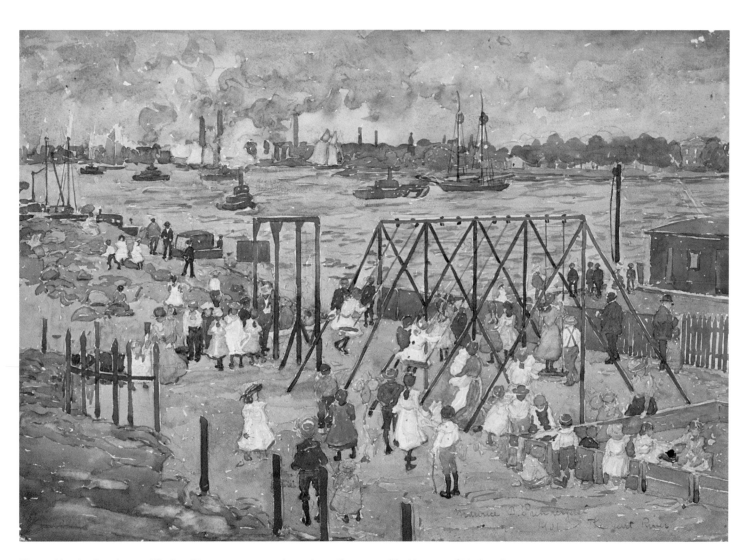

Fig. 1. Maurice Prendergast, *The East River*, 1901, watercolor and pencil on paper. The Museum of Modern Art, New York, Gift of Abby Aldrich Rockefeller (132.1935.a–b)

understanding the period on several levels. Their art conveys in precise, human terms such abstract historical processes as industrialization, immigration, and urbanization. It presents an alternative, generally positive, view of commercial pleasures that most of their reform-minded contemporaries characterized as immoral. And it permits unparalleled access to the parks, beaches, dance halls, saloons, cafés, theaters, movie houses, and sporting arenas of a bygone era, illuminating them as key sites of conflict between the classes, the sexes, the races, and the generations. In sum, their art allows us to trace the tumultuous origins of our own diverse, pleasure-obsessed consumer society.

New York was never bereft of commercial delights; the city boasted many convivial taverns and coffeehouses as first a Dutch and then a British colony; it saw the spread of private parks or "pleasure gardens" during the early Republic and amassed a wealth of penny restaurants and dime museums. Those in the know claimed that some six hundred brothels operated in Manhattan after the Civil War. The island metropolis was also awash with grog shops, beer halls, and wine gardens. In fact, by 1885, 10,000 watering holes—one for every 140 residents—plied their trade.[3] Impressive as these statistics are, the number, variety, and influence of leisure and entertainment venues soared at the turn of the twentieth century, creating a new "Age of Amusement."

The dawning of this new age, now seemingly inevitable, was the result of an extraordinary set of conditions. The driving force was a booming industrial economy that required a constant infusion of workers. Over one million European immigrants and three hundred thousand Southern migrants made New York their destination during the first quarter of the twentieth century.[4] Labor conditions improved in some sectors of the economy, bringing higher pay and shorter hours. Nationwide, manufacturing wages increased 25 percent between 1900 and 1920, the average workweek dropped 10 percent to slightly over fifty hours, and the number of legal holidays reached nine. The concept of the weekend emerged in these years in the heavily unionized printing trades and then spread as a growing number of firms required only a half-day's work on Saturday.[5]

Women, too, began to enjoy the fruits of paid labor and public transportation. For the first time a majority—60 percent—of young single women in New York found work outside the home, mainly in the garment, retail, and clerical industries, earning new freedoms and mobility along with their wages.[6] The opening of the subway in 1904 and its subsequent extensions made travel throughout four of the five boroughs a breeze. A nickel could take one from the northern meadows of the Bronx to the southern shores of Brooklyn. The completion of the Williamsburg, Manhattan, and Queensborough bridges further shrank the city, reinforcing in steel and concrete the political consolidation of Greater New York in 1898. New money poured into the city as 70 percent of the nation's corporations set up shop in its unsurpassed skyscrapers.[7]

Lights and literacy also encouraged the spread of leisure. The electrification of streets and signs bathed certain districts in glamour and transformed nighttime into a commodity. A nascent advertising industry and thriving print culture spread the word quickly about new products and fashions. The richly illustrated *New York World Magazine*, for example, where many in the Ashcan circle found work, sold an incredible 1.5 million copies a week in the late 1890s. Meanwhile, the growing demand for entertainment created new suppliers, including many immigrants who made their own music, formed their own acts, and opened their own dance halls, restaurants, and theaters. Some gambled on a new gimmick—movies. As with oil, steel, and beef, showbiz spawned its own syndicates and trusts. Converging inexorably on New York City, these powerful forces produced a "perfect storm" of fun and profit.

Dramatic as these changes were, it was labor, not leisure, that structured the lives of the vast majority of New Yorkers. Working-class men and women still spent most of their waking hours on the job or engaged in unpaid domestic work. Poverty coexisted with prosperity. Wage labor was often sporadic, particularly in construction, manufacturing, and shipping. But workers in all industries faced layoffs

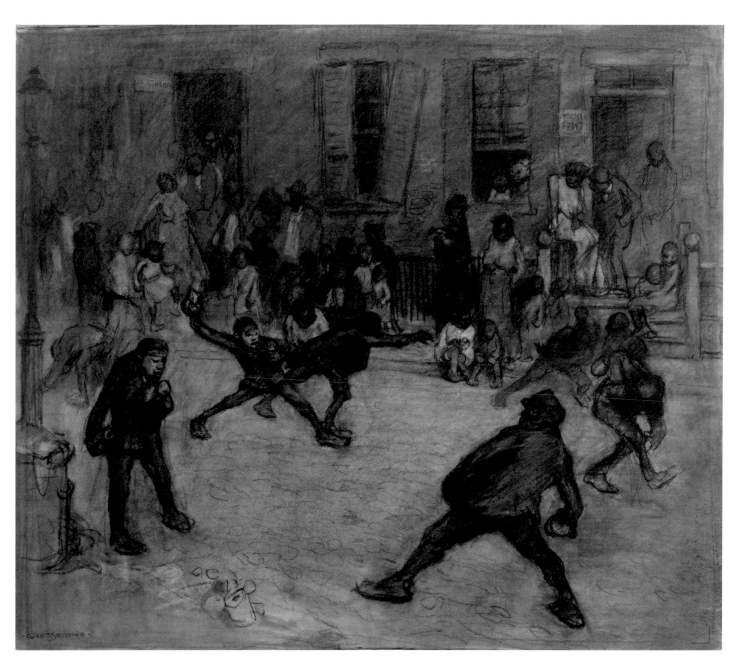

Fig. 2. George Bellows, *Tin Can Battle, San Juan Hill, New York*, 1907, crayon, ink, and charcoal on paper. Sheldon Memorial Art Gallery and Sculpture Garden, University of Nebraska–Lincoln, UNL-F. M. Hall Collection

during the depressions that wracked the country from 1893 to 1897, 1907 to 1908, and 1913 to 1915. Public assistance was minimal, often intentionally so. After the panic of 1893, the Manhattan legislature amended its charter to prohibit outdoor relief—public aid to people outside of the poorhouse—so as not to foster dependency among the city's seventy-five thousand unemployed.[8] Few of these people would recall the period as an Age of Amusement. Life's pleasures usually lay beyond their reach, as was the case with an Irish immigrant maid, a mother of seven, who lived downtown for thirty years and never once visited Central Park. She explained to a reporter in 1902: "I have never seen ten cents for carfare that wasn't needed some other way more—that's why."[9]

The distribution of income in the United States in the first decades of the century was more unequal than it had ever been, with 1 percent of the population owning more than half of the country's wealth.[10] Poverty, protest, and a surge of "applied Christianity" led to the formation of a loose coalition of reformers known as progressives. Made up of Republicans, Democrats, and even socialists from the middle and working classes, progressives attacked what they saw as the worst ravages of the industrial system, from such social ills as child labor, unsanitary slums, and corporate graft to such personal impieties as drinking, gambling, and smoking. Cities, with their dreadful delights, and youngsters, with their high spirits, emerged as main targets of reform. Progressives were pragmatists who founded settlement houses and voluntary associations, launched investigations to gather the facts and raise awareness, and enlisted the power of the state to address problems and stave off demands for more radical change. The jury is still out on whether they were an enlightened minority who advanced the public good or uptight busybodies who simply imposed their own standards of propriety on the rest of society. One can find evidence supporting both sides of the argument in the Ashcan artists' brush with leisure.

What is clear, however, is that recreation was not a side issue to the progressives but a central concern. They called attention to the importance of play to the physical and moral well-being of all ages, but especially children. Only in play, they argued, could children learn the principle of fairness and develop ethics. Children thus needed safe, supervised places to play, not the busy streets and vacant lots pictured by Bellows in *Tin Can Battle, San Juan Hill, New York* (fig. 2) and *Lone Tenement* (fig. 3), where violence and chaos prevailed. "A child's right to play is an integral part of his claim upon the state," proclaimed Henry Street Settlement founder Lillian Wald, who spearheaded efforts to construct playgrounds with private and public funds. Seward Park, New York's first public playground, established on the Lower East Side in 1903, featured lawns, baths, a pavilion, gymnasium equipment, and separate attendants for boys and girls. Other playgrounds soon followed, and the city established a Bureau of Recreation to oversee them and organize interborough sports tournaments.[11]

Some working-class children resisted the efforts of adults to oversee their play. "I can't see any fun playing as school ma'ams say we must play," complained one fourteen-year-old boy.[12] But one new game caught on. Shortly after the invention of basketball in Springfield, Massachusetts, in 1891, New York schools, settlement houses, ethnic associations, and YMCA chapters organized games and leagues in halls, lofts, and armories. Bellows sketched one such game in 1906 (*Basketball*; private collection), focusing on two players fighting for the ball before a gym full of engrossed spectators. Basketball's appeal quickly spread upward in age, helping New York colleges dominate the sport nationally and laying the foundation for the city's first professional team, the New York Celtics, in 1914.[13]

River swimming also fell under the gaze of improvers. It was not so much a sport as a way to keep clean and to cool off in the summer. In Bellows's *Forty-two Kids* (cat. 49) boys are seen diving, tussling, strutting, smoking, splashing, and lolling about in the state of nature on the edge of a modern metropolis. His depiction visually reinforces psychologist G. Stanley Hall's theory of adolescence as a savage stage of life that recapitulates the savage stage in the evolution of the human race. Writing in 1904, Hall argued that boys in particular were entitled to a moratorium on the exercise of

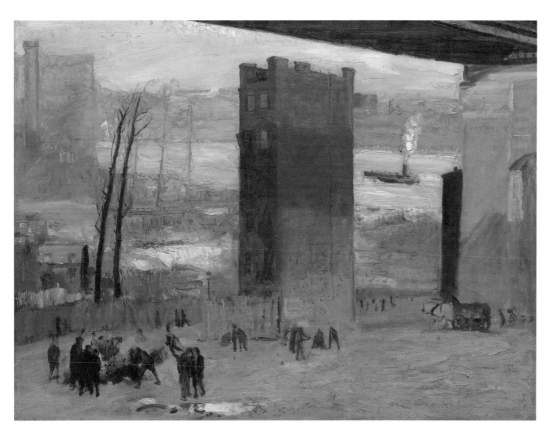

Fig. 3. George Bellows, *Lone Tenement*, 1909, oil on canvas. National Gallery of Art, Washington, D.C., Chester Dale Collection

adult responsibilities. Play was their proper business, but again under supervised conditions. New York officials tried to ban indiscriminate river swimming and to encourage its growth in designated areas, such as the fifteen free-floating baths that were installed in the Hudson and East rivers between 1890 and 1910, and in the dozens of public bathhouses built by 1912. The founding of aquatic clubs for boys and girls further refined swimming into a competitive sport, but the lazy, stolen swim persisted as an urban delight.[14]

One informal waterfront pastime that reformers ignored was fishing. John Sloan's *Fishing for Lafayettes* (cat. 48) captures how the poor of all ages and races regularly dropped lines off the docks of Manhattan to help supplement their diets and pass the time. In addition to lafayettes (named after the famous general), they also pulled in porgies, flounder, and striped bass. The fishermen, many of whom were transplanted rural folk, usually fashioned their own gear. But few activities were safe from entrepreneurs in New York. In 1892, a former railroad engineer, David Abercrombie, opened a small waterfront sporting-good shop and factory on South Street to outfit gentlemen anglers and outdoorsmen. He soon went into partnership with his best customer, attorney Ezra Fitch, and expanded uptown to Madison Avenue. Long before its recent incarnation as a purveyor of scent and sexuality, Abercrombie and Fitch provided equipment for such

upscale sportsmen and celebrity adventurers as Theodore Roosevelt and Charles Lindbergh.[15]

Central Park offered most New Yorkers their best opportunity to commune with nature. It permitted them not to escape the city so much as to experience one of its more aesthetically pleasing sides. A product of the antebellum reformist vision of Frederick Law Olmsted and Calvert Vaux, the park aimed to provide visitors not with "mere exemption from urban conditions," but "with conditions remedial of urban conditions."[16] By the turn of the twentieth century, visitors could still take bucolic walks, but they could now also enjoy Sunday concerts, carousel rides, a petting zoo, and such winter and summer sports as sledding, skating, lawn tennis, and bicycling. To capture the park's harmonious diversity of uses, William Glackens and Edward Manigault seized on the concept of procession as both ritual and metaphor. In *Little May Day Procession* (see Leeds essay, this volume, fig. 4), Glackens depicts children engaged in an annual rite of spring, while Manigault's *Procession* (cat. 66) presents the park as a multilayered democratic space where horses, automobiles, and pedestrians coexist in perfect equilibrium.

John Sloan expressed a less charitable opinion of this new hobby of motoring in his painting *Gray and Brass* (cat. 47). It portrays a Packard touring car full of jowly gents in khaki driving togs and blasé ladies in high plumage cruising past a row of vagrants sitting under shade trees in the park. Sloan's motorists are the very picture of "conspicuous consumption"—economist Thorstein Veblen's catchy 1899 neologism for spending undertaken mainly to display the spender's superior status, prowess, and distance from common labor. Motoring was indeed one of the most exclusive hobbies of the period; cars cost between $4000 and $6000, four times the annual income of a skilled union factory worker and ten times that of an unskilled nonunion worker.[17] As a leading producer of carriages, New York became an early center of automobile production, ownership, racing, and resentment.

Despite the obvious attractions of Central Park, most ethnic associations, churches, and unions held their annual festivals at commercially run picnic grounds such as the one pictured by Robert Henri in *Picnic at Meshoppen, PA* (cat. 60). Unlike municipal parks, these private grounds permitted speeches, beer kegs, dancing, sporting events, and games of chance.[18] Newspapers and charities sponsored similar "fresh air" excursions for poor city children to help them combat the stunting effects of tenement life.

Coney Island became the prime destination for excursionists. Its beaches and pavilions had long drawn New Yorkers, but the 9-mile (14-km) trip from Manhattan had never been easier than on the subway lines nor the attractions so fantastic as with the opening of Steeplechase Park in 1897, Luna Park in 1903, and Dreamland in 1904. These were thoroughly modern marvels that used technology to manufacture fun. They featured such roller-coasters as Loop the Loop, the Flip Flap, and the Whirl-Fly, as well as fun houses, waterslides, dance halls, skating rinks, and an array of dazzling exhibitions. Rich and poor (but not African Americans) were welcomed every season to experience a kind of perpetual childhood, at least for a day. Victorian virtues of industry, thrift, and self-control had no place here. Modesty itself was made a mockery of on the midway by hidden air jets that blew girls' skirts up over their heads. The sexes were literally thrown together in the Tunnel of Love and on the Human Roulette Wheel. Was this harmless fun or a damnable immorality masquerading as fun? The presence of honky-tonks, pool halls, and a brothel housed in a rundown elephant-shaped hotel seemed to argue for the latter. This roiling moral debate informs Sloan's *South Beach Bathers* (cat. 74). The painting depicts bumptious youths cavorting and consuming frankfurters and cigarettes on a crowded beach.[19]

Coney Island was not just about thrills and spills, but also about display—showing off one's figure and one's style, an art perfected in the city by young working women who had little spending money but a mortal fear of shabbiness. The mostly single gals who worked in New York's garment and millinery industries made products that they themselves consumed, not as indulgences but as investments in their search for excitement and a suitable mate. This pursuit sometimes brought them into conflict with their immigrant

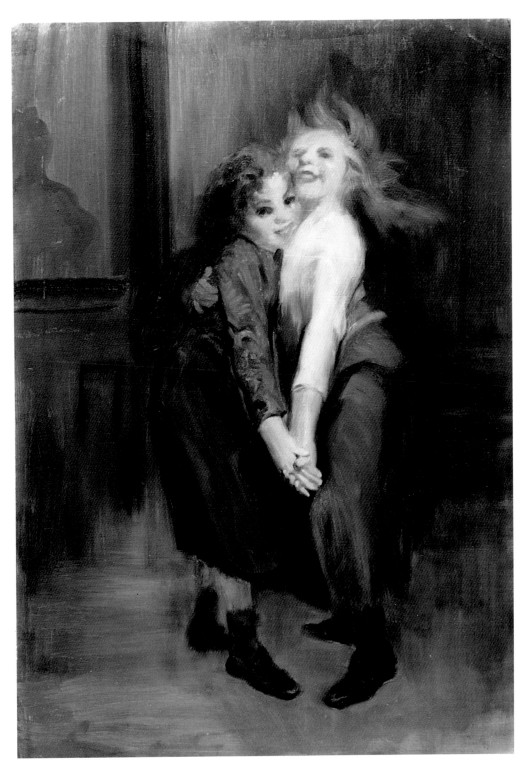

Fig. 4. George Luks, *The Spielers*, 1905, oil on canvas. Addison Gallery of American Art, Phillips Academy, Andover, Massachusetts, Gift of anonymous donor, 1931.9

parents, who expected them to hand over the bulk of their earnings and find marriage partners in traditional ways. Nevertheless, these dutiful daughters increasingly gained more control over their time and money.

Shopping itself became a pastime in this modern age. In addition to the pushcarts and neighborhood stores, many working girls patronized such big department stores as Macy's, B. Altman's, Gimbels, Saks Fifth Avenue, and

Lord and Taylor. These multistoried midtown emporiums, already nationally famous, revolutionized the retail industry in countless ways, not the least of which was their use of a new invention—plate-glass windows—that transformed sidewalks into showrooms. Everett Shinn documented the arrival of this innovation in his painting *Window Shopping* (1903; Collection of Arthur and Holly Magill), which shows a dowdy, rain-soaked woman stopped in her tracks in front

Fig. 5. John Sloan, *Fun, One Cent*, 1905, etching printed in black on wove paper. In *John Sloan New York Etchings*, no. 5. Detroit Institute of Arts, City of Detroit Purchase (29.212)

of a well-lit window display. Shinn did not exaggerate; so stunning were these displays, particularly when utilizing mannequins, that women's clubs initially crusaded against them as immoral.[20]

Once they looked presentable, young women and men wanted nothing more than to go dancing to ragtime bands. They were virtually "dance mad." By the 1910s, greater New York had more than five hundred dance halls. No image captures this cultural pandemic better than George Luks's *The Spielers* (fig. 4), his painting of two girls joyfully if awkwardly demonstrating one of the most exuberant dances of the day. Irving Berlin's song "Everybody's Doin' It Now," written in 1911, also caught the mood of the times. "It" referred to doing the grizzly bear, another popular step, but the lyrics were ripe with innuendo. "It" could mean anything; Berlin's song was peer pressure set to a syncopated beat. Working girls on tight budgets did indeed engage in dicey behavior in order to afford their nights out. Many relied on "treating," letting men pay for the food, drink, and entertainment in exchange for their companionship and perhaps a little sex play. Middle-class progressives found this situation appalling, and denounced commercial dance halls and unchaperoned "blowouts." They opened well-supervised municipal dance halls and endorsed "pleasure clubs" affiliated to churches, factories, and fraternal societies. But in continuing to dance how and where they pleased, these youths established patterns of dating and romance that quickly climbed the social ladder. As went the spielers, so went the nation.[21]

Vaudeville, the set of live variety acts that delighted working-class audiences for decades, still thrived in its hometown, but only movies surpassed dancing as the most popular form of commercial entertainment in the new century. As Sloan's *Movies, Five Cents* (1907; H.A. Goldstone Collection) illustrates, their appeal was greatest among the working class, who occupied three out of every four seats. Audiences comprised males and females of all ages and national origins. A lack of English was no barrier to enjoying these silent pictures, although here, too, the color of one's skin could be a hindrance. Some big theaters discriminated

against blacks, a number of whom would seek redress through the National Association for the Advancement of Colored People, founded in Harlem in 1909.[22]

Movies were a quintessentially modern form of entertainment. They were mechanical reproductions of vaudeville acts and real-life vignettes made possible by literally thousands of patented inventions (reels, cranks, and sprockets), and were controlled by upstart companies bent on monopolizing production, distribution, and exhibition. New York was the hub of the industry until the 1910s. The first Kinetoscope parlors opened on Broadway in 1894 (fig. 5), followed by storefront theaters that projected longer (five-minute) films on screens. By 1910, weekly attendance in greater New York neared 1.5 million, or a quarter of the city's entire population.[23]

Middle-class progressives initially embraced movies as an alternative to the unsavory vaudeville theaters and burlesque houses, but soon denounced the new industry on a number of grounds. They said nickelodeons encouraged immorality with their racy offerings, darkened interiors, and Sabbath screenings. In addition, they found many to be firetraps and "germ factories." Such charges resulted in the temporary banning of Sunday shows and unaccompanied children, but state and municipal lawmakers ultimately sided with their constituents, most of whom were moviegoers.[24]

Spectator sports also became a growth industry at this time. The rise of other commercial amusements may have familiarized people with paying to see athletic contests, but the so-called crisis of masculinity also prepared the ground. Middle-class males such as the delicate exercisers caricatured in Bellows's *Business Men's Class* (1913; Boston Public Library) felt threatened by the flood of swarthy immigrants who, despite their poverty and doubtless racial inferiority, worked in hearty manual trades that gave them a vitality lacking in Anglo-Saxons of the comfortable classes. The solution was to revitalize the native stock through hunting, hiking, and competitive athletics. No one personified this ethos better than Theodore Roosevelt, who preached to Chicago clubmen in 1899 that "our country calls not for the life of ease but for the life of strenuous

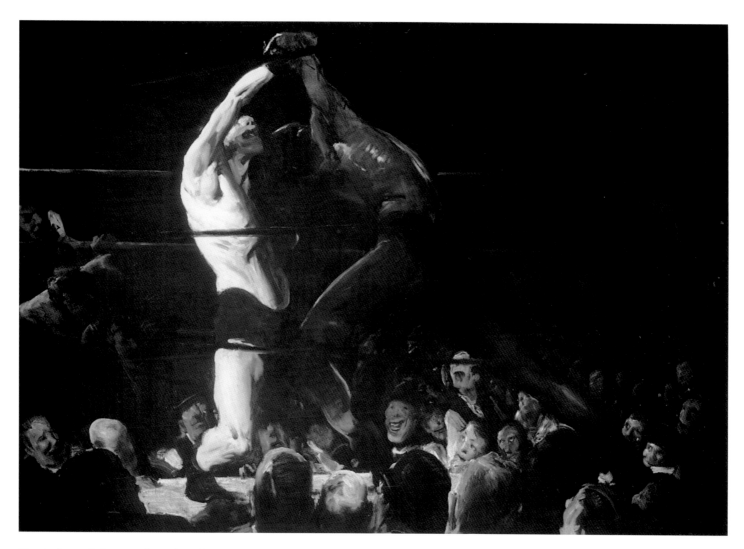

Fig. 6. George Bellows, *Both Members of This Club*, 1909, oil on canvas. National Gallery of Art, Washington, D.C., Chester Dale Collection

endeavor." The main thing on his mind that day was the insurgency in the Philippines and America's future role in the world, but the future president recommended football, boxing, and wrestling as excellent ways for American youths to steel themselves for the challenges ahead. Luks's excruciatingly realistic painting *The Wrestlers* (cat. 46) is a testament to Roosevelt's "strenuous" life, even though its creator was more a bon vivant of the barroom, as Henri portrayed him a year earlier.

The word "sport" connoted gambling as well as athletics. Indeed, two of the three most popular sports of the era—horse racing and boxing—were betting sports, and the third—baseball—was not unknown to odds makers. Long popular in New York, horse racing enjoyed a renaissance with the opening of four new tracks between 1895 and 1905: Aqueduct, Empire City, Jamaica, and Belmont. The muckraker David Graham Philips attributed this building boom to "our new crop of idle rich, with the

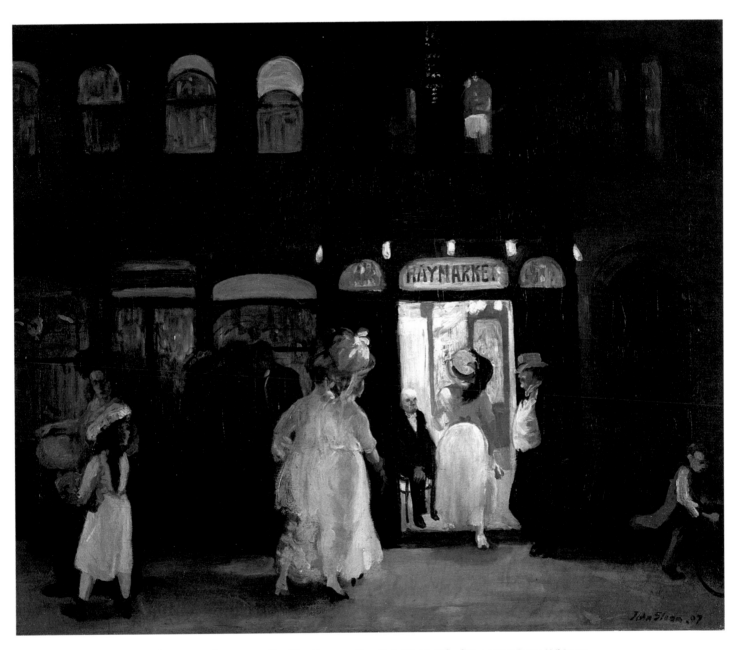

Fig. 7. John Sloan, *The Haymarket*, 1907, oil on canvas. Brooklyn Museum, New York, 23.60, Gift of Mrs. Harry Payne Whitney

passion for aping the aristocracy of Europe."[25] In *Taking the Hurdles* (cat. 41), John Grabach portrays thoroughbred racing as the high-society spectacle it was. Yet the idle rich alone did not make up the crowds of thirty to forty thousand that turned out for the big events. Technically, betting on horse races was prohibited by the state constitution, but bookmakers operated openly in betting sheds at the track and more discreetly in hundreds of pool halls throughout the city. Tracks charged their bookies for the privilege and, by law, handed over 5 percent of gross receipts to the state. Philips asked: How could this hypocrisy be tolerated? Because of a legal loophole introduced by Democratic politicians stipulating that gambling could be punished only if the loser of a bet filed suit to recover the amount of his loss. Prosecutions were thus made moot; it was Tammany Hall at its best.

Boxing existed even further out on the fringes of respectability. It was a popular form of amateur athletics, but also a seedy professional game barely tolerated by the law. Fight promoters in New York got around the ban against prizefights by staging them as "exhibitions of the manly art of self-defense" at such private clubs as the one depicted by Bellows in *Both Members of This Club* (fig. 6). The title of the painting is ironic because neither the black nor the white fighter would have been a member for longer than the night of their bout. Boxing became legitimate in New York in 1911, when Tammany Democrats passed the Frawley Act, legalizing ten-round, no-decision contests supervised by a state athletic commission. However, Republicans repealed the law in 1917, when they took control of the state house. Only with the election of reform Democrat Al Smith as governor in 1920 was pugilism restored to its rightful place in the smoke-filled, cone-shaped sun of such big arenas as Madison Square Garden.[26]

Bellows, ever the witness to history, found himself ringside at another big stadium, the Polo Grounds, on 14 September 1923, when heavyweight champion Jack Dempsey was sent sprawling into the seats by the powerful hook of Luis Angel Firpo, the "Wild Bull of the Pampas." "When Dempsey was knocked through the ropes he fell in my lap," Bellows informed Henri. "I cursed him a bit and placed him back in the ring with instructions to be of good cheer."[27] Bellows covered the fight for the *New York Evening Journal* and later recorded the scene on canvas in *Dempsey and Firpo* (cat. 38). A balding, big-eared man resembling the artist can be seen cringing under the falling heavyweight. Doubtless few of those who saw the painting exhibited in that period had to be told that Dempsey came back to knock Firpo down and keep his title.

Although New Yorkers avidly followed their National League Giants and American League Yankees, baseball did not draw much attention from the Ashcan artists. Even Bellows, a star shortstop at Ohio State University who almost turned professional, did not find the sport of interest artistically. Much more appealing to him were the exclusively upper-class sports of polo, tennis, and golf. Bellows watched or played these games while socializing with patrons in their stylish resorts. Like others in his circle, he cultivated elite collectors and had no qualms about sharing their good life, even if his sympathies lay with the masses. He called polo "a peach of a subject," and proved himself its equal in *Polo at Lakewood* (cat. 35). The painting, like his *Tennis at Newport* (cat. 37), fails as a coherent argument about the class divide but succeeds brilliantly as a representation of social life.[28]

Then as now, New York was a city of neighborhoods, each with a distinctive economy and character. Certain districts became emblematic of a particular, almost name-brand good time. Times Square, with its lavish theaters and supper clubs, was New York's amusement center. The Tenderloin, on Sixth Avenue between Twenty-third and Thirty-fourth streets, offered a thriving, racially mixed nightlife in low dives and wicked concert halls such as the Haymarket, depicted by Sloan in 1907 (fig. 7). Harlem had its blues clubs and cabarets; Chinatown its chop suey joints and Chinese opera houses; the Bowery its sawdust-floor saloons such as McSorley's Old Ale House, which allowed no women but plenty of cats; and Greenwich Village its bohemian cafés and "fairy hangouts." The Age of Amusement gave rise to a relatively open gay subculture. From the 1890s, homosexual men met in parks, clubs,

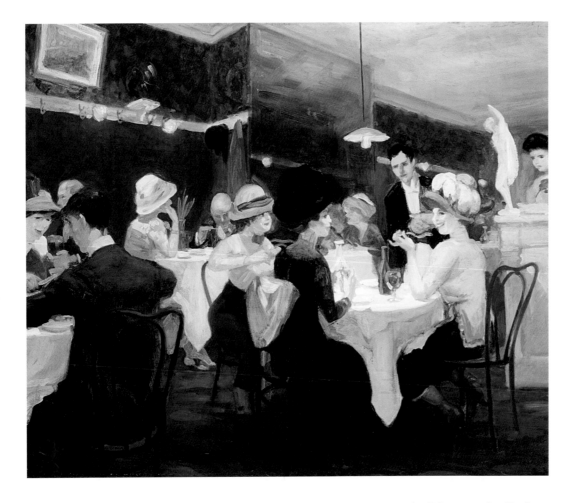

Fig. 8. John Sloan, *Renganeschi's Saturday Night*, 1912, oil on canvas. The Art Institute of Chicago

saloons, cafeterias, and cabarets. They made the Bowery a center of gay life and organized drag balls, which by the 1920s had moved uptown and become well-publicized annual affairs that attracted thousands of participants and spectators. For some New Yorkers, being gay "was what you did on the weekend."[29]

Being black, however, was a full-time job. African Americans constituted a small but growing minority in New York in the early twentieth century. Thousands sought to escape debt peonage and racial violence in the rural South for factory work and regular wages in the urban North. But migrants also craved the music, dance, and theater available in northern cities. Arriving from Florida in 1901 at the age of thirty, the poet James Weldon Johnson found New York

to be "the most fatally fascinating thing in America." He likened the city to "a great witch" who entices and crushes her victims. "I began to feel the dread power of the city," he said; "the crowds, the light, the excitement, the gaiety began to take effect on me. My blood ran quicker and I felt that I was just beginning to live."[30] Here, and perhaps in some of Shinn's desperately glamorized theater scenes (cats. 26 and 27), we see New York's nightlife not as a diverting amusement but as a force in history, an aspect of modern life that offered hope and possibility.

Nightlife in New York meant fine meals as well as shows. Dining out had been a formal, primarily upper-class experience in the nineteenth century. Working people patronized street stands, penny restaurants, boardinghouses,

and free-lunch saloons, but more as a necessity than as a luxury. The influx of immigrants at the turn of the century greatly enriched New York's culinary offerings. Italian pizzerias, French bistros, German beer gardens, Jewish delicatessens, Russian tearooms, and Chinese restaurants proliferated. Class mixing was common in the cheaper eateries, but much less so in the city's fancy hotel restaurants, where the velvet rope was invented in the 1890s. Before this decade, respectable women could not dine in the public rooms of restaurants without causing gossip, but this too changed, as we see in Sloan's *Renganeschi's Saturday Night* (fig. 8).[31]

Like theaters and department stores, some New York restaurants employed designers to create fantasy environments where customers could escape from their drab workaday lives. For example, Hammerstein's Olympia Theater featured a pastoral grotto with a pond and real swans. It also offered such acrobatic aerial shows as the ones depicted by Glackens (cat. 16). Prohibition crippled fine dining in the city, and among its casualties was the Ashcan hangout Mouquin's, on Twenty-eighth Street and Sixth Avenue (cat. 1). Out of the ashes rose the café society of the 1920s, its crowded glamour caught by Edward Hopper's *New York Restaurant* (fig. 9) and its frenzied pace epitomized by Edna St. Vincent Millay's famous line, "My candle burns at both ends."[32]

Smoking also became a kind of mass amusement. American men had long enjoyed a fine cigar or a sociable pipe. (Regulars at McSorley's kept their clay pipes on the wall.) But the invention of cigarette-rolling machines and the expansion of national advertising—including tobacco cards featuring famous actors and athletes—created a mass

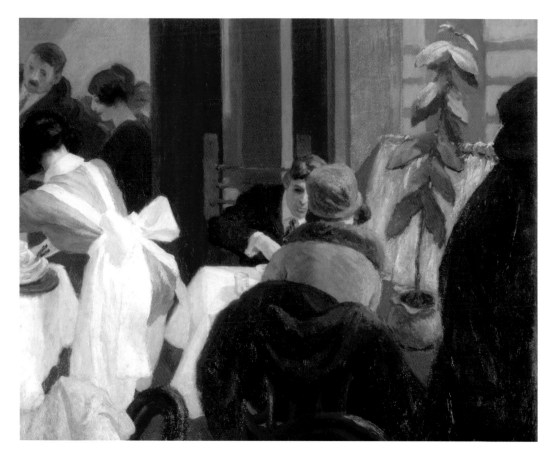

Fig. 9. Edward Hopper, *New York Restaurant*, ca. 1922, oil on canvas. Muskegon Museum of Art, Michigan, Hackley Picture Fund Purchase (1936.12)

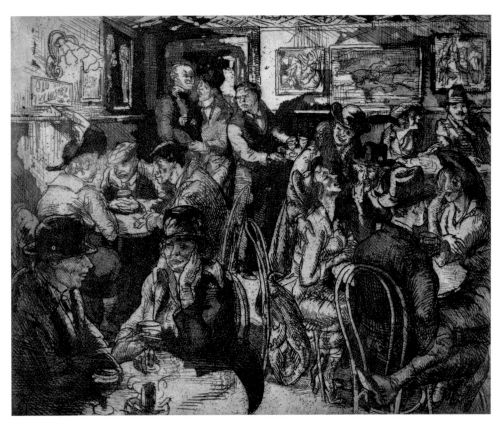

Fig. 10. John Sloan, *Hell Hole*, 1917, etching and aquatint printed in brown on laid paper. In *John Sloan New York Etchings*, no. 36. Detroit Institute of Arts, City of Detroit Purchase (26.18)

market for tobacco consumption. James Duke's factory in the Bowery produced cigarettes in such vast quantities (a billion a year in the 1890s) that he gave them away free to immigrants in hopes of making them loyal customers. Women also acquired the "filthy habit" and were increasingly permitted to light up in public. Yet as Lily Bart, the social-climbing heroine of Edith Wharton's bestseller of 1905, *The House of Mirth*, lamented, smoking might still be considered unbecoming in a *jeune fille à marier*.[33]

Eating, drinking, and smoking were pleasurable enough activities, but only insofar as they stimulated good talk. One of the most easily missed yet culturally significant leisure activities depicted by the Ashcan realists was talking. Their bar and restaurant scenes resonate with banter, flirtation,

argument, and storytelling. One strains to overhear the roguish raconteur in Charles Hawthorne's *The Story (The Diners; Pleasures of the Table)* (cat. 2), the friends gathered around in *Yeats at Petitpas'* (cat. 11), and the men in *McSorley's Bar* (cat. 12). Nowhere was talk valued more self-consciously than in Greenwich Village, where artists, revolutionaries, vagabonds, poets, playwrights, professors, trade unionists, and journalists mixed freely (fig. 10). They carried on in Yiddish, French, German, and Russian, as well as in English. Hobnobbing in this milieu was not just about escaping the pressures of work, but also about engaging with the power of such ideas as anarchism, socialism, cubism, free love, and psychoanalysis.[34] New York's organic intellectuals also attended lectures, discussions, lyceums, art and music

Fig. 11. John Sloan, *The Woman's Page*, from the "New York City Life" series, 1905, etching printed in black ink on wove paper. Detroit Institute of Arts, Gift of Bernard F. Walker (64.279)

classes, gallery openings, and "monster meetings" in support of striking workers. At the end of the day, they engaged in the kind of informal neighborhood discussions recorded in Robert Spencer's *Courtyard at Dusk* (cat. 75) and Jerome Myers's *Evening Recreation* (cat. 68).

Informing such talk was the written word. New Yorkers of the new century were first and foremost readers—not diners, dancers, or moviegoers. Reading was still the cheapest and most popular mass amusement (fig. 11). Even ordinary working people enjoyed far richer intellectual lives than is usually acknowledged.[35] They chose from 132 daily and weekly newspapers published in New York in 1900 (80 in English and 52 in other languages) and scores of magazines made possible by national advertising.[36] Appealing more to

the middle class were the new muckraking journals such as *McClure's* (1893) and *Everybody's* (1899). Newsstands bloomed like spring gardens, especially compared to previous years, when most periodicals bore gray, brown, or buff covers with no pictures.[37] Last but not least, residents of all ranks were welcomed into the magnificent New York Public Library, opened on Fortieth Street and Fifth Avenue in 1895, and the forty-three neighborhood branches erected between 1902 and 1921.[38]

Politics and pleasure were inextricably linked in New York. Tammany Hall, the Democratic headquarters on East Fourteenth Street, hosted saloon meetings, summer chowders, and torchlight parades that functioned as mass amusements themselves. Poll victories set off celebrations

that were the equivalent of Mardi Gras, Halloween, and New Year's Eve all rolled into one. John Sloan captured this side of the electoral process in his oil painting *Election Night* (fig. 12), which depicts a sidewalk thronged with revelers blowing horns, tossing confetti, and groping women. Moreover, New York politicians enjoyed close business ties to the city's entertainment industry—so close that Tony Pastor's Theater occupied space in Tammany Hall. Tammany boss "Big Tim" Sullivan made a fortune investing in vaudeville, nickelodeons, and racetracks while representing the Bowery in state government and the U.S. Congress. He used his influence to "protect" liquor sales, gambling, and prostitution, and levied informal "taxes" on the saloons, theaters, and restaurants in his district in order to underwrite his annual Christmas banquet for the poor.[39]

Radical politics was also not immune from the lures of show business. America's most notorious anarchist, "Red" Emma Goldman, enjoyed a kind of celebrity status based on her provocative writings, multiple arrests, mesmerizing open-air orations, and national lecture tours. Among the smitten were Robert Henri, who painted her portrait, and vaudeville impresario Oscar Hammerstein, who in 1913 offered her a thousand dollars a week to appear at his Victoria Theater. Although desperate to free herself from the "everlasting economic grind," Goldman ultimately declined, feeling she could not "plead her ideas" sandwiched between high kickers and trained dogs.[40]

The Ashcan painters were performers themselves, former commercial artists, most of them, who articulated their ideas visually in a vast marketplace of thoughts and images. However well or poorly they sold during their lifetimes, they were active players in the production and consumption of goods and pleasures. They both joined in the new commercialized fun and explored it as a subject of their art. They are sometimes accused of painting too rosy a picture of city life, particularly in comparison with their contemporaries—the muckraking journalists, documentary photographers, and progressive reformers who sketched the lower orders in much darker hues. There is some truth to the charge. Most Ashcan painters addressed the poverty, squalor, and injustice around them only obliquely through their images of laundresses, dockworkers, ragpickers, street urchins, and the homeless. Yet more often than not, they brought out the humor and *joie de vivre* of humble scenes and people. This tendency does not make them hopeless romantics; to capture humor and joy is to apprehend genuine aspects of reality. It is also true that civilization is as much about *homo ludens* (people at play) as about *homo faber* (people at work).[41] One could easily argue that it was the journalists, photographers, and reformers, not the Ashcan artists, who distorted reality owing to their sober reformist agendas.

Ultimately, the Ashcan artists chose their subjects not simply because they lived in New York and enjoyed the prevalent popular and elite amusements available, but because they found them interesting. Edward Hopper, who was always the most anxious of his peers about his choice of subjects, shared those anxieties with his artist wife, Jo. "E. has made such sketches at a burlesque & is juggling with advisability of attempting a canvas," she confided in her diary, "but wants to see things more clearly—wants to make sure he is really interested before starting off."[42] The interests of the Ashcan painters encompassed the aesthetic and the political, the moral and the historical. Certain subjects posed new technical challenges in terms of lighting, color, or composition. Others demanded attention because they were so beautiful, amusing, or fleeting. These artists daily encountered faces, gestures, expressions, styles, spaces, places, and pastimes that were unimaginable a few years earlier and that conceivably might be again a few years hence. In this sense, they were social historians of their own time. For all these reasons, and others probably not entirely clear to themselves, the Ashcan artists felt inspired to paint life's pleasures, though fully aware of its pains. Today their paintings enable us to see exactly *what* Irving Berlin thought everybody was doin', and to judge for ourselves whether their mad pursuit of pleasure brought forth a liberating advance in modern consumer society or just more hoopla.

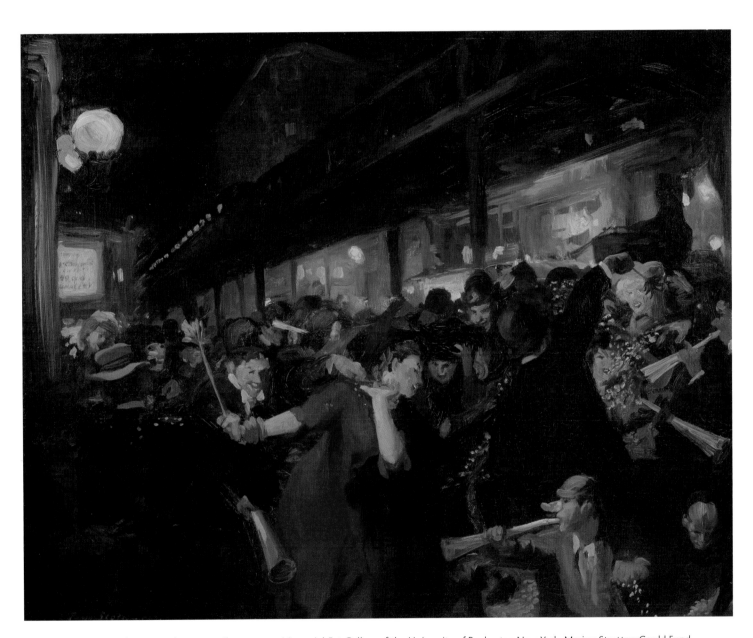

Fig. 12. John Sloan, *Election Night*, 1907, oil on canvas. Memorial Art Gallery of the University of Rochester, New York, Marion Stratton Gould Fund

Notes

1. Leon Fink, *Major Problems in the Gilded Age and the Progressive Era* (Lexington, Mass., 1993); Alan Brinkley, *The Unfinished Nation: A Concise History of the American People* (New York, 1997); Eric Foner, *Give Me Liberty! An American History* (New York, 2006). Other examples include Edward Hopper's *Yonkers* (1916; Whitney Museum of American Art, New York) on the cover of George Brown Tindall and David E. Shi, *America: A Narrative History*, vol. 2, 6th ed. (New York, 2004); Gifford Beal's *Elevated Columbus Avenue, New York* (1916; New Britain Museum of American Art, Conn.) on the "Activebook" to John Mack Faragher et al., *Out of Many: A History of the American People*, vol. 2, 3rd ed. (Upper Saddle River, N.J., 2002); and John Sloan's *The City from Greenwich Village* (1922; National Gallery of Art, Washington, D.C.) on John M. Murrin et al., *Liberty, Equality, Power: A History of the American People*, vol. 2: *From 1863*, 2nd ed. (Fort Worth, Tex., 1998).

2. See Charles Tilly, "Retrieving European Lives," in *Reliving the Past: The Worlds of Social History*, ed. Olivier Zunz (Chapel Hill, N.C., 1985), 15.

3. Michael Batterberry and Ariane Batterberry, *On the Town in New York: The Landmark History of Eating, Drinking, and Entertainments from the American Revolution to the Food Revolution* (New York, 1999), 27–31; Richard Butsch, *The Making of American Audiences: From Stage to Television, 1750–1990* (Cambridge, Mass., 2000), 51; *The Encyclopedia of New York City*, ed. Kenneth T. Jackson (New Haven, Conn., 1991), 79–80, 1167; Bruce McConachie, "'The Theatre of the Mob': Apocalyptic Melodrama and Preindustrial Riots in Antebellum New York," in *Theatre for Working-Class Audiences in the United States, 1830–1980* (Westport, Conn., 1985), 43, n. 14; Timothy J. Gilfoyle, *City of Eros: New York, Prostitution, and the Commercialization of Sex, 1790–1920* (New York, 1992), 30–31, 57.

4. Jackson 1991, 921–23.

5. Roy Rosenzweig, *Eight Hours for What We Will: Workers and Leisure in an Industrial City, 1870–1920* (Cambridge, Mass., 1983), 179–80; David R. Roediger and Philip S. Foner, *Our Own Time: A History of American Labor and the Working Day* (New York, 1989), 177–207; Witold Rybczynski, *Waiting for the Weekend* (New York, 1991), 133–35.

6. LeRoy Ashby, *Amusements for All: A History of American Popular Culture Since 1830* (Lexington, Ky., 2006), 173.

7. Lewis A. Erenberg, *Steppin' Out: New York Nightlife and the Transformation of American Culture, 1890–1930* (Westport, Conn., 1981), 36.

8. Jackson 1991, 1209; Edwin G. Burrows and Mike Wallace, *Gotham: A History of New York City to 1898* (New York, 1999), 1186.

9. *New York World* [newspaper], 18 August 1902, cited in Roy Rosenzweig and Elizabeth Blackmar, *The Park and the People: A History of Central Park* (New York, 1992), 309.

10. James L. Roark et al., *The American Promise: A Compact History*, vol. 2: *From 1865*, 3rd ed. (Boston, 2007), 485.

11. Justin Krebs, *Grounds for Play: The Movement That Built Playgrounds for the People of New York* (New York, 2002), 10; Jackson 1991, 907.

12. Ashby 2006, 149.

13. Jackson 1991, 85–86.

14. G. Stanley Hall, *Adolescence: Its Psychology, and Its Relations to Physiology, Anthropology, Sociology, Sex, Crime, Religion, and Education*, 2 vols. (New York, 1904); Jackson 1991, 1145.

15. Jackson 1991, 1, 1102–3.

16. Frederick Law Olmsted, "The Plan for the Park" (1858), in *Empire City: New York through the Centuries*, ed. Kenneth T. Jackson and David S. Dunbar (New York, 2002), 279.

17. *Encyclopedia of Urban America: The Cities and Suburbs*, vol. 1, ed. Neil Larry Shumsky (Denver, 1998), 54; Paul H. Douglas, *Real Wages in the United States, 1890–1926* (Boston, 1930), 232, cited in Richard O. Boyer and Herbert M. Morais, *Labor's Untold Story* (New York, 1973), 181.

18. Kathy Peiss, *Cheap Amusements: Working Women and Leisure in Turn-of-the-Century New York* (Philadelphia, 1986), 118–20.

19. John Kasson, *Amusing the Millions: Coney Island at the Turn of the Century* (New York, 1978); Richard Snow, *Coney Island: A Postcard Journey to the City of Fire* (New York, 1984); Peiss 1986, 115–38; David Nasaw, *Going Out: The Rise and Fall of Public Amusements* (New York, 1993), 80–95; and Woody Register, *The Kid from Coney Island: Fred Thompson and the Rise of American Amusement* (New York, 2003).

20. Nan Enstad, *Ladies of Labor, Girls of Adventure: Working Women, Popular Culture, and Labor Politics at the Turn of the Twentieth Century* (New York, 1999), 62–63; Rebecca Zurier et al., *Metropolitan Lives: The Ashcan Artists and Their New York* [exh. cat., National Museum of American Art] (Washington, D.C., 1995), 146–56; William Leach, *Land of Desire: Merchants, Power, and the Rise of a New American Culture* (New York, 1993), 66.

21. Peiss 1986, 88–114.

22. Peiss 1986, 146; Nasaw 1993, 171–72.

23. Peiss 1986, 146.

24. Daniel Czitrom, "The Politics of Performance: From Theater Licensing to Movie Censorship in Turn-of-the-Century New York," *American Quarterly* 44, 4 (December 1992): 431.

25. David Graham Philips, "The Delusion of the Race-Track," *The Cosmopolitan* (January 1905), in *Tale of Gaslight New York*, comp. Frank Oppel (Secaucus, N.J., 1985), 289–300.

26. Steven A. Reiss, *Sports in Industrial America, 1850–1920* (Wheeling, Ill., 1995), 145–49.

27. Mahonri Sharp Young, *The Paintings of George Bellows* (New York, 1973), 144. For an analysis of the Dempsey–Firpo fight and Bellows's interpretations of it, see Marianne Doezema, "The 'Real' New York," in *The Paintings of George Bellows* (New York, 1992), esp. 126–29.

28. Michael Quick, "Technique and Theory: The Evolution of George Bellows's Painting Style," in *Paintings of George Bellows* 1992, 91.

29. Yet there were always risks; those arrested in periodic crackdowns faced $50 fines and up to sixty days in the workhouse. George Chauncey, *Gay New York: Gender, Urban Culture, and the Making of the Gay Male World, 1890–1940* (New York, 1994), 171–73, 227–28, 274. See also Chauncey's "Long-Haired Men and Short-Haired Women: Building a Gay World in the Heart of Bohemia," in *Greenwich Village Culture and Counterculture*, ed. Rick Beard and Leslie Cohen Berlowitz (New Brunswick, N.J., 1993), 151–64.

30. James Weldon Johnson, "Autobiography of an Ex-Colored Man" (1912), in *Empire City: New York through the Centuries*, ed. Kenneth T. Jackson and David S. Dunbar (New York, 2002), 519–20.

31. Batterberry and Batterberry 1999, 201–3; James Trager, *The New York Chronology* (New York, 2003), 238.

32. Leach 1993, 82; Edna St. Vincent Millay, *A Few Figs from Thistles: Poems and Sonnets* (New York, 1922), 9.

33. Batterberry and Batterberry 1999, 150–51; John C. Burnham, *Naughtiness: Drinking, Smoking, Taking Drugs, Gambling, Sexual Misbehavior, and Swearing in American History* (New York, 1993), 88; Ray Ginger, *Age of Excess: The United States from 1877 to 1914* (New York, 1965), 30; Trager 2003, 208, 220; Edith Wharton, *The House of Mirth* [1905], *A Norton Critical Edition* (New York, 1990), 56.

34. Christine Stansell, *American Moderns: Bohemian New York and the Creation of a New Century* (New York, 2000), 89.

35. A history of American workers as thinkers remains to be written. On working-class intellectuals elsewhere, see Jacques Rancière, *The Nights of Labor: The Workers' Dream in Nineteenth-Century France*, trans. John Drury (Philadelphia, 1981), and Jonathan Rose, *The Intellectual Life of the British Working Classes* (New Haven, Conn., 2001).

36. Thorin Richard Tritter, "Paper Profits in Public Service: Money Making in the New York Newspaper Industry, 1830–1930," Ph.D. diss., Columbia University, 2000, 370.

37. Franklin Luther Mott, *A History of American Magazines*, vol. 3 (Cambridge, Mass., 1957), 9.

38. Jackson 1991, 840–41.

39. Gilfoyle 1992, 210; Daniel Czitrom, "Underworlds and Underdogs: Big Tim Sullivan and Metropolitan Politics in New York, 1889–1913," *Journal of American History* 78, 2 (September 1991): 536–58.

40. Emma Goldman, *Living My Life*, vol. 2 [1931] (New York, 1970), 526; Stansell 2000, 85, 138.

41. Johan Huizinga, *Homo Ludens: A Study of the Play Element in Culture*, trans. R.F.C. Hull (London, 1949).

42. Jo Hopper, diary entry for 30 March 1939, quoted in Gail Levin, *Edward Hopper: An Intimate Biography* (New York, 1995), xii.

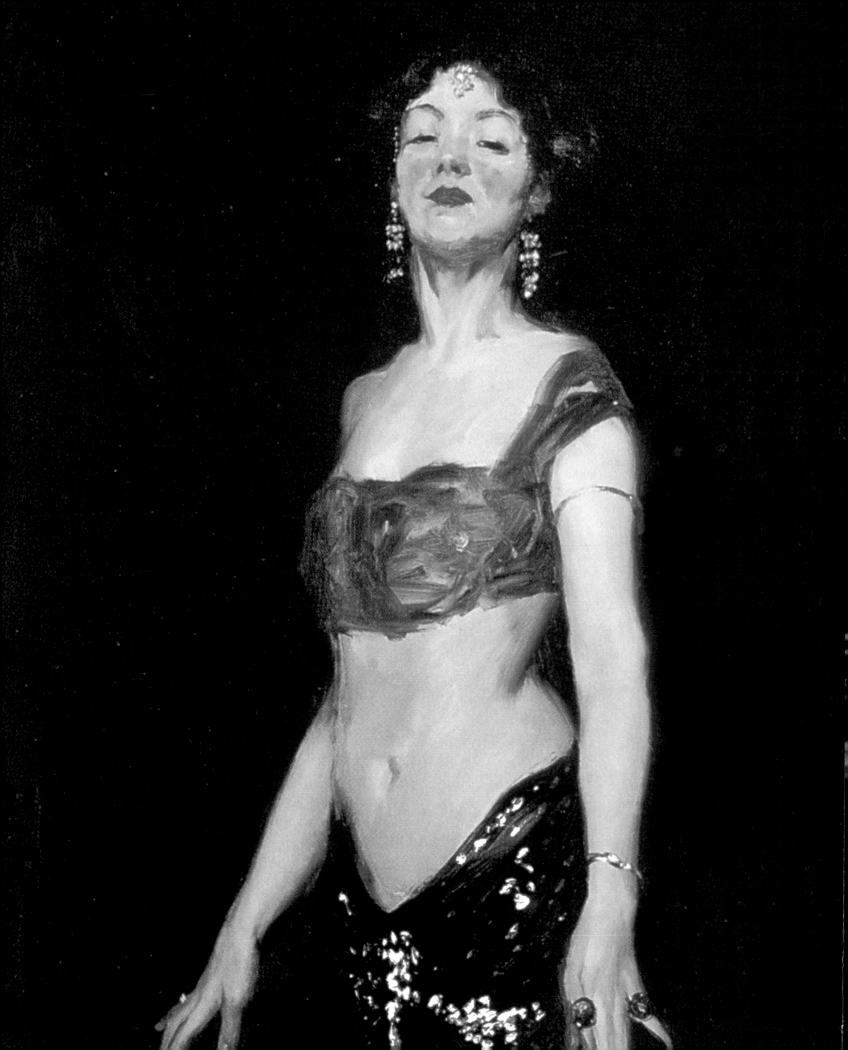

Representing Women

Marianne Doezema

During the first decade of the twentieth century, the image of the American woman, as she was represented in visual and literary texts, took on particular importance, helping shape changing concepts of femininity and thus challenging the parameters of the "women's sphere." At a cultural moment when traditional values were perceived to be under assault, she had come to represent those of the nation. Urban Americans were reeling from the impact of a shift in industrial and social orders that had been under way for decades. Economic and social developments that followed the Civil War had altered the way American culture perceived women. In many segments of society, middle- and upper-class women were ever more removed from economically significant activity as their intellectual and commercial prowess increasingly caused concern and their role as moral and spiritual exemplars became more highly valued. At the same time, observers of American culture noted the bourgeois woman's growing engagement with educational, political, and occupational pursuits outside the home.

With the exception of portraiture, images of women rarely appeared in the United States until after the Civil War. Winslow Homer depicted fashionably dressed equestriennes, croquet players, and even sea bathers as he focused on modern life and new forms of bourgeois leisure.[1] Thomas Eakins and Lilly Martin Spencer painted women in various roles, most often in the domestic setting and occasionally outside it. But in the later nineteenth century—at the time when it became popular for artists to go to Paris for training—images of women were produced in much greater abundance. The female figure was such an important subject in French art that American students assimilated the idea that the ability to paint the figure was the ultimate sign of artistic accomplishment. Back home, these young artists wanted to show what they had learned.

Samuel Isham, author of the first history of American art movements and aesthetics, offered an explanation for the prevailing attitude about the female figure:

> [Americans] have no goddesses or saints, they have forgotten their legends, they do not read the poets, but

Fig. 1. Thomas Wilmer Dewing, *The Recitation*, 1891, oil on canvas. Detroit Institute of Arts, Detroit Museum of Art Purchase, Picture Fund, 08.9

something of what goddess, saint, or heroine represented to other races they find in the idealization of their womankind. They will have such idealization decorous; there is no room for the note of unrestrained passion, still less for sensuality.[2]

When paintings of the female figure did become popular in the United States, most often the subject was the decorous young woman Isham described, exhibiting grace, civility, and purity. This idealized—and desexualized—vision of the American woman became an icon of culture at the turn of the century, an embodiment of refinement and taste and the evocation of aesthetic beauty and spirituality.

Most artists of the time represented contemporary women. Interior, domestic settings—areas typically regarded as the woman's sphere—were most common. Represented as clean, orderly, and exquisitely appointed, these spaces are

oftentimes strangely claustrophobic. Here, the woman is one more object of beauty in an array of beautiful objects, often in an expressly passive state.

Such images as Thomas Wilmer Dewing's *The Recitation* (fig. 1) defined the world of leisure and refinement. Only women had the luxury of reflection, and thus woman became the symbol of introspection and aesthetic contemplation. In an age of vulgar materialism, women were perceived as preservers of things spiritual. As one turn-of-the-century etiquette manual stated: "Women are our only leisure class. It is women who create society ... and it is largely to women with their leisure, and their tact, that we must look to create and sustain the social fabric."[3]

While images of refined, contemplative women abounded, there was also a considerable discussion of the so-called New Woman, characterized as an independent person with a public role. In a few short years after she first appeared on the pages of *Life* magazine, the svelte and elegant Gibson Girl was on her way to becoming the prevailing embodiment of this new breed of woman. She was beautiful, healthy, sensual, and the favorite among men. Self-assured and independent, she epitomized the modern American woman, cycling, skating, and playing golf, but she undertook those activities in sporting attire that was clearly tightly laced at the waist (fig. 2). The Gibson Girl and Gibson-like girls proliferated in American magazines during the 1890s, when illustrated periodicals flourished.[4] The appearance of the New Woman in American culture and her move into the public realm signaled the erosion of the separate spheres for men and women.

In November 1905, a less wholesome depiction of a woman was awarded an honorable mention at the Carnegie International in Pittsburgh. William Glackens's *Chez Mouquin* (cat. 1) reveals the artist's admiration for Manet and Renoir, but the picture was set in a New York restaurant that would have been known to many contemporaries. Located at Twenty-eighth Street and Sixth Avenue, Mouquin's was popular among theatergoers, as well as artists and writers, and was a favorite eatery for several members of the Robert Henri circle. The formidable-looking gentleman

Fig. 2. Charles Dana Gibson, *Scribner's for June*, 1895, lithograph. Currier Museum of Art, Manchester, New Hampshire, Gift of Orien B. Dodge, 1943.10.5

Fig. 3. Edouard Manet, *A Bar at the Folies-Bergère*, 1882, oil on canvas. The Samuel Courtauld Trust, Courtauld Institute of Art Gallery, London

on the right is James B. Moore, owner of the nearby Café Francis, which he advertised as "New York's Most Popular Resort of New Bohemia." A well-to-do lawyer, Moore most enjoyed associating with and hosting a circle of bohemian friends, including Glackens. In *Chez Mouquin*, Moore is leaning toward his elegant female companion, one of several young ladies who accompanied him on outings and to whom he referred as his "daughters."[5]

The relationship between Moore and these various "daughters" can only be guessed. Likely, he bought these women gifts, including fashionable gowns or money to buy clothing that would have been appropriate for outings such as the one depicted in *Chez Mouquin.* Working- and middle-class young women occasionally traded sexual favors for gifts or a good time. These women, known as "charity girls," were not prostitutes; they may have sought jobs as shop girls or office workers and found their way to one of the many venues for leisure entertainment, where they were noticed by a gentleman with means. Once they came under the wing of such a man as Moore and wore fashionable garments, it would have been virtually impossible to determine their status. As one waiter explained: "The way women dress today they all look like prostitutes."[6]

The elegant, though wistful-looking woman in *Chez Mouquin* invites comparison with the barmaid in Edouard Manet's *A Bar at the Folies-Bergère* (fig. 3). Both are psychologically fascinating; their expressions might speak of loneliness or apathy. Both paintings depict an atmosphere of communal pleasure, clinking glasses, and bustle. Both artists have created marvelous still lifes in the foreground of their pictures. The use of the mirror effect—a compositional device that had appeared rarely in American painting previously—also suggests that Glackens admired the earlier painting and borrowed from it for his masterpiece of 1905. We also know that *A Bar at the Folies-Bergère* was on view at Paul Durand-Ruel's New York gallery in March 1895 and that Glackens was taken by the show.[7] Shortly thereafter Glackens went to Europe in the company of Robert Henri, and during the fifteen months spent there, both artists confirmed their devotion to Manet.

A decade later, Manet's depiction of a beautiful barmaid and the interior of the Folies-Bergère reflected in the mirror behind her may still have been vivid in Glackens's memory when he created one of the most spectacular paintings of his career. The female figure in each painting has an intriguingly mysterious presence, and despite the possibility that their models might have exchanged sexual favors for gifts, the dazzling portraits make no such allusion. Instead, the subjects are portrayed as beautiful, elegant, thoughtful women, although one of the most negative critical comments about *Chez Mouquin* did make a dire prediction: "[Glackens] brings out every phase of the gross roué and the young woman who is taking her first step in the field of dissipation, and the misery shown in her eyes is a mighty lesson."[8]

For society's conservative elite, the most unsettling threat to the social structure and the sanctity of the woman's sphere was posed by young working-class women who were visible in the shops and on the streets of New York. Wandering the neighborhoods of his newly adopted city in search of subject matter, John Sloan often focused his attention on the young working-class adults who were very much part of the urban environment and who had become the subject of his art since he began associating with a small cadre of artists around Henri. To gallerygoers in the first decade of the twentieth century, the animated audience depicted in his *Movies, Five Cents* (1907; H.A. Goldstone Collection) was clearly working class. The young woman at the right, taking her seat with the help of her male companion, raises one concern the painting may have brought to the minds of middle- and upper-class observers. In the *Ladies Home Journal*, Mrs. Burton Harrison had addressed the "question of whether or not it is a departure from good form for a young girl to accompany a young man to the theatre alone." As she noted: "In New York, among the people whose customs I set out to describe, this is not done." The etiquette specialist admitted, however, that the question was "vexed," as she was conscious that other regions of the country differed with regard to judgments of public conduct.[9]

Fig. 4. "New York's Art War and the Eight 'Rebels,'" *New York World Magazine*, 2 February 1908

Sloan was quite aware that his approach to the subject of the working-class New Woman, and new forms of working-class leisure in general, posed an affront to the guardians of American culture. Of *Movies, Five Cents*, he later wrote, "At the time when this picture was painted, the cinema was in its sordid infancy."[10] He may have taken some satisfaction in knowing that the likes of Mrs. Harrison would not have imagined her daughter venturing into such a place.

Sloan's mentor, Henri, had advised his protégés to draw from fresh visual perception rather than imitate conventional forms of academic idealism. Working as newspaper illustrators, Sloan and his colleagues Glackens, George Luks, and Everett Shinn had the perfect opportunity to practice what Henri preached, to make pictures from what they saw around them. Sloan's frank portrayal of everyday life in New York concentrated particularly on women, in part, no doubt, because images of women remained so highly prized in established art circles. When a scene includes both sexes, Sloan's focus is on the women, and it is the women who are invariably the primary impetus for the observed activity in his paintings and prints.[11] Thus, Sloan's women could hardly be more different from the women of leisure depicted by Thomas Dewing or Edmund Tarbell in at least two crucial respects: they are active and they are working class.

The title of the first substantial analysis of Sloan linked his professional identity with the working classes: "The Real Drama of the Slums, as Told in John Sloan's Etchings." Writing in the *Craftsman*, Charles Wisner Barrell made it clear in his second paragraph that he would address not only Sloan's prints but his paintings as well, and he identified the three "best known" as *The Rathskeller*, *Picnic Grounds*, and *The Coffee Line*. Given the title and the substance of Barrell's article, the reader must have concluded that he perceived all three paintings to be populated by denizens of the slums. The working-class associations of *Picnic Grounds* (1906; Whitney Museum of American Art, New York) may be less than obvious to twenty-first-century eyes, but not to anyone viewing the painting when it was first seen. Barrell described the three young women in the foreground as a

"bevy of city hoydens."[12] Their uninhibited romping exemplifies carefree disregard for the strictures of genteel deportment; the fun includes both sexes and is apparently unchaperoned. Sloan adulates the goings-on, which a moralistic middle-class audience would have found unseemly—in part because Sloan's women are sexualized.

Barrell had seen *Picnic Grounds* at least twice before. Certainly, he noticed it at the National Academy of Design's much-discussed spring exhibition in New York in 1907. Robert Henri had only recently been elected as a member and was on the jury that March. He tried to promote his students' work, to no avail. The head of the jury, Kenyon Cox, dismissed an entry by Luks with a brusque "To hell with it!" Entries by Glackens and Luks fared poorly, and *Picnic Grounds* was given a number 2 ranking, which meant it was eligible for reconsideration. (There were four possible scores, in descending order: 1, 2, 3, or R, for outright rejection.) On the third day of deliberations, Henri received the ultimate insult, when his colleagues on the jury rated one of his canvases number 2 and another was dropped from a 1 to a 2. Henri dramatically withdrew both, resigned from the jury, and went directly to the press with his version of the story. Both canvases were reproduced to illustrate a long article about the entire episode that appeared within weeks in *Harper's Weekly*.[13] But *Picnic Grounds* survived the mayhem and was on view when the show opened. In the days that followed, plans began to take shape for the now famous exhibition at the Macbeth Galleries of work by Henri and his colleagues.

Thanks in part to Henri's connections with the press, there was considerable coverage leading up to the opening at Macbeth's, and the first week of the exhibition met with a flurry of articles and reviews. The splashiest may have been the full-page cover of the *New York World Magazine* (fig. 4), with a full-length portrait of Henri wielding a paintbrush filling the left edge, a circle of photographic portraits of all eight participants at the top/center, and large reproductions of paintings by seven of the artists scattered over the page. *Picnic Grounds* did not receive specific critical attention in the press, but another of Sloan's entries was selected

for the *World*'s collage. Just inches under the bold headline, "New York's Art War and the Eight 'Rebels,'" was *The Haymarket* (see DiGirolamo essay, this volume, fig. 7), a stunning picture in which Sloan presented three chicly dressed women, most likely prostitutes, stepping into one of the most notorious nightspots in New York City. It was the first of four works referred to in the text, which was devoted primarily to the concept of radicalism. The writer seemed impressed that Sloan had "dared to paint the Haymarket dance hall."[14] It was, in fact, daring to confront contemporary sexuality in the way that Sloan did, without the mitigating suggestion of an Orientalist guise made familiar by paintings by such artists as Frederick Arthur Bridgman.[15] Instead, Sloan's sexualized women walked the familiar streets of the early twentieth-century American city.

James Gibbons Huneker came to the Macbeth Galleries with a more sophisticated understanding of contemporary art and declared the show not revolutionary at all: "They are realists inasmuch as they paint what they see, let it be ugly, sordid or commonplace.... They invest the commonest attitudes and gestures of life with the dignity of earnest art."[16]

Admiring Sloan's *Cot* (1907; Bowdoin College Museum of Art, Brunswick, Me.) as "one of the best things we have had from him," Huneker took in his stride the subject, "a woman in nightdress." He praised the tonality, the way the figure's pose was "caught"—the figure, of course, in a state of partial undress, tantalizingly adjacent to a bed with covers opened. Touching on the humor as well as the sadness of another of Sloan's depictions of women, *Sixth Avenue and Thirtieth Street* (1907; Mr. and Mrs. Meyer P. Potamkin, Philadelphia), Huneker concluded that the artist's ability to see "to the core of ugliness" was philosophical.

When turning to Henri, however, Huneker's plaudits were more reserved: "despite his fresh, dashing brush work, his breadth of style and vigor of attack," the acknowledged leader of the eight painters was termed "less an innovator" than his followers. Henri's achievements as a portraitist and figure painter have commonly received relatively short shrift. Henri never said or wrote anything to indicate that he felt slighted by reviews that appeared during his lifetime.

The record makes clear that he took great pride in the accomplishments of his protégés, but he must have been stung when he was deemed "less an innovator" than them. Perhaps in response to reviews of the Macbeth Galleries exhibition, whether consciously or not, the following year Henri painted two of the most sensational paintings of his career: full-length portraits of Salome.

Henri may have felt a kinship of sorts with the infamous dancer Salome since Richard Strauss's eponymous opera was suppressed after only one American performance, on 22 January 1907. Highly publicized debates about questions of impropriety and earlier censorship of the opera swirled around New York City for months, competing for attention with debates about the merits of paintings by Henri's protégés. A lengthy article for the *Craftsman* was written before the opera was closed. Henri, who had a special affinity for the magazine and its editor, Mary Fanton Roberts, certainly saw the article in the February issue. (The issue was probably available shortly after the owners of the Metropolitan Opera House decided to prohibit any further performance of the work in their theater.) The author, Katharine Metcalf Roof, laid out the essentials of the opera's history and most specifically of the play written by Oscar Wilde, which then "appealed to the strange musical imagination of Richard Strauss." Salome was not new as a subject for art, as Roof noted, citing a play by Hermann Sudermann and an opera by Jules Massenet. She might also have noted countless visualizations ranging from medieval sculpture to several renditions by Gustave Moreau. More importantly, though, Wilde's Salome was entirely new. The passive biblical Salome had been transformed into a personality with desires and motivations of her own. Following Wilde's text closely, Strauss's opera fixed that "strange, exotic, grewsome [sic]" personality "into immortality."[17] And finally, while Wilde had given Salome "The Dance of the Seven Veils," Strauss wrote nine full minutes of music to accompany the sequence, which he termed "the heart of the plot."[18]

Salome's dance, of course, pleased her father-in-law, Herod, and inspired him to grant her virtually any request.

Fig. 5. Robert Henri, *La Reina Mora*, 1906, oil on canvas.
Colby College Museum of Art, Waterville, Maine, Museum
Purchase from the Jere Abbott Acquisitions Fund, 1992.005

In traditional versions of the story, when she asks for the head of John the Baptist, she is acting on her mother's instructions, but in Wilde's play it is Salome who develops complex relations with the prophet. On the one hand, he has rejected her advances, for which she wants revenge, and on the other hand, he has aroused her sexual desire. According to Roof's report, the music and the rhythms of the dance express that her thoughts throughout are focused on John the Baptist, whose head she demands to have presented to her on a platter. In a scene Roof described as "unspeakably revolting," Salome declares her love for the prophet in a sensuous soliloquy addressed to his severed head, and then makes good on her vow to kiss John's lips. Horrified, Herod commands "Kill the woman!," and his soldiers crush Salome with their shields.[19]

After the opera closed in New York, the ballerina who had performed "The Dance of the Seven Veils" took her show to the Lincoln Square Variety Theatre. Thus, Salome quickly moved from the world of high art to vaudeville and there became an instant hit. Soon there were undulating Salomes all over New York City, and within a year Salomania was a national craze. The reason for Salome's popularity was obvious to at least one observer: "She is bad and that is a great element of her attraction."[20]

Henri decided to portray Salome not long after Strauss's opera was brought back to New York City.[21] Very likely Henri was taken not only by the way she danced but also by the way she had a mind and a will of her own, the way she wielded power—the way she embodied the New Woman. But the fact that Salome had such currency in American society and culture on many levels undoubtedly played a large part in the creation of Salome (cat. 17).

Henri was an avid fan of dance. He collected photographs and an array of other materials related to performances he saw. His letters home from a trip to Spain in 1906 speak of his excitement at meeting Milagros Moreno, a renowned Andalusian dancer. Of her performance he wrote: "On the stage she is almost savage in her dance—a fierceness that is terrible."[22] He very much wanted to paint her portrait and exerted considerable effort to do so (fig. 5).

In three two-hour sittings he used loose, rapid brushwork to depict the "white shawl, with embroidery in brilliant red and colors," which he himself was able to select from her elaborate wardrobe of costumes.[23] The striking portrait also conveys the outgoing, self-assured, and even proud personality of Moreno as she confronts the viewer with hands on hips and an engaging glance. The painting stops short, however, of evoking the passion that fueled the dance that Henri had described as "almost savage" and "terrible."

Salome provided Henri with a subject that inspired him to push the conventions of figure painting in a way he had not done previously. He hired a professional dancer, Mademoiselle Voclezca, to pose. Clear reference to "The Dance of the Seven Veils" is established by the sheer wrap she holds. The painting presents the dancer as she steps forward and arches her back at the same time. Contemporary viewers would have understood immediately that the dance—the alluring removal, one by one, of the veils—is under way, suggesting that even more flesh may be revealed imminently. Salome gazes at the viewer straight on, as Henri's portrait subjects typically do, but with a beckoning gaze that is more explicitly sexual than any he had painted to date.

The immediacy of the presentation, rarely achieved so successfully in Henri's figure paintings, was reiterated in the second version of the same subject. In Salome (No. 2) (fig. 6), the dancer has dropped the white veil she had been holding, moved a step forward, and inclined her head slightly toward the viewer, softening her haughty expression. These two fully realized treatments of the same subject, composed as if recording sequential moments, may very well have embodied Henri's ambitions during the year following the achievements of The Eight at Macbeth's.

Henri's original title for the first of the two pictures, Salome Dancing (also sometimes exhibited as Salome Dancer), suggests that he intended to connote not only the venerable art-historical tradition associated with the biblical character and the recent notoriety of Strauss's opera, but also more directly contemporary Salomes who were performing "The Dance of the Seven Veils" on a nightly basis. Henri's

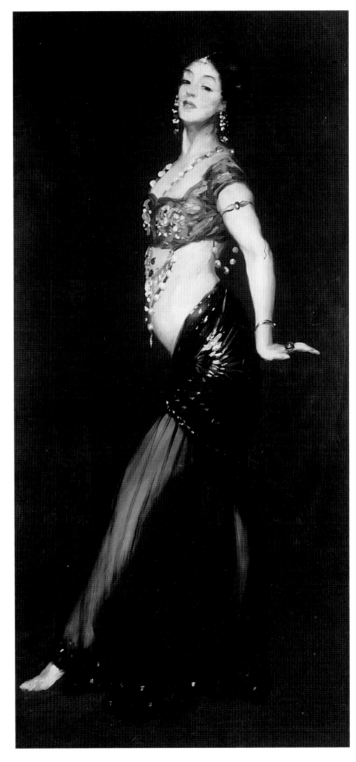

Fig. 6. Robert Henri, *Salome (No. 2)*, 1909, oil on canvas. The John and Mable Ringling Museum of Art, The State Art Museum of Florida, Sarasota

paintings of Salome confronted a range of very current issues, including changing notions of the feminine and the female body as a symbol of liberation, especially as it increasingly appeared on the stage. It was widely assumed that the world of actresses and dancers was characterized by loose morals. While the stage was the only way for many women to achieve financial independence, bestowing sexual favors was often considered a prerequisite for a career. Performers also enjoyed a degree of freedom and access to public spaces that was rare for women, on or off the stage.[24]

It is impossible to know for certain whether Henri expected his painting of Salome to be rejected by the National Academy of Design jury when he submitted it for the spring annual in February 1910. Sloan made a note in his diary about his own *Three A.M.*, predicting it "won't have a chance I'm sure." Then after the decisions were made, he wrote: "Back rejected! from the N.A.D. jury came the "City Pigeons" and "Three A.M." … [T]he new portrait of Mrs. H. in Brown is fired, also the Salome Dancer with naked legs. Of course the last was too much for them."[25]

Plans were quickly put in place for a large-scale show that would be known as the Exhibition of Independent Artists. Invitations to exhibit were sent to nearly eighty artists. There was no jury and, on Henri's insistence, no prizes. Once again considerable press attention was garnered, and Henri was consistently identified as the driving force behind the project, which was described as "epoch-making."[26] Although Henri maintained that the exhibition was not about rejected artists, two of his own four entries, including *Salome Dancer*, had recently been National Academy rejects. With some 260 paintings, 219 drawings, and 20 sculptures, the Exhibition of Independent Artists was a large show. In a review for the *New York Evening Mail*, critic Joseph Edgar Chamberlin called it "one of the biggest exhibitions, in various senses, ever seen in New York." Then he picked out *Salome Dancer* as "perhaps the most remarkable work."[27]

Both Henri and Sloan were admirers of another dancer, Isadora Duncan. They were together when Sloan first saw her perform at the Metropolitan Opera House,

in box seats purchased by Mary Fanton Roberts, editor of the *Craftsman*. He recorded his enthusiastic reaction in his diary:

It's positively splendid! I feel that she dances a symbol of human animal happiness as it should be, free from the unnatural trammels. Not angelic, materialistic— not superhuman but the greatest human love of life. Her great big thighs, her small head, her full solid loins, belly—clean, all clean—she dances away civilization's tainted brain vapors, wholly human and holy—part of God.[28]

The performance in November 1909 was Duncan's second appearance in New York. Her first American tour began in July 1908 with what she termed "a flat failure." Roberts, recognizing the connections between Duncan's emphasis on freedom of expression and the battle cries of the "revolutionary" American artists, determined to bring them together. Duncan broke her contract for a six-month tour and instead remained in New York City, "dancing every evening for the poets and artists."[29]

When Duncan returned to New York in 1909, Roberts renewed her work to bring the dancer to the audience of artists and writers who would embrace her. Roberts's efforts included hosting a reception where Sloan had the opportunity to meet Duncan, and it may have been because of her urging that Sloan received a pair of tickets on 27 November, "compliments of Isadora Duncan from her manager," to see a second performance.[30]

When Duncan returned for her third New York engagement in 1911, Sloan was eager to see her and, when he did, described the event as "the great thing of the day and the year." Two weeks later, on 2 March, he saw Duncan again and that evening began a painting of her. He worked on it frequently over a period of several days, on one occasion scraping and repainting it. On 14 March he finished: "Made a last grand slam at the Duncan picture and now I like it! It has been a drag and a problem but I think that I have pulled out a good thing."[31]

Sloan's picture shows Duncan alone on stage, with a free-flowing costume, bare feet, and loose hair (cat. 30). Using a relatively spare composition, he presents her as she had appeared to him on "that big simple stage." Like many of his contemporaries, Sloan perceived her as large, in his words, "big as the mother of the race." He endowed her "heavy solid figure" with "large columnar legs," one of them lifted as if to present a thigh to onlookers.[32] She is arrested in the midst of her celebrated natural movement, inspired by classical vase painting, folk dances, and the forces of nature, and the image expresses not only Sloan's admiration for the dancer but also his conviction that Duncan epitomized the emancipated, and sexualized, New Woman.

Sloan's canvas stands as one of the earliest fully fledged painted images that expressly presented Duncan as a symbol of personal liberation. Sloan was particularly fond of the work and showed it at every opportunity, but the brightly colored picture probably appeared as something of an anomaly in his oeuvre in the early 1910s, and it was never the focus of a critical review.[33] A year after it was painted, Floyd Dell, who was extremely interested in the way Western feminism was changing the world, penned an early editorial tribute to Duncan's dancing body, connecting her explicitly to American modernism. Prior to Dell's arrival in New York and his engagement with artists and writers centered in Greenwich Village, his column of 12 July 1912 in the *Friday Literary Review*, a supplement to the *Chicago Review*, included the following:

And what of Miss Duncan—what is her part in the woman's movement? … Here we have an inspiring expression of the spirit which, through the poems of Walt Whitman and the writing of various moderns, has renovated the modern soul and made us see, without any obscene blurring by Puritan spectacles, the goodness of the whole body. This is as much a part of the woman's movement as the demand for a vote (or, rather, it is more central and essential a part); and only by realizing this is it possible to understand that movement.[34]

In 1909 and 1911, Sloan and Henri painted portraits of female dancers that resonated with issues associated with the women's movement as well as the cry for freedom of expression. Both artists continued to portray strong, sexual women. Sloan reserved his most explicitly political images for publication in *The Masses*, where he was instrumental in developing a visual iconography of sorts for depicting the New Woman.[35]

Meanwhile, the public appetite for exotica heightened. In the wake of *Salome*, in particular, audiences flocked to plays and dances that evoked the textures and colors of a mythical East. A generation of American artists found in the Transcendentalists Emerson, Whitman, and Thoreau a frame for nationalizing the spirituality of Eastern cultures. Duncan evoked Whitman when she related dance movements to the eternal rhythm of the spheres. Ruth St. Denis, another of the small number of solo female dancers in the early years of the twentieth century, cultivated an interior space, as Emerson had described. While Duncan used her body to convey a sense of mass and weight, moving in a joyful, childlike harmony, St. Denis seemed to diffuse the mass and weight of her body in a linear flow. She developed a repertoire of highly imaginative and spectacular dances inspired by the arts and religions of Egypt, India, and East Asia. In 1919, Henri created a stunning, life-size portrait of St. Denis (cat. 18). She posed as if performing one of her signature dances, "The Peacock," derived from a tale of Muslim origin in which a cruel and ambitious girl is transformed into a peacock.[36] By the end of the decade, such a portrayal, of a sensuous exotic dancer, would not have raised an eyebrow, in part because it was well understood that in American culture the female body could serve as paradigmatic image of the emancipated, self-reliant woman.

Notes

I am deeply grateful to Michael Marlais, Elizabeth Milroy, and Mary Elizabeth Strunk for their critical readings of this essay.

1. Sarah Burns offers an insightful analysis of Homer's depictions of women, in relation to such contemporary types as the Girl of the Period, in her essay "Winslow Homer's Ambiguously New Woman," in *Off the Pedestal: New Women in the Art of Homer, Chase, and Sargent*, ed. Holly Pyne Connor [exh. cat., The Newark Museum] (Newark, N.J., 2006), 53–90. *Off the Pedestal* is a recent addition to the substantial body of literature devoted to the analysis of visual representations of women. Important publications that I have found useful, in addition to several cited in the notes below, include Linda Nochlin, *Representing Women* (New York, 1999); Kathleen Pyne, *Art and the Higher Life: Painting and Evolutionary Thought in Late Nineteenth-Century America* (Austin, Tex., 1996); Ellen Wiley Todd, *The "New Woman" Revised: Painting and Gender Politics on Fourteenth Street* (Berkeley, Calif., 1993); Martha Banta, *Imaging American Women* (New York, 1987); and Bram Dijkstra, *Idols of Perversity: Fantasies of Feminine Evil in Fin-de-Siècle Culture* (New York, 1986).

2. Samuel Isham, *The History of American Painting* (1905; rev. ed., New York, 1927), 468–71. Isham's observations have been quoted in two useful studies: Ann Uhry Abrams, "Frozen Goddess: The Image of Woman in Turn-of-the-Century American Art," in *Woman's Being, Woman's Place: Female Identity and Vocation in American History*, ed. Mary Kelley (Boston, 1979), 93; and Bailey Van Hook, *Angels of Art: Women and Art in American Society, 1876–1914* (University Park, Pa., 1996), 55–56.

3. Maud C. Cooke, *Social Etiquette, or Manners and Customs of Polite Society* (Chicago, 1890), 358, quoted in Maureen E. Montgomery, *Displaying Women: Spectacles of Leisure in Edith Wharton's New York* (New York, 1998), 7.

4. The body of literature on the Gibson Girl is extensive. I relied here primarily on Lois W. Banner, "The Gibson Girl," chapter 8 in *American Beauty* (Chicago, 1983), 154–74.

5. On William Glackens and James B. Moore, as well as Mouquin's, see Ira Glackens, *William Glackens and the Ashcan Group: The Emergence of Realism in American Art* (New York, 1957), 54–66, and William H. Gerdts, "William Glackens Life and Work," in *William Glackens* [exh. cat., Museum of Art, Fort Lauderdale, Fla.] (New York, 1996), 53–54. Notwithstanding the new information about the suggested identity of Moore's companion in *Chez Mouquin* (see Leeds essay, this volume, p. 27), the figure's pose and expression invite the interpretation that has been associated with the painting since it was first exhibited publicly. Glackens may not have intended to present a portrait of a specific person but rather a suggestive, though ultimately ambiguous, relationship between two individuals, and, most importantly, he aimed to create a magnificent work of art.

6. Vice investigator's report, Weimann's, 11 February 1917, Records of the Committee of Fourteen, Rare Books and Manuscripts Division, New York Public Library, Astor, Lenox and Tilden Foundations, quoted in Kathy Peiss, *Cheap Amusements: Working Women and Leisure in Turn-of-the-Century New York* (Philadelphia, 1986), 98. This excerpt from a waiter's response to a vice investigator who wished to be introduced to available women at an establishment located on St. Nicholas Avenue is recorded in full as follows: "The way women dress today they all look like prostitutes and the waiter can some times get in bad by going over and trying to put someone next to them, they may be respectable women and would jump on the waiter."

7. For the exhibition history of the painting, see Denis Rouart and Daniel Wildenstein, *Edouard Manet: Catalogue raisonné*, vol. 1: *Peintures* (Paris, 1975), 286. For Glackens's interest in Manet's work, see Gerdts 1996, 15.

8. "Art and Artists," *Philadelphia Press*, 9 March 1909, Pennsylvania Academy of the Fine Arts Scrapbooks, microfilm roll no. P54, frame 842, quoted in Judith Zilczer, "The Eight on Tour, 1908–1909," *American Art Journal* 16 (Summer 1984): 33. The comment was made in the context of a review of the exhibition of The Eight on its national tour, when reviewers might have been more inclined to see the "underside" of the painting, which was not noticed when it was on view at the Carnegie Annual.

9. Mrs. Burton Harrison, "The Well-Bred Girl in Society: Fourth Paper—Social Laws at Opera, Theatre, and Public Places," *Ladies Home Journal* 10 (February 1893): 4.

10. Remarks Sloan wrote for the reproduction of the painting in *Gist of Art: Principles and Practice Expounded in the Classroom and Studio, Recorded with the Assistance of Helen Farr* (New York, 1939), 211.

11. Patricia Hills has pointed this out in "John Sloan's Images of Working-Class Women: A Case Study of the Roles and Interrelationships of Politics, Personality, and Patrons in the Development of Sloan's Art, 1905–16," *Prospects* 5 (1920): 157–96. Additionally, Sloan's depictions of women are considered in Janice M. Coco, *John Sloan's Women: A Psychoanalysis of Vision* (Newark, Del., 2004); Laural Weintraub, "Women as Urban Spectators in John Sloan's Early Work," *American Art* 15 (Summer 2001): 72–81; Robert W. Snyder and Rebecca Zurier, "Picturing the City," in *Metropolitan Lives: The Ashcan Artists and Their New York* [exh. cat., National Museum of American Art] (Washington, D.C., 1995), 130–89; and Suzanne L. Kinser, "Prostitutes in the Art of John Sloan," *Prospects* 9 (1984): 231–54.

12. Charles Wisner Barrell, "The Real Drama of the Slums, as Told in John Sloan's Etchings," *Craftsman* 15 (February 1909): 559–64. Barrell first contacted Sloan in July 1907 to talk about writing an article, but the *Art Studio* decided not to publish it. See Sloan's diary, *John Sloan's New York Scene from the Diaries, Notes, and Correspondence*, ed. Bruce St. John (New York, 1965), 142–43, 160 (15, 22, 23 July and 11, 12 October).

13. *The Matador* (1906; Henri Estate, LeClair Family Collection) and *Spanish Gypsy and Child* (1906; Robert Henri Estate, LeClair Family Collection) were reproduced in Samuel Swift, "Revolutionary Figures in American Art," *Harper's Weekly* 51 (13 April 1907): 535.

14. "New York's Art War and the Eight 'Rebels,'" *New York World Magazine* (2 February 1908).

15. See Holly Edwards, *Noble Dreams, Wicked Pleasures: Orientalism in America, 1870–1930* [exh. cat., Sterling and Francine Clark Art Institute, Williamstown, Mass.] (Princeton, N.J., 2000).

16. James Gibbons Huneker, "Eight Painters—First Article," *New York Sun*, 9 February 1908, 8.

17. Katharine Metcalf Roof, "Salomé—The Play and the Opera," *Craftsman* 11 (February 1907): 523, 524. Previous writers, especially Gustave Flaubert and Joris-Karl Huysmans, had evoked a sensuous Salome while retaining the essential power relations of the original story. For the biblical account, see Matt. 14 and Mark 6.

18. Richard Strauss, *Recollections and Reflections*, ed. Willi Schuhm (London, 1949), 154, quoted in Toni Bentley, *Sisters of Salome* (New Haven, Conn., 2002), 36.

19. Roof 1907: 528.

20. "The Vulgarization of Salome," *Current Literature* (October 1908): 440, quoted in Susan A. Glenn, *Female Spectacle: The Theatrical Roots of Modern Feminism* (Cambridge, Mass., 2000), 96.

21. Oscar Hammerstein, who had both contributed to and benefited from Salomania, staged the production at the Manhattan Opera House. He gave the lead role to Mary Garden, a beautiful operatic voice and the first singer also to perform the dance. After a Saturday evening performance, Henri's wife reported: "Mary Garden is certainly it, and the Boss takes back everything he has ever said against her, either as an actress or singer. She's a wonder he says." Letter from Marjorie Henri to Dolly Sloan, 23 February 1909, quoted in *Revolutionaries of Realism: The Letters of John Sloan and Robert Henri*, ed. Bennard B. Perlman (Princeton, N.J., 1997), 191.

22. Henri to his parents, 23 September 1906, Henri Papers, Beinecke Rare Book and Manuscript Library, Yale University, New Haven, Conn., quoted in Valerie Ann Leeds, *"My People": The Portraits of Robert Henri* [exh. cat., Orlando Museum of Art, Fla.] (Orlando, 1994), 24.

23. Henri to his parents, 23 September 1906, quoted in Leeds 1994, 24. Michael Marlais has characterized the portrait as an "artistic collaboration" in "Robert Henri: La Reina Mora," *American Art Review* 5 (Fall 1993): 84–85, 159.

24. *Women in American Theatre*, ed. Helen Krich Chinoy and Linda Walsh Jenkins (New York, 1987), especially Claudia D. Johnson, "Enter the Harlot," 66–74.

25. Sloan's diary, 24 February and 9 March 1910, St. John 1965, 391, 395–96.

26. Guy Pène du Bois, "Exhibition by Independent Artists Attracts Immense Throngs," *New York American*, 4 April 1910.

27. Joseph Edgar Chamberlin, "With the Independent Artists," *New York Evening Mail*, 4 April 1910, 6.

28. St. John 1965, 352 (16 November 1909).

29. Isadora Duncan, *My Life* (New York, 1927), 219.

30. St. John 1965, 355 (27 November 1909).

31. St. John 1965, 507 (15 February 1911), 516 (14 March 1911).

32. St. John 1965, 507.

33. In a group show at the MacDowell Club that opened on 24 January 1912, Sloan had seven paintings. In his diary (St. John 1965, 597), he listed all seven, beginning with the painting of Isadora Duncan. His first one-person show came in 1916, and he took pains to be certain that his picture of Duncan would be included. See John Loughery, *John Sloan: Painter and Rebel* (New York, 1995), 214.

34. Reprinted in *Floyd Dell: Essays from the Friday Literary Review, 1909–1913*, ed. R. Craig Sautter (Highland Park, Ill., 1995), 146–47. Dell published a slightly revised version of the editorial in *Women as World Builders: Studies in Modern Feminism* (Chicago, 1913), 41–51. Prior to Dell's informed analysis in the *Friday Literary Review*, there was considerable discussion of Duncan in the American press, primarily descriptions, interviews with the dancer, and both positive and negative criticism. For a study of the meanings of Duncan's dancing for American audiences, see Ann Daly, *Done into Dance: Isadora Duncan in America* (Bloomington, Ind., 1995).

35. See Rebecca Zurier, *Art for The Masses: A Radical Magazine and Its Graphics, 1911–1917* (Philadelphia, 1988), esp. 99–101, 145–54.

36. Henri described the painting in a letter: "I am painting a portrait of Ruth St. Denis, the great dancer. Have had three sittings and am to have 3 more next week—it's a big piece of work getting on very well so far. She is in her dance of the 'Peacock.' The story is Egyptian princess very proud, etc. whose spirit is confined in a peacock. It is a very wonderful dance and she is very beautiful in it. Costume is naturally in the character and colors of peacock." Henri to his mother, 15 February 1919, Henri Papers, Beinecke Rare Book and Manuscript Library, Yale University, New Haven, Conn., quoted in Leeds 1994, 38. On Orientalism and dance, see Suzanne Shelton, *Divine Dancer: A Biography of Ruth St. Denis* (Garden City, N.Y., 1981), 89–102.

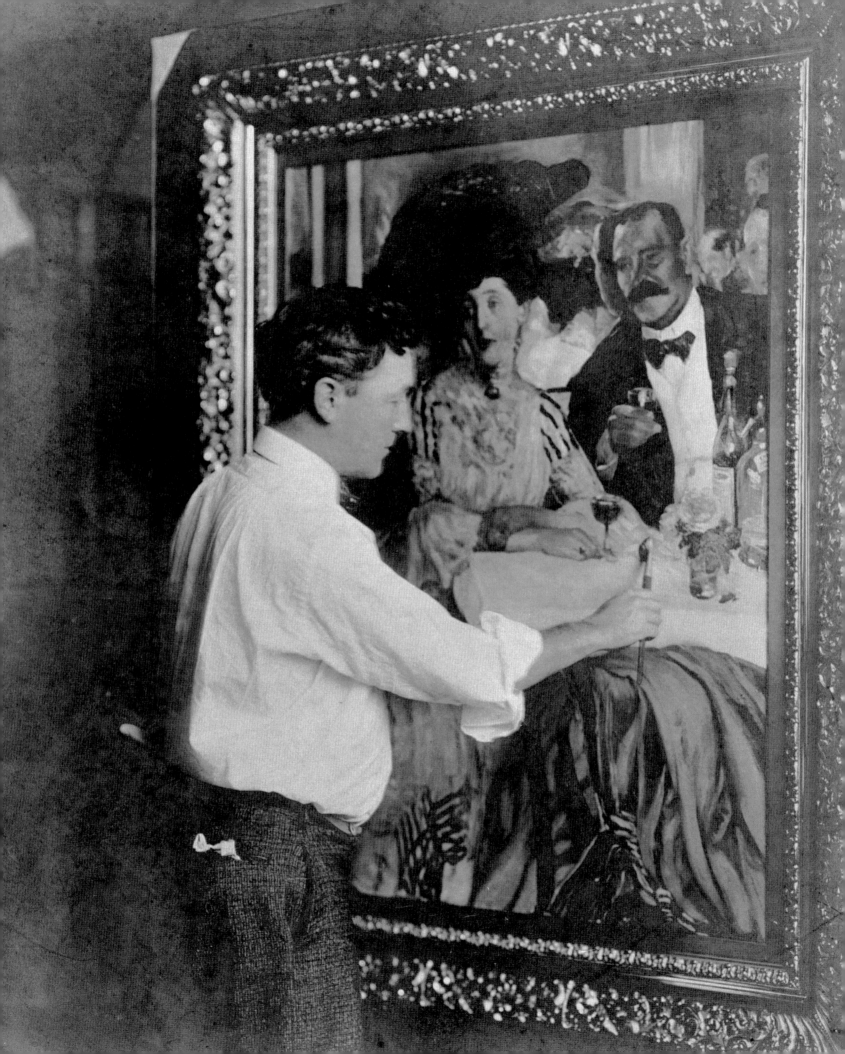

Embracing Realism: Frames of the Ashcan Painters, 1895–1925

Suzanne Smeaton

An exploration of frames for paintings of the Ashcan artists yields one certain truth: there is no definitive Ashcan frame. But certain frame styles that were popular during the years the Ashcan artists were active are especially well suited to their artworks.

Most often, frames that best complement Ashcan paintings employ decorative elements that are stronger and more sculptural, as well as more diffused and less articulated, than those on earlier frames. These elements are frequently characterized by a use of surface treatments other than traditional gold leaf, such as metal or silver leaf. Further, several Ashcan painters designed or even made their own frames, and while not every artist used one particular frame style throughout his career, several styles emerge as characteristic of a particular artist at a particular time.

Although it may be tempting to think of the Ashcan artists as a homogeneous circle, they were, in fact, a group of painters who exhibited diverse artistic styles. The unifying factor was an attitude rather than an artistic style, a commitment to independence from the staid academic system that had played such a defining role in American art until the turn of the twentieth century. Styles ranged from Robert Henri paintings that referenced such Spanish masters as Velázquez and the dark colors of the Old Masters, to the feathery brushstrokes of William Glackens's colorful depictions inspired by French impressionist Pierre-Auguste Renoir.

The ideas and imagery of the Ashcan school were but one facet of a dynamic period in American art, just as the frames associated with these artists include a range of styles that embody and reflect the profound changes occurring not only in art but also across many disciplines, including furniture, decorative arts, and architecture. Frames in use at that time include those closely derived from historical European models, artist-designed frames crafted by hand in striking new forms and finishes, and more generic versions of artist-designed frames synthesized and widely marketed by frame companies in large volume.

Amid this remarkable variety, however, several themes in American frame design can be gleaned. The

Fig. I. Nineteenth-century American frame with composition ornament

most significant are the return, after more than a century, to hand-carved frames, the eschewing of excessively decorative embellishment, the simplification of frame profiles, and the manipulation of gilded surface treatments to further support and enhance the art.

Unlike hand-carved frames of previous centuries, nineteenth-century frames in Europe and America were meticulously constructed of a complex wooden foundation adorned with molded and applied ornament, known as composition or "compo," made of chalk, hide glue, linseed oil, and resin. These frames were created not in great number but one at a time, with the ornament thoughtfully placed so that decorative patterns resolved at the corners and the overall design exhibited a sense of deliberate choice and careful craftsmanship (fig. 1).

By the late nineteenth century, America's industrial revolution had spawned the mass production of frames. Several-foot lengths of molding were made in large quantity by pressing ornament by machine and affixing it to the wooden surface of each length, and each piece was joined without concern for careful arrangement. This caused one critic to lament: "Nothing shows the hasty and inartistic character of framing as the fact that it has grown into an enormous trade—where so little work or labor is expended in framing a picture, that the operation can be knocked off in a few minutes almost 'while you wait.' The length of molding is rudely sawn up in a few minutes, a dab of glue, a few tacks… and the job is done."[1]

At about the same time that mass-produced frames proliferated, older European frames inspired modern-day variants.[2] Nineteenth-century reproductions of seventeenth- and eighteenth-century French examples were especially popular. Although some were faithful to the original, others were loose interpretations.

In a studio photograph of Henri and Glackens, dating from about 1905, several such frames are visible (fig. 2). Based on French Louis XIV frames, the frames in the photograph have projecting corner and center cartouches and a floral pattern over the entire surface. In another photograph, dated about 1908, *Chez Mouquin* is shown in

Fig. 2. Studio shot of Robert Henri (left) and William Glackens, ca. 1905. Courtesy of the Museum of Art, Fort Lauderdale, Florida, Glackens Archives

Fig. 3. William Glackens in his studio, with *Chez Mouquin*, ca. 1908. Courtesy of the Museum of Art, Fort Lauderdale, Florida, Glackens Archives

Glackens's studio in a reproduction Louis XIII-style frame, characterized by a convex round profile decorated with flowers and strapwork and acanthus-leaf corners (fig. 3).[3]

French Revival-style frames were especially favored by American impressionist painters, who had seen similar frames on the works of their French counterparts. Ironically, this was not the style favored by the French impressionists,[4] but rather a choice made by such dealers as Paul Durand-Ruel.[5] Decades earlier, Durand-Ruel had marketed the new and unfamiliar style of impressionist paintings by putting them in a context with which his clientele was familiar: elaborate Louis XIV- and Louis XVI-style frames that held works by such artists as Fragonard and Boucher. This practice persists today on both French and American impressionist paintings.

By the time Ashcan artist John Sloan sold his first painting to collector Albert C. Barnes, in 1913, some French-style frames only alluded to the meticulously carved and patterned frames that had inspired them. The frame on Sloan's *Nude with Green Scarf* (fig. 4) retains the characteristic corners and midpoints of a Louis XIV frame, but they are contained within the boundaries of the profile rather than projecting beyond the edges, and the richly patterned surface of floral carving on the original is eliminated almost entirely, with the only decorative passages remaining near the innermost (or sight) edges and back edges.

The most significant development in American frame design—the return to hand-carved frames—emerged from Boston at the turn of the century and is closely linked to the Arts and Crafts movement.[6] Originating in England, this movement advocated "aesthetic and social reform, in reaction to the decline in craftsmanship and the dehumanization of labor which accompanied the Industrial Revolution."[7] At the vanguard of this change in frame-making was Charles Prendergast, brother of Maurice, noted artist and member of the Ashcan group.

Frames by Charles Prendergast can be found not only on paintings by his brother, but also on those by Ashcan artists Glackens, Arthur B. Davies, Ernest Lawson, and Guy Pène du Bois.[8] Encouraged by Maurice, Charles Prendergast

Fig. 4. John Sloan, *Nude with Green Scarf*, 1913, oil on canvas. The Barnes Foundation, Merion, Pennsylvania

Fig. 5. Frame attributed to Charles Prendergast surrounding Arthur B. Davies, *Dancing Children* (1902; Brooklyn Museum, New York)

began making frames and benefited from his brother's connections with many artist friends.[9] In fact, both Maurice and Charles made frames. Prendergast scholar Nancy Mowll Mathews writes: "Since Charles needed to devote as much time as possible to frames for paying clients, it is likely that Maurice made the frames for his own paintings, or exchanged time helping Charles with outside commissions for Charles' help with the occasional special frame. As a rule, Maurice charged for the frame when he sold a painting, and thus the brothers were paid for their labors."[10]

Regrettably, the frames by both Maurice and Charles are seldom signed, making specific attribution especially difficult (fig. 5). Many of Maurice Prendergast's frames refer to historical forms. Those clearly traced to Charles exhibit a decidedly hand-wrought appearance, with the attendant irregularities of a freely worked surface (fig. 6);[11] later frames incorporate incised surface decoration and the use of silver leaf, anticipating a chapter in his career when he made screens and boxes with incised, painted, and gilded decoration.[12]

After visiting the Prendergasts' Boston studio in the winter of 1908–9, artist Marsden Hartley said, "I got to know Maurice and Charles Prendergast.... I ... remember this place on Mount Vernon Street—a frame shop really—where Charles made his frames and Maurice painted in one corner. There always was this sense of fluttering gold in the air of that room."[13]

At the time that Charles Prendergast began his frame-making career, another Boston artist, Hermann Dudley

Fig. 6. Charles Prendergast frame surrounding Arthur B. Davies, *Air, Light, Wave* (ca. 1914–17; High Museum of Art, Atlanta, Georgia)

Fig. 7. Example of a Carrig-Rohane *cassetta* frame, 1903

frames. Much has been written about the influence of James McNeill Whistler on Murphy;[16] both artists explored frame design in depth. When Murphy built his first home in Winchester, Massachusetts, he named it Carrig-Rohane, Gaelic for red cliff, a nod to his Celtic roots. Murphy and Charles Prendergast worked together for a time, creating the Carrig-Rohane frame business in 1903, although it does not appear that Prendergast remained an active participant much beyond this first year.[17] Murphy set up the frame shop in his basement and retained the name as the business prospered and moved into its own space in 1905. In addition to the transformative *cassetta*, the Carrig-Rohane shop offered a wide range of frames.

Most significantly, many framemakers quickly adopted and reinterpreted Murphy's *cassetta* form in variations in the ensuing years. The Royal Art Company of New York and the Newcomb-Macklin Company of Chicago and New York are just two companies that made near duplicates of Murphy's original design over the next two decades. They also made many variants, all characterized by simple compositions, no applied ornament, and decoration contained most often to the corners.

In 1906, an in-depth article appeared in the *International Studio* discussing the reform in picture-framing. The author reviewed a recent exhibition of frames for mirrors and pictures held at the Society of Arts and Crafts, Boston, and illustrated his article with several frames of Murphy's design. He remarked on the success of both Murphy and Prendergast among artists of Boston, New York, and other cities.[18]

The continued appeal of both Prendergast and Murphy is again evident in 1909, as reported in a review for *American Art News*: "The reform in picture framing now very apparent in most general exhibitions, undoubtedly started in Boston … and it is probably no exaggeration to say that at no time and in no place since the degradation of the frame in the middle nineteenth century have so good frames been designed and executed, as in the New England capital in the past two or three years."[19]

Although the Prendergast brothers did not move to New York until 1914, Charles's skill as a framemaker was

Murphy, was also beginning to make frames and would introduce a design that radically transformed American styles for several decades. Murphy's revolutionary contribution was his interpretation of the seventeenth-century Venetian *cassetta* frame. *Cassetta* ("little box" in Italian) is a reference to its profile or shape: a flat panel embraced by raised inner and outer moldings (fig. 7). With its wide, flat frieze and carved corner decorations, Murphy's *cassetta* frame became extremely popular among many American artists, providing a sensitive foil for paintings executed by both impressionist and Ashcan artists that employed innovative styles of brushwork using new palettes of color.[14]

Initially, Murphy painted tonalist works and studied at the Académie Julian in Paris in the early 1890s.[15] On his return to Boston in 1895, he began designing and making

well known in the city prior to that time. In 1912, noted collector John Quinn wrote to Maurice: "I wondered whether your brother was coming to New York … I have about a dozen pictures that I should like to consider the frames of with him. I want good frames on them and Kuhn tells me that your brother is the best man on hand-made frames that we have."[20] Walt Kuhn, an Ashcan artist known for his depictions of circus performers and clowns, was a principal figure in the organization of the Armory Show in 1913 and made frames for a number of his own works, most of which date from the late 1920s onward.[21] Prendergast was also engaged to make many frames for Barnes. Many paintings in Barnes Foundation's collection in Merion, Pennsylvania, are surrounded by carved, incised, and gilded Prendergast frames, and the correspondence between Barnes and Prendergast is well documented.[22]

When the Prendergast brothers moved to New York, the relocation was financed by a commission to carve frames for the portraits of eighteen of the past presidents of a Philadelphia insurance company.[23] The move to New York deepened the sense of camaraderie the brothers enjoyed with their fellow artists, the Ashcan painters in particular. Charles Prendergast recalled: "We'd visit our friends in their studios, and they'd visit in ours, and almost every night we'd all go out to dinner somewhere…. I suppose we liked Mouquin's the best of all. That was a real Paris place. I can't even count the times we had dinner there with our friends—Henri, Sloan, Glackens, Lawson, Luks, Shinn, Davies and lots of others."[24]

Turn-of-the-century innovations in frames originating in Boston were not confined to the shape and style of frames. Artists and framemakers were focusing increased attention on the subtleties of the gilded surface. A technical manual written for Renaissance artists in about 1400 by Cennino Cennini—*The Book of Art*—was translated into English in 1899[25] and was widely read by artists of the day.[26] The book contains extensive instructions on gilding methods and materials, and it certainly played a role in the heightened attention of artists and framemakers to the final surface

treatment of gilded frames. Many were specifically toned and finished to amplify and complement the works they enclosed. Frame orders in the Carrig-Rohane order books, for example, regularly specify what type and karat of gold leaf was used, and frequently include notes on finishes—"French No. 2," "Old Gold toned for green background," "Pale gold for silvery picture," and "Old Gold well rubbed."[27] Charles Prendergast's notes similarly include recipes for finishes, including black surfaces.[28]

The Newcomb-Macklin Company used metal leaf extensively in its frames during the early decades of the twentieth century. Metal leaf, also known as Dutch metal,

AMERICAN DESIGNS

Fig. 8. Page from the Newcomb-Macklin catalogue, late 1800s–early 1900s

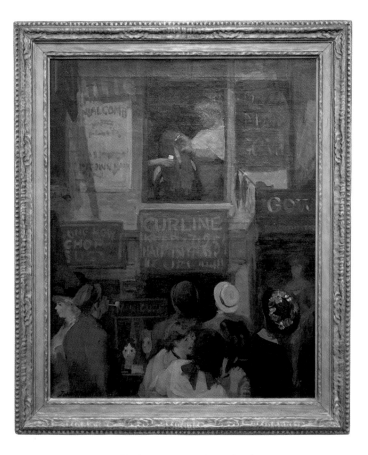

Fig. 9. Newcomb-Macklin frame surrounding John Sloan, *Hairdresser's Window* (1907; Wadsworth Atheneum Museum of Art, Hartford, Connecticut)

is an alloy of copper, tin, and zinc, and is less expensive than gold leaf.[29] It is coarser than gold leaf, with a texture visible to the eye. Metal leaf also darkens and turns more coppery with age, unlike gold leaf, which remains constant.

Although a desire for economy may have driven the choice of metal leaf for frames during the early years of the twentieth century, the material is particularly well suited to the dark palettes employed by many of the Ashcan artists, whose paintings are best complemented by the warm hues that the leaf offers. Alternatives to traditional gold leaf and metal leaf included silver leaf and bronze powder. Detailed instructions for working with all these materials were given in 1909 in a book entitled *The Art and Science of Gilding.*[30]

The Newcomb-Macklin Company originated in Chicago in 1883 and introduced a wide array of variants to Murphy's *cassetta* designs (fig. 8).[31] In addition to one-of-a-kind pieces, Newcomb-Macklin offered an extensive range of frames available in standard sizes and finishes that were commonly gilded with metal leaf. After using a force of traveling salesmen to reach artists in the Northeast, Newcomb-Macklin established an office–showroom at 233 Fifth Avenue, at the corner of Twenty-seventh Street, in about 1912. The showroom was run by George McCoy, who also traveled to Boston and Pennsylvania to sell Newcomb-Macklin frames. McCoy is known to have worked closely with artists to design frames for their works.[32] Among the Ashcan artists known to have used Newcomb-Macklin frames are Henri, Bellows, and Sloan (fig. 9).

Three styles in particular appear frequently on paintings by Henri, Bellows, and Sloan and are worth exploring. It is difficult to pinpoint the first appearance of a distinctive frame by the Milch brothers partnership, now known as a Henri frame.[33] Based on Spanish baroque examples of the seventeenth century, this type is characterized by an energetic, sculptural carving usually confined to foliate motifs at the corners and centers of the frame (fig. 10). The style "encapsulates … important elements of baroque form— theatricality, the manipulation of light and shade, the use of curving lines, the voluptuous explosion of ornament and the preference for organic rather than geometric motifs."[34]

The Milch design recalls Spanish baroque frames, with robust ornament situated at the centers and corners and an overall decorative exuberance. The strong overlapping half-round pattern at the sight edge further echoes the stylized leaf elements of the Spanish precedent. Unlike the Spanish antecedent, however, the Milch interpretation employs a cove profile, and the decorative elements are more abstracted motifs that merely allude to the foliate rather than render it precisely. The boldly articulated motifs provide a harmonious complement to the loose brushwork typical of Henri. In spite of its name, the so-called Henri frame can also be found on works by Sloan and Bellows. It is likely that this was the frame to which Henri was referring when writing to Albert Milch from La Jolla, California, in September 1914:

> Will you please make two frames … same design and finish as preceding frames you made for me. Please give the finish your personal attention … also that the design be not too heavy at the corners or centers. (On some of the smaller frames of my last order the corners and centers were made much larger than those of the first order.) If not too much trouble you might see the frame that is on my "Spanish Gipsy" which is at the Metropolitan Museum and follow its proportions in design.[35]

The partnership between Austrian immigrant brothers Edward and Albert Milch was formed in 1916, when they were incorporated as E. and A. Milch. Both had been engaged in frames prior to their partnership. Edward was listed as a gilder in the New York directory of 1894, the year he and his brother came to the city; by 1898, he is listed as a framer.[36] From 1911 to 1916 he operated the Edward Milch Gallery, offering prints and framing services. His younger brother Albert is first listed in the city directories in 1907 as a framemaker, and when the partnership was formed, Albert continued to offer framing services.[37]

Of note is a related Milch frame that appears on two paintings by John Sloan: *Pigeons* (1910; Museum of Fine

Fig. 10. Example of a seventeenth-century Spanish frame

Arts, Boston) and *McSorley's Bar* (cat. 12). More in keeping with simpler early twentieth-century frames, this frame has a convex, rounded outer rail, a central panel relieved by a shallow hollow on each side, and the same overlapping half-round at the sight edge. This distinctive motif suggests the frame is also by Milch.

An important relationship between frame and painting is that the forms and decorative elements of the frame can serve to echo and reinforce elements of the composition it surrounds. A similar dynamic is achieved when the tonality of the gilded surface serves to enhance the palette of the artwork. Further correspondence between Henri and Milch offers a fascinating glimpse into Henri's attention to this subtlety.

Writing in July 1915 from Ogunquit, Maine, Henri requests that Milch use metal leaf on the frames:

I am so very much pleased with the … frame wh [*sic*] you bill as 4075 metal that I wish to make the following change in my order if it is still possible—that is if you have not all the wood carved frames underway. To finish those of the wood carved frames now underway and make the rest of this 4075 metal. This will give me more variety and will reduce my bill considerably wh [*sic*] will be best in these doubtful times.[38]

Although this passage implies that Henri's choice of metal leaf was dictated by thrift, it is also evident that he was much concerned with the final finishes on his frames. Writing from Santa Fe in November 1917, he stated:

I want to tone down the frame that is here in the new museum. The one you made and sent here last year. For the walls here it is too red and rather too bright. Will you give me directions how to tone it down what to use etc. You will remember that it is a gold frame … I think it should be given a dry effect and more gray brown, deeper tone.[39]

The so-called Bellows frame is a modern-day variant of the reeded moldings popularized by the British Pre-Raphaelites and James McNeill Whistler.[40] The molding style was first developed by British artists Dante Gabriel Rossetti and Ford Madox Brown in the 1860s; shortly thereafter, Whistler adopted and further expanded on the reeded moldings for his own paintings.[41] Reeded molding became popular in America in the 1890s and 1900s, and a number of variations were available (fig. 11).[42]

In the Bellows frame, the reeded form of repeating parallel lines is carved in undulant, uneven strokes that are more exaggerated in size than conventional reeded moldings. There are no additional embellishments, and the progression of parallel passages also vary in width and incorporate a soft curve as the frame slopes in toward the sight edge. The wavy, uneven rendering of the successive reeds reveals the pleasing irregularities of a hand-carved frame. The lush, exaggerated attributes of the frame provide a consonant setting for Bellows's fully loaded brushstrokes and strong rendering of form. This frame style, usually identified only with Bellows, also surrounds several portraits by Henri, including *Dorita* (1923; Le Clair Family Collection), *Portrait of Marcia Anne M. Tucker* (1926; private collection), and *Viv Reclining (Nude)* (1916; LeClair Family Collection).

The Bellows frame can be attributed to framemaker Maurice Grieve, since many of the frames examined bear his stamp on the back. Grieve came from a long line of woodcarvers,[43] and his company is known to have worked with the illustrious art dealer Joseph Duveen. Through that association he made many frames, among them the frame for Thomas Gainsborough's *Blue Boy* (1770; The Huntington Library, Art Collections, and Botanical Gardens, San Marino, California), which belonged to Henry Huntington.[44] Opened in New York in 1906, the Grieve workshop carved ceilings, house paneling, and doorways as well as frames. Frames marked by the Grieve imprint display a wide range of styles, from traditional to modern. The Grieve frame is found on many of Bellows's paintings, such as *Club Night* (cat. 34), *Polo at Lakewood* (cat. 35), and the "War" series of 1918.

The third "name frame" style—also by Milch— appears on several Henri images and is based on the frames

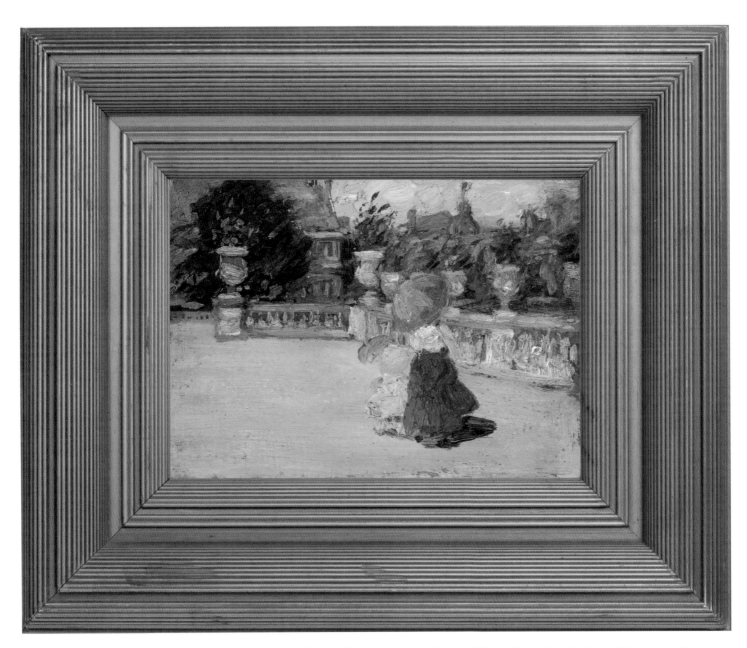

Fig. 11. Reeded frame surrounding George Luks, *Luxembourg Gardens, Paris No. 3* (1902; Munson-Williams-Proctor Arts Institute, Utica, New York)

Fig. 12. Detail of an eighteenth-century Canaletto frame

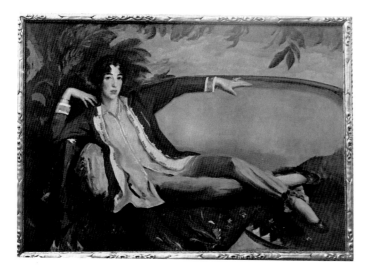

Fig. 13. Robert Henri, *Gertrude Vanderbilt Whitney* (1916; Whitney Museum of American Art, New York). Frame ca. 1916, Peter A. Juley and Son Collection, Smithsonian American Art Museum, Washington, D.C.

frequently used to enclose the dramatic and meticulous depictions of eighteenth-century Venice by Giovanni Antonio Canal, known as Canaletto (fig. 12). The frame is a narrow molding, with undecorated centers and floral patterns carved at the corners that are set into a recess defined by pointed edges. The modern-day Milch version of this frame is on the portrait *Gertrude Vanderbilt Whitney* (fig. 13) and other Henri works such as *Gypsy Mother (Maria y Consuelo)* (1906; LeClair Family Collection). The frames are clearly original to the paintings, since the frame is visible in photos taken of the artworks shortly after their completion.

Among the second generation of Ashcan painters, distinctive frames are found on paintings by Edward Hopper and Rockwell Kent. Along with the frame designs of Walt Kuhn, these are indicative of evolving ideas regarding the role that form and surface treatments play in frames that sensitively complement and amplify the works they surround.

With the wide variety of styles, forms, and surface treatments in use at the turn of the century, and the broad range of artistic styles expressed by the Ashcan painters, we are afforded a fascinating and illuminating glimpse into the many subtle features that constitute the perfect marriage of painting and frame.

Notes

1. Percy Fitzgerald, "Picture Frames," *Art Journal* 12 (1886): 324–28.
2. For an in-depth study on this topic, see Tracy Gill, *The American Frame: From Origin to Originality* (New York, 2003).
3. *Chez Mouquin* (cat. 1) is no longer in its original frame.
4. Eva Mendgen, *In Perfect Harmony: Picture and Frame, 1850–1920* [exh. cat., Van Gogh Museum, Amsterdam] (Zwolle, 1995), 129–80.
5. Nina Gray, "Frame Choices for the French Impressionists," *Picture Framing Magazine* (May 1995): 42–49.
6. Wendy Kaplan, *The Art That is Life: The Arts and Crafts Movement in America, 1875–1920* (New York, 1987).
7. *Inspiring Reform: Boston's Arts and Crafts Movement*, ed. Marilee Boyd Meyer [exh. cat., Davis Museum and Cultural Center, Wellesley College] (Wellesley, Mass., 1997), 14.
8. See, for example, William Glackens, *Woman in Red Dress* (ca. 1918; Pennsylvania Academy of the Fine Arts, Philadelphia) and Guy Pène du Bois, *The Blue Chair* (1923; The Metropolitan Museum of Art, New York).
9. Hamilton Basso, "A Glimpse of Heaven," part 2, *New Yorker* 23 (August 1946): 24–27.
10. Nancy Mowll Mathews, "Beauties … of a Quiet Kind: The Art of Charles Prendergast," in *The Art of Charles Prendergast from the Collections of the Williams College Museum of Art and Mrs. Charles Prendergast* [exh. cat., Williams College Museum of Art] (Williamstown, Mass., 1993), 9–37.
11. Carol Derby, "Charles Prendergast's Frames: Reuniting Design & Craftsmanship," in W. Anthony Gengarelly and Carol Derby, *The Prendergasts and the Arts and Crafts Movement* [exh. cat., Williams College Museum of Art] (Williamstown, Mass., 1989), 37.
12. Marion M. Goethals, "My Work is Done in Gesso the Old Italian Method," in exh. cat. Williamstown 1989, 39–51.
13. Richard J. Wattenmaker, *Maurice Prendergast* (New York, 1994), 12.
14. Susan G. Larkin, "How Hassam Framed Hassams," in *Childe Hassam, American Impressionist* [exh. cat., The Metropolitan Museum of Art] (New York, 2004), 325–42.
15. William A. Coles, "Hermann Dudley Murphy: An Introduction," in *Hermann Dudley Murphy: Boston Painter at Home and Abroad* (New York, 1985), 7–12.
16. Suzanne Smeaton, "On the Edge of Change: Artist-Designed Frames from Whistler to Marin," in *The Gilded Edge*, ed. Eli Wilner (San Francisco, 2000), 61–81.
17. Mathews 1993, 12–13.
18. Frederick W. Coburn, "Individual Treatment of the Picture Frame," *International Studio* 30 (November 1906): 12–16.
19. Anonymous, "Picture Framing Reform," *American Art News* 7, 17 (April 1909): 6.
20. John Quinn (4 August 1913), as quoted in Wattenmaker 1994, 113.
21. See, for example, *The Dressing Room* (1927; Brooklyn Museum) and *Joey* (1943; Detroit Institute of Arts).
22. Violette DeMazia, "What's in a Frame?" *Barnes Foundation Journal of the Art Department* 8, 2 (Autumn 1977): 48–64.
23. Hamilton Basso 1946, n.p.
24. Hamilton Basso 1946, n.p.
25. There have been many translations of the book; Christina Herringham's translation dates from 1899. Erling Skaug, "Cenninianna: Notes on Cennini and His Treatise," *Arte Cristiana* 81, 754 (January–February 1993): 15–22, discusses the date of the treatise.
26. Goethals in exh. cat. Williamstown 1989, 39.
27. Carrig-Rohane Papers, order books 1904–7, Box 1, Archives of American Art, Washington, D.C.
28. Derby 1989, 31.
29. "Dutch metal" is actually a faulty translation of "Deutsch metal," a reference to the German source of some early metal leaf.
30. Ford and Mimmack of Rochester, *The Art and Science of Gilding* (New York, 1909), 39–45.
31. Suzanne Smeaton, *The Art of the Frame: American Frames of the Arts and Crafts Period* (New York, 1988), 61–81.
32. Thanhardt-Burger Archives, LaPorte, Indiana. "Gleanings from a conversation held with Dewey Imig … 13th of December, 1984." (Imig worked for Newcomb-Macklin for several decades, beginning in 1922, and was eighty-six at the time of the interview.)
33. Three of the earliest documented paintings to use this type of frame are all from 1907: *Dutch Soldier*, by Robert Henri (Munson-Williams-Proctor Arts Institute, Utica, N.Y.); *Picture Shop Window*, by John Sloan (The Newark Museum); and *Election Night*, by John Sloan (Memorial Art Gallery, University of Rochester, N.Y.).
34. Paul Mitchell and Lynn Roberts, *Frameworks* (London, 1996), 118.
35. Milch Papers, Reel 4420, frame 861, Archives of American Art, Washington, D.C.
36. New York City Directories 1896–1946.
37. The appearance of this frame design on paintings dating to 1907 implies that the frame was first made for the artists by Albert Milch when he was on his own, and that he continued to make the frame after the partnership was formed with his brother. Milch Papers, Reel 4422, frame 686.
38. Milch Papers, Reel 4420, frame 862.
39. Milch Papers, Reel 4420, frame 871.
40. Ira M. Horowitz, "Whistler's Frames," *Art Journal* 39 (Winter 1979–80): 124–31.
41. Alastair Grieve, "The Applied Art of D.G. Rossetti," *Burlington Magazine* 115 (January 1973): 16–24.
42. Larkin 2004, 35.
43. *New York Times*, 18 February 1955, 23. At the closing of the business in 1955, it was reported that Grieve's ancestors had started business in Bruges, Belgium, 235 years previously and moved subsequently to Edinburgh, then to London, and then to New York in 1906.
44. *New York Times*, 18 February 1955, 23. Other clients included Henry Frick, the Astors, the Vanderbilts, John D. Rockefeller, the Whitneys, and the Knoedlers.

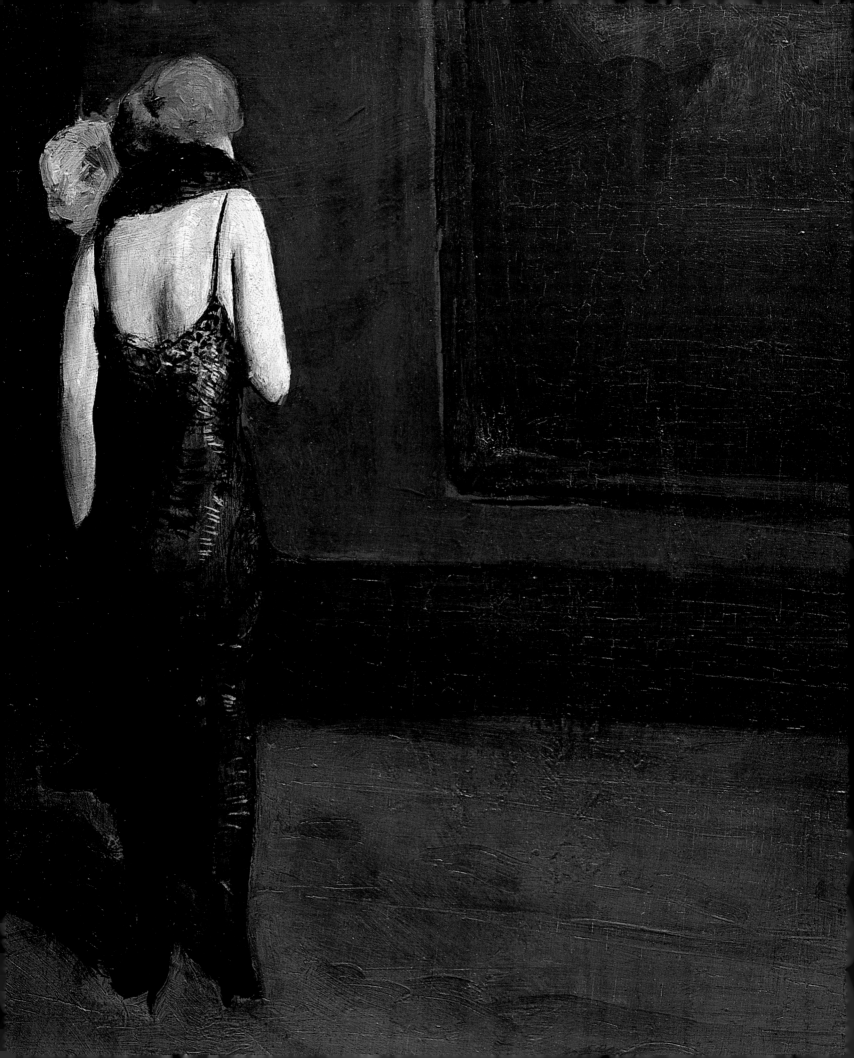

Catalogue of Paintings

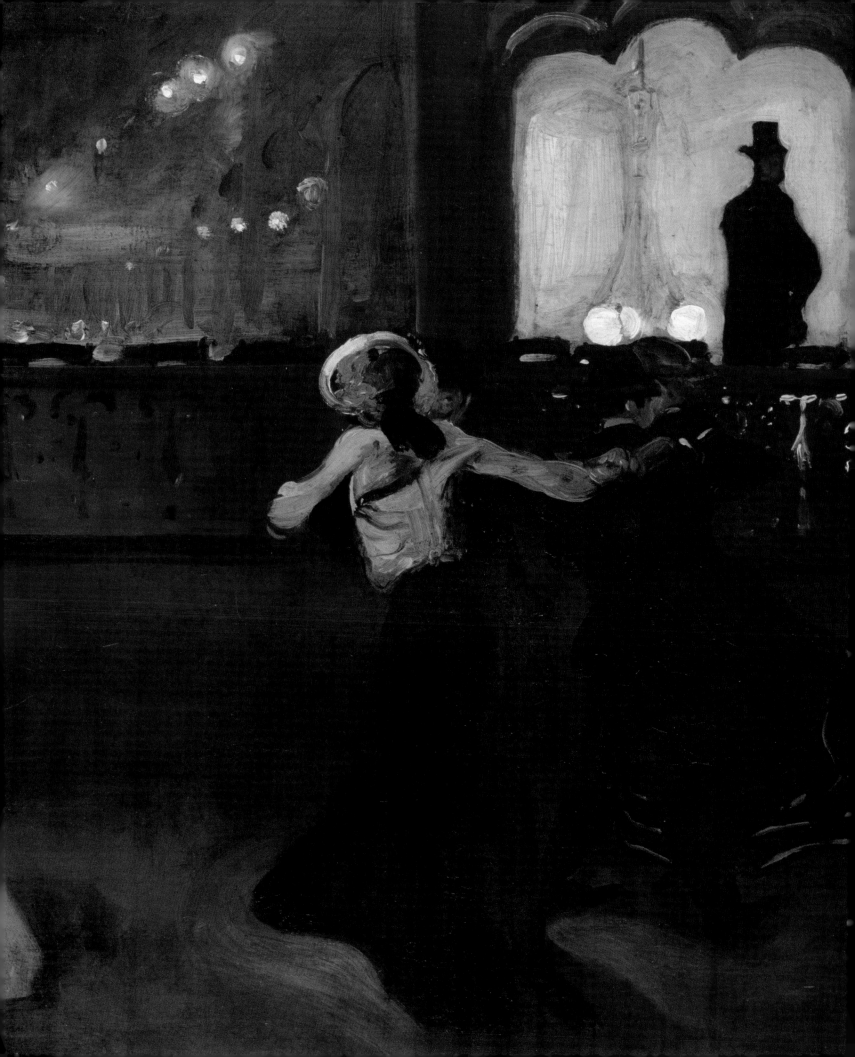

Dining Out

Having a meal or drinks out exemplifies the spirit of leisure. The social aspect of dining out—meeting friends, having drinks, and lingering—was not lost on the Ashcan artists, who frequented the establishments they painted. Such social occasions were often accompanied by lively discussions, presumably covering a myriad of subjects, including art and other themes addressed in these sections. The artists were not just observers of these gatherings, but were participants as well, often joined by other notable personalities.

In John Sloan's *Yeats at Petitpas'* (cat. 11), the artist includes himself (furthest figure to the right) among a group surrounding Irish painter and friend John Butler Yeats (bearded figure to the left). William Glackens is responsible for possibly the most recognizable Ashcan painting depicting café society, *Chez Mouquin* (cat. 1), which includes restaurateur James B. Moore with a young female companion. Captured in the mirror's reflection behind the two figures is the artist's wife, Edith. The introduction of Prohibition in 1920 unfortunately aided in the closure of the establishment and several other favorite Ashcan haunts. Skirting the laws of Prohibition, McSorley's Old Ale House, still at its original location on East Seventh Street, served "near beer" (beer brewed with a low alcohol content) and may have participated in the practice of spiking beer—that is, illegally adding extra alcohol. *McSorley's Bar* (cat. 12) was painted prior to Prohibition, but, ironically, purchased by the Detroit Institute of Arts during it. Sloan wrote to DIA Director

Clyde Burroughs on 15 April 1924, after the painting's sale, stating:

> Nothing but ale was ever sold over this bar…. A place [McSorley's] where the world seems shut out, where there is no time—no turmoil. Had all American saloons been of this kind, no Eighteenth Amendment would now be driving us to "hard liquor." I hope that Detroit will enjoy this record of New York's temperance days. McSorley's Ale House was the temple of temperance.[1]

Sloan captures any given afternoon at the Irish bar, which was located close to his studio and was where members of several different social classes interacted comfortably.

The Henri circle's portrayal of café society extended beyond American shores to European settings, in particular those of Paris. Many members of the circle studied in or visited the inspirational city, capturing its visual delights in their art. Maurice Prendergast offers a splendid glimpse into Parisian café society in *The Band Concert, Luxembourg Gardens* (cat. 10). In it, fashionably dressed men and women enjoy conversation and drinks while listening to music. Alfred Maurer's *Café in Paris* (cat. 5) is cropped in a manner that cuts in half the table on the far right, leaving us to wonder whether the seated woman is alone or accompanied. The fact that the background tables are filled with people presumably enjoying themselves and interacting only intensifies the sense of discomfort that Maurer creates.

Guy Pène du Bois's *Café d'Harcourt* (cat. 8) depicts a grouping of four unoccupied tables arranged diagonally from the foreground to the distance. Next to these tables are two groups of seated customers socializing against the café's illuminated windows. These Parisian canvases complete this section, which presents examples of dining and drinking both at home and abroad.

Note

1. DIA Curatorial Files.

Cat. I
William Glackens
Chez Mouquin, 1905

Oil on canvas
48 × 39 in. (121.9 × 99 cm)
The Art Institute of Chicago, Friends of American Art Collection, 1925.295
(Detroit only)

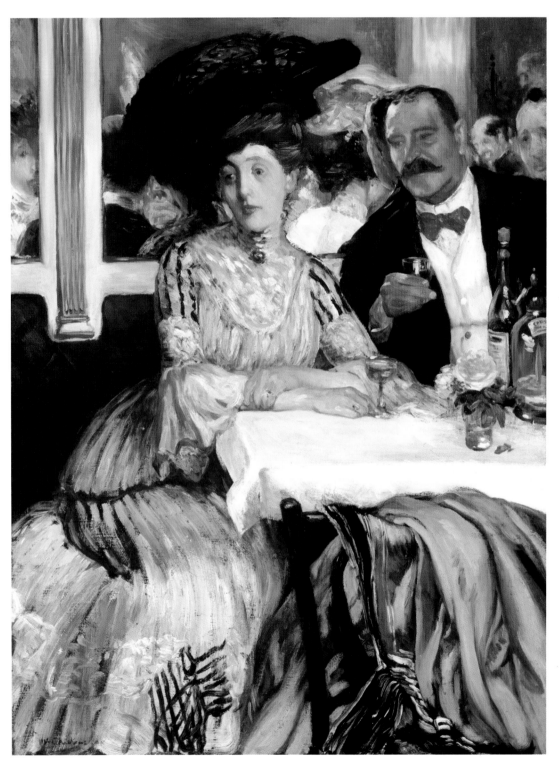

Cat. 2
Charles Webster Hawthorne
The Story (The Diners; Pleasures of the Table), ca. 1898–99

Oil on canvas
48 × 30 in. (121.9 × 76.2 cm)
Hirshhorn Museum and Sculpture Garden, Smithsonian Institution, Washington, D.C.,
Gift of Joseph H. Hirshhorn, 1966 (HMSG 66.2410)

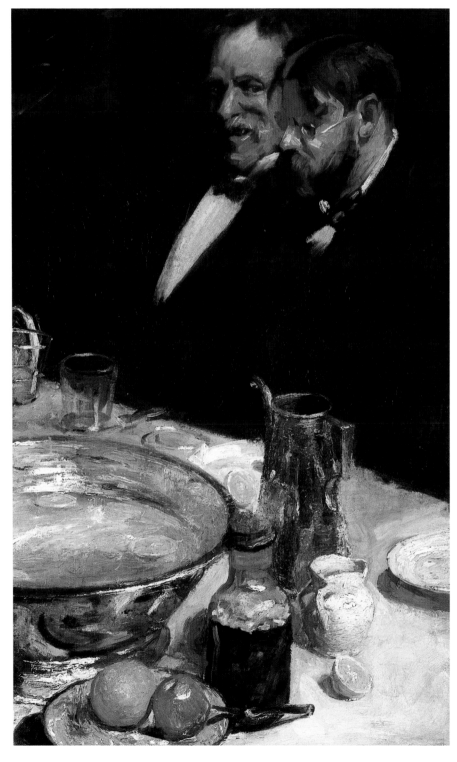

Cat. 3
George Luks
The Café Francis, ca. 1906

Oil on canvas
36 × 42 in. (91.4 × 106.7 cm)
The Butler Institute of American Art, Youngstown, Ohio, Museum Purchase

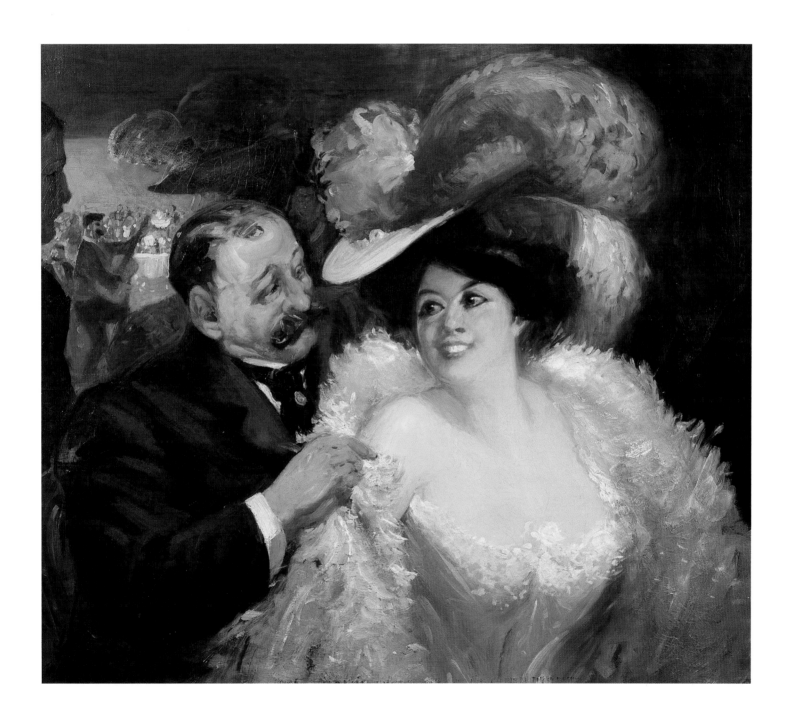

Cat. 4
George Luks
Pedro, ca. 1920

Oil on canvas
52³/₈ × 44³/₈ in. (133 × 113 cm)
Los Angeles County Museum of Art,
Mr. and Mrs. William Preston Harrison Collection

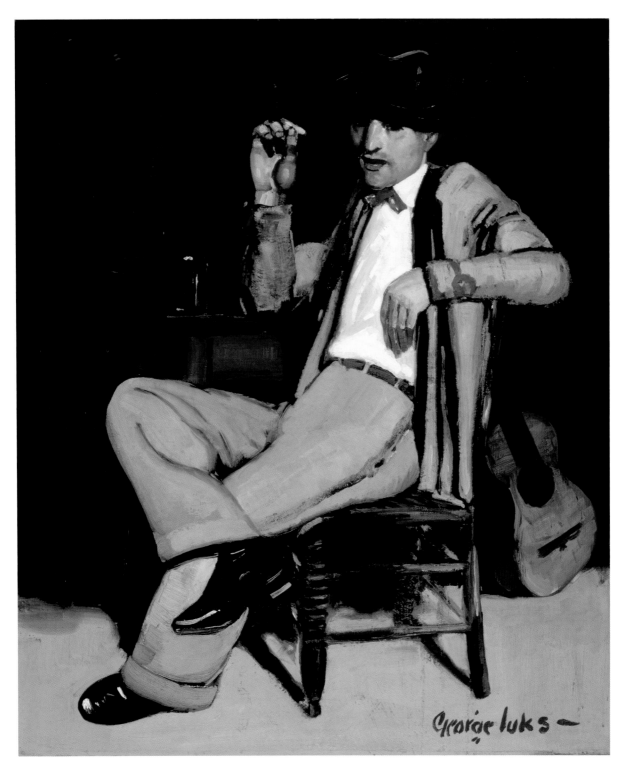

Cat. 5
Alfred Maurer
Café in Paris, ca. 1901

Oil on canvas
23³/₄ × 19¹/₂ in. (60.3 × 49.5 cm)
Hollis Taggart Galleries, New York

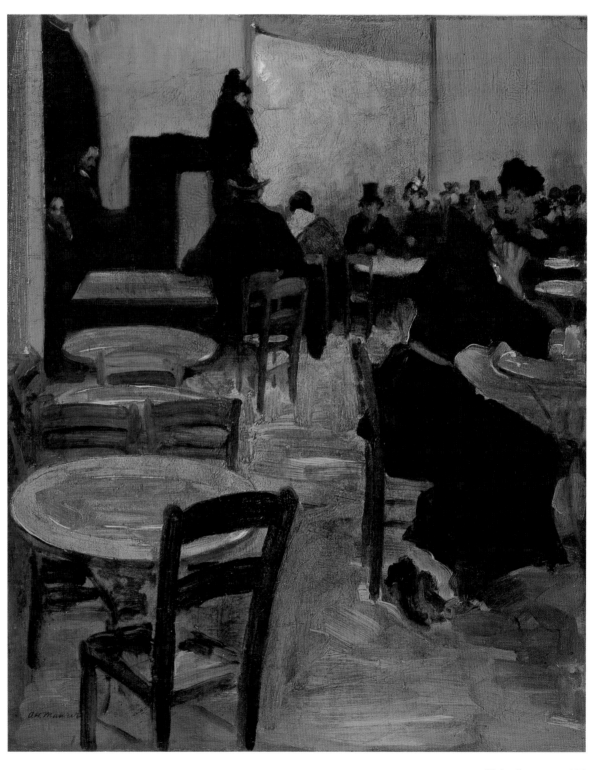

Cat. 6
Alfred Maurer
Le Bal Bullier, ca. 1901–3

Oil on canvas
28½ × 36½ in. (72.4 × 92.7 cm)
Smith College Museum of Art, Northampton, Massachusetts,
SC 1951:283

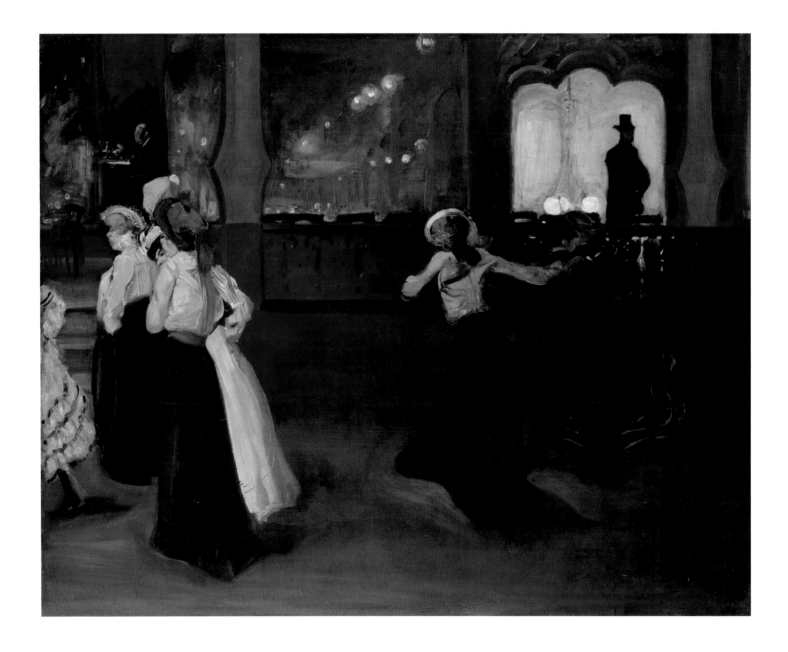

Cat. 7
Guy Pène du Bois
At the Table, 1905
Oil on board
9³/₈ × 12⁷/₈ in. (23.8 × 32.7 cm)
Cohen Collection

Cat. 8
Guy Pène du Bois
Café d'Harcourt, ca. 1905–6
Oil on canvas board
12⁷/₈ × 9³/₈ in. (32.7 × 23.8 cm)
Cohen Collection

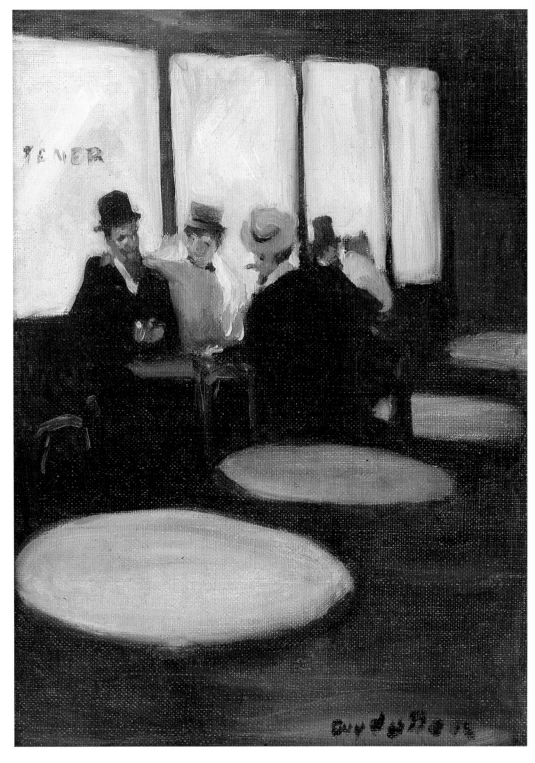

Cat. 9
Guy Pène du Bois
Café Madrid (Portrait of Mr. and Mrs. Chester Dale), 1926

Oil on canvas
27 × 23½ in. (68.6 × 59.7 cm)
Museum of Fine Arts, Saint Petersburg, Florida,
Bequest of John Hinkle 1990.8

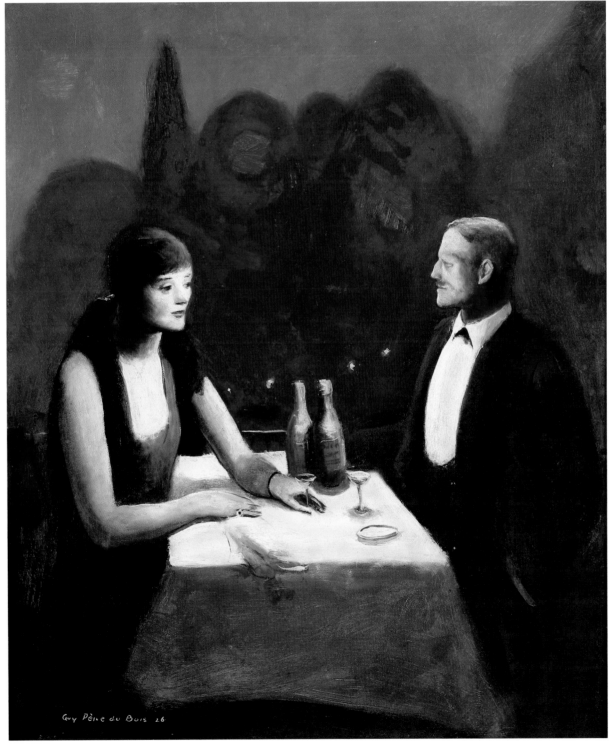

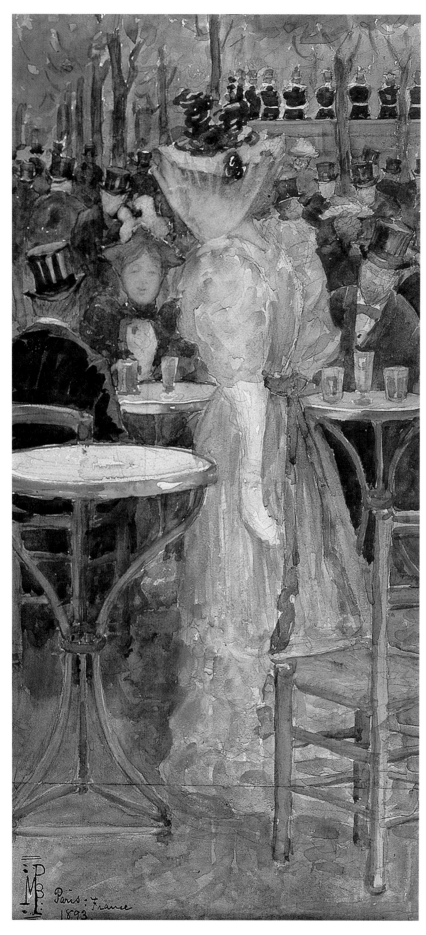

Cat. 10

Maurice Prendergast

The Band Concert, Luxembourg Gardens, 1893

Watercolor and pencil on paper
16 × 7³/₄ in. (40.6 × 19.7 cm)
Ambassador and Mrs. Ronald Weiser

Cat. 11
John Sloan
Yeats at Petitpas', 1910

Oil on canvas
26³/₈ × 32¹/₄ in. (67 × 81.9 cm)
Corcoran Gallery of Art, Washington, D.C.,
Museum Purchase, Gallery Fund (32.9)

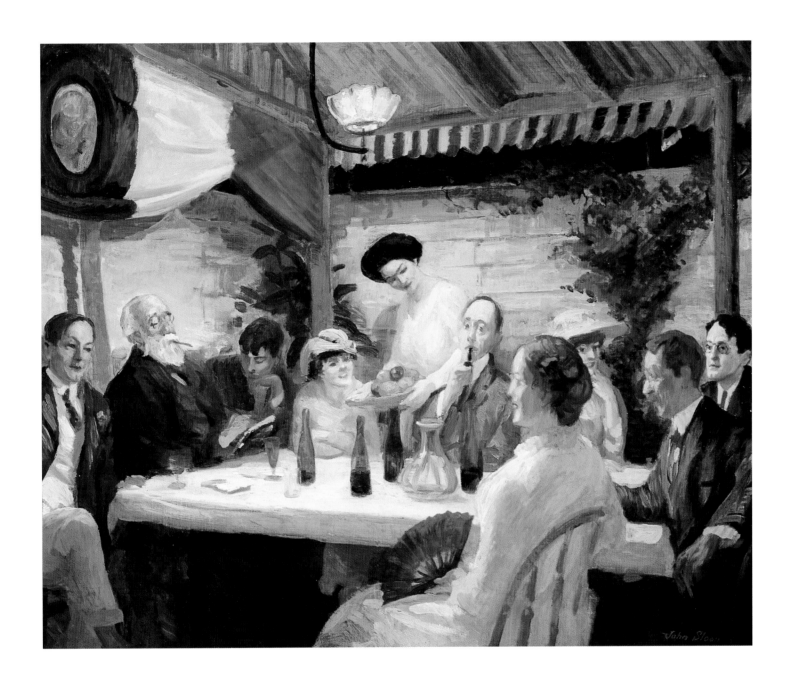

John Sloan

McSorley's Bar, 1912

Oil on canvas
26 × 32 in. (66 × 81.3 cm)
Detroit Institute of Arts, Founders Society Purchase

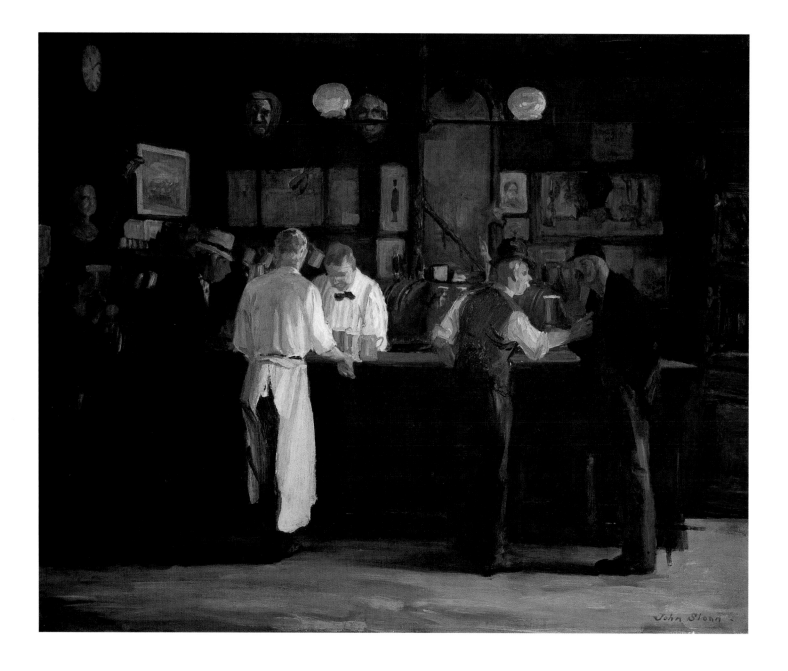

Cat. 12.1
Everett Shinn
The Bar at McSorley's, 1908
Watercolor, gouache, and pencil on paper
10¹/₂ × 19 in. (26.7 × 48.3 cm)
Collection of Mr. and Mrs. Eugene A. Gargaro, Jr.

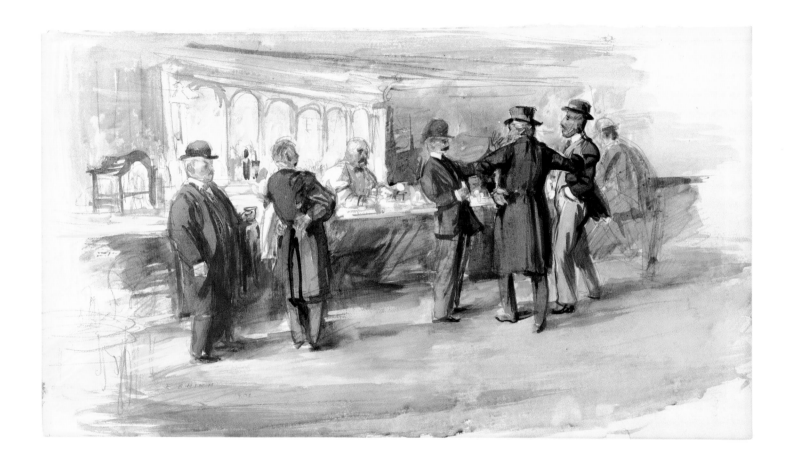

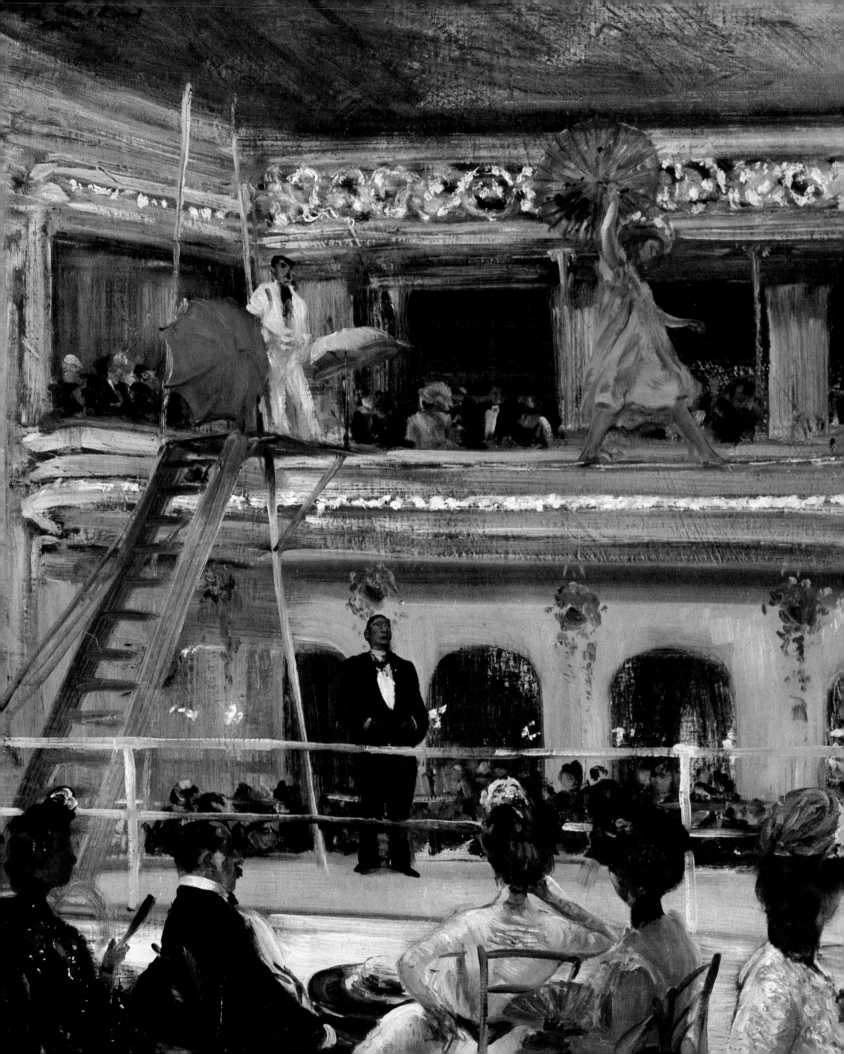

Fine and Performing Arts

The Henri circle created images of the world in which they lived and participated. Several of these artists not only captured theater scenes in their art, but also wrote plays, acted, and painted stage sets. Everett Shinn is most commonly linked to this section, having both painted and been involved in theater production. His work as an art director and set designer in Hollywood from 1917 to 1923 helped him explore many facets of theatrical performances in his art. *Theatre Scene* (cat. 27) gives the illusion of sitting among the audience, while *Theatre Box* (cat. 26) offers a similar view but from a more sought-after seat. A less formal composition depicting a fictional performance is George Luks's *Three Top Sergeants* (cat. 20), in which the painter has posed three younger artists as musicians.

As today, celebrities commanded a certain amount of attention, which extended to the canvases of some of the Ashcan group. John Sloan's painting of Isadora Duncan (cat. 30) shows the American expatriate, whom many call the "mother of modern dance," performing under the dramatic light of the stage. Robert Henri's full-length paintings of *Ruth St. Denis in the Peacock Dance* (cat. 18) and *Salome* (cat. 17), for which he used a professional dancer as model, capture the essence of these performers, both of whom are portrayed in provocative attire.

Circuses and carnivals, with their bright lights, excitement, and thrills, also caught the imagination of these artists. Popular events, including the Barnum and Bailey circus, provided a new (and reasonably

priced) outlet for leisure. William Glackens's *Hammerstein's Roof Garden* (cat. 16) shows an interior scene of a popular New York auditorium. A daring tightrope walker thrills the audience below with her high-wire antics, as a second performer, perhaps awaiting his turn, looks on from a perch. Much like the crowds and paying audiences, Ashcan artists were captivated by the activities and famous performers associated with circuses and carnivals. George Bellows's *Outside the Big Tent* (cat. 14) successfully evokes the energy exuded from such amusements. A man on stilts attracts a crowd to the right, and a Ferris wheel anchors the canvas's left side. Sloan's *Traveling Carnival, Santa Fe* (cat. 31) presents another view of a temporary attraction. A merry-go-round spins on the left in the foreground, while a Ferris wheel looms in the background in the upper right. The Ferris wheel first appeared at the World's Columbian Exposition of 1893 in Chicago and reached an impressive 250 feet (76 m) in height, accommodating an astonishing 2,160 passengers on each ride. Designed to rival the Eiffel Tower, the highlight of the Paris Exposition of 1889, the Ferris wheel has been a popular attraction ever since its introduction.

Cat. 13
Gifford Beal
Waiting for the Show, ca. 1917

Oil on panel
17⁵/₈ × 15 in. (44.8 × 38.1 cm)
Dr. and Mrs. Stephen Craven

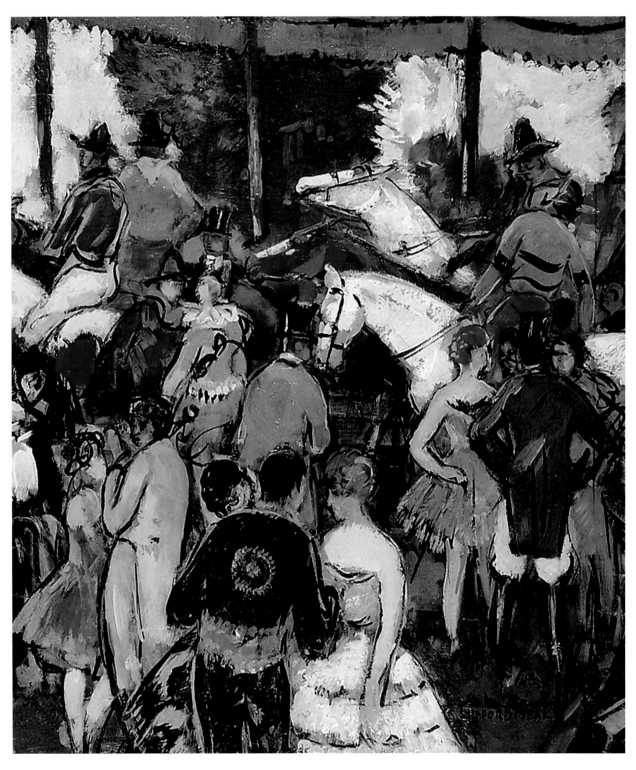

Cat. 14
George Bellows
Outside the Big Tent, 1912

Oil on canvas
30 × 38³/₁₆ in. (76.2 × 97 cm)
Addison Gallery of American Art, Phillips Academy, Andover, Massachusetts,
Gift of anonymous donor (1928.39). All rights reserved

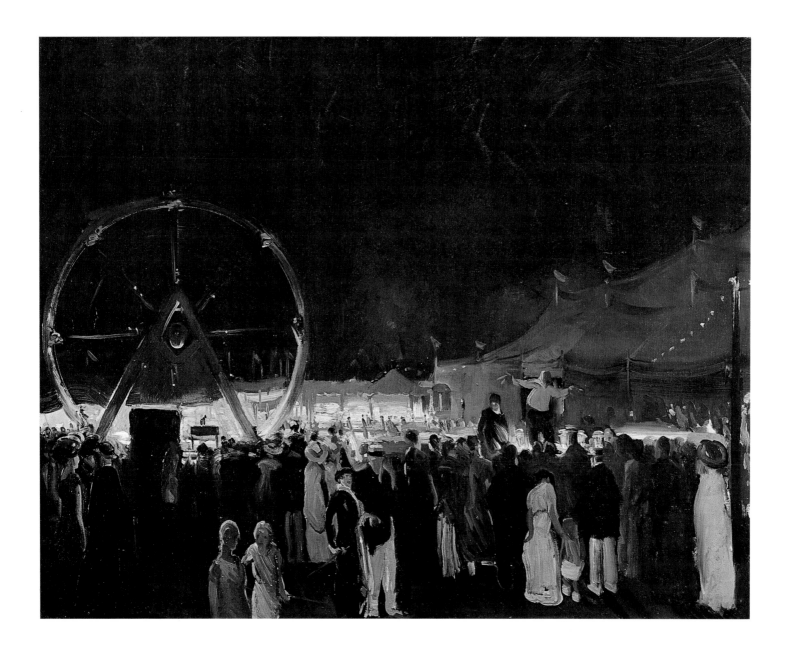

Cat. 15
Arthur B. Davies
The Horn Players, ca. 1893

Oil on canvas
10³/₄ × 9¹/₄ in. (27.3 × 23.5 cm)
Spanierman Gallery, LLC, New York

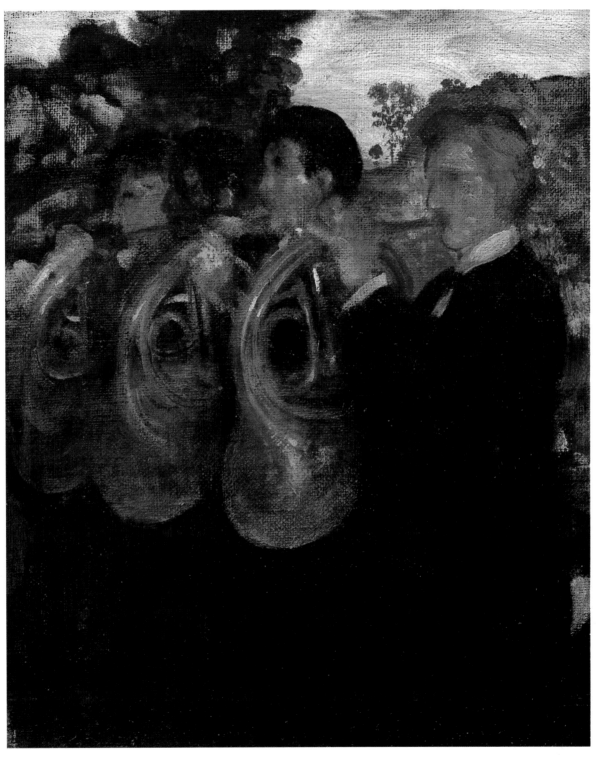

Cat. 16
William Glackens
Hammerstein's Roof Garden, ca. 1901

Oil on canvas
30 × 25 in. (76.2 × 63.5 cm)
Whitney Museum of American Art, New York,
Museum Purchase (53.46)

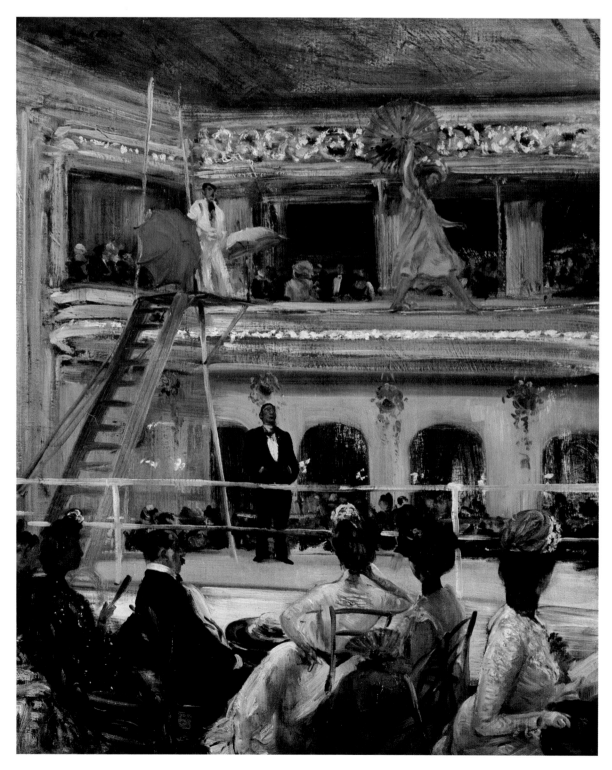

Cat. 17
Robert Henri
Salome, 1909

Oil on canvas
77 × 37 in. (195.6 × 94 cm)
Mead Art Museum, Amherst College,
Amherst, Massachusetts

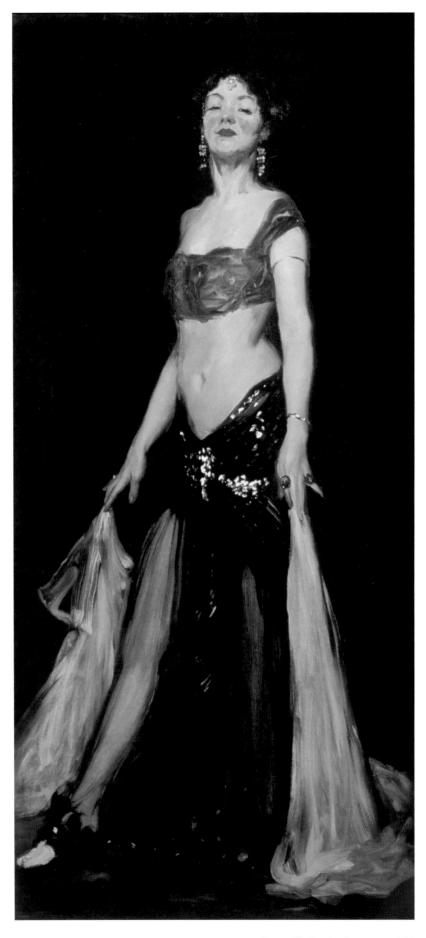

Cat. 18
Robert Henri
Ruth St. Denis in the Peacock Dance, 1919

Oil on canvas
72 × 49¼ in. (183 × 125 cm)
Pennsylvania Academy of the Fine Arts, Philadelphia,
Gift of the Sameric Corporation in memory of Eric Shapiro

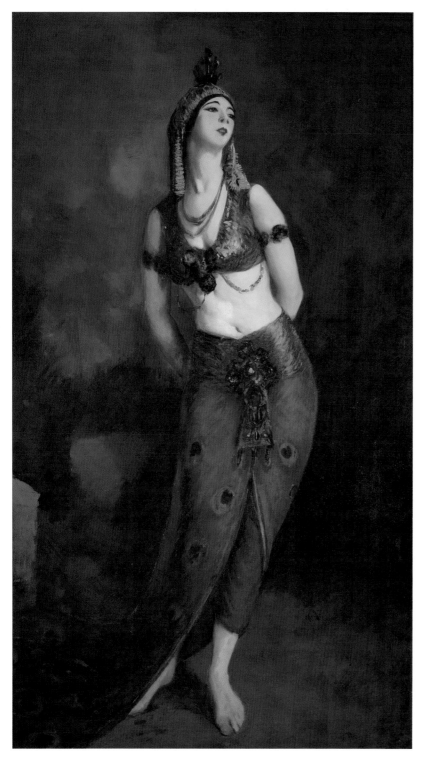

Cat. 19
George Luks
Artist and His Patron, ca. 1905

Oil on canvas
25 × 28 in. (63.5 × 71 cm)
Private collection

Cat. 20
George Luks
Three Top Sergeants, 1925

Oil on canvas
30 × 36 in. (76.2 × 91.4 cm)
Detroit Institute of Arts, City of Detroit Purchase

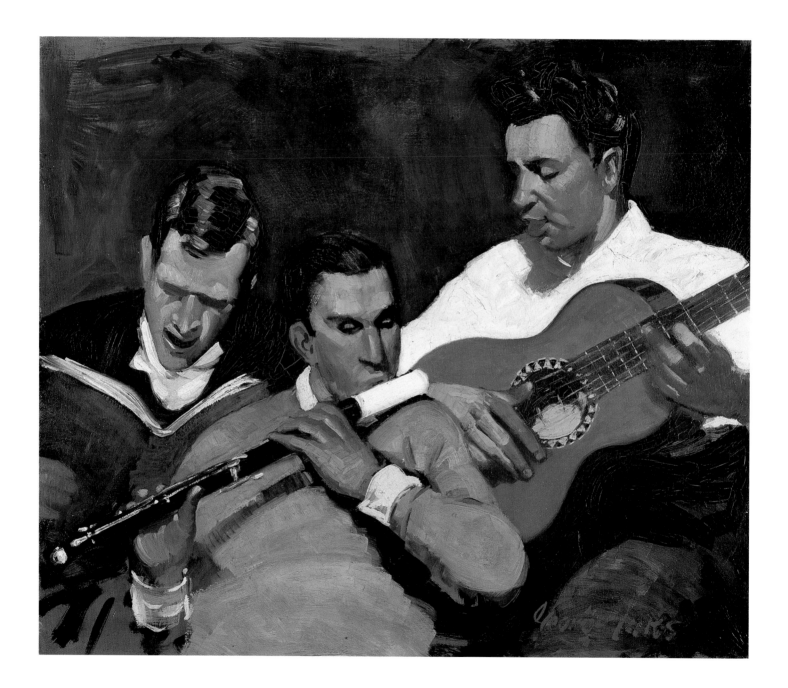

Cat. 21
Jerome Myers
The Children's Theatre, ca. 1925

Oil on canvas
25 × 30 in. (63.5 × 76.2 cm)
Detroit Institute of Arts, Gift of Miss Julia E. Peck

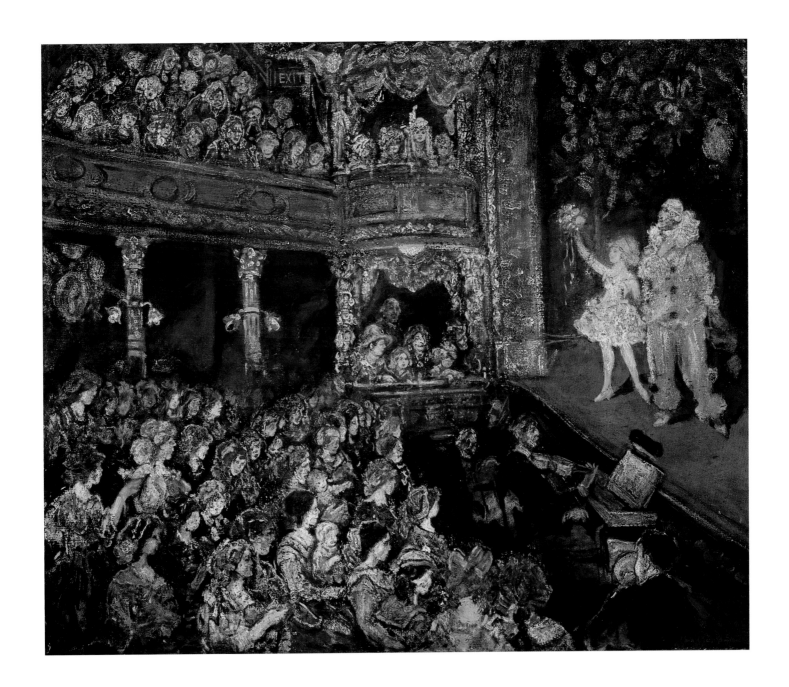

Guy Pène du Bois
The Pianist, ca. 1912–14

Oil on canvas
12 × 16 in. (30.5 × 40.6 cm)
Private collection

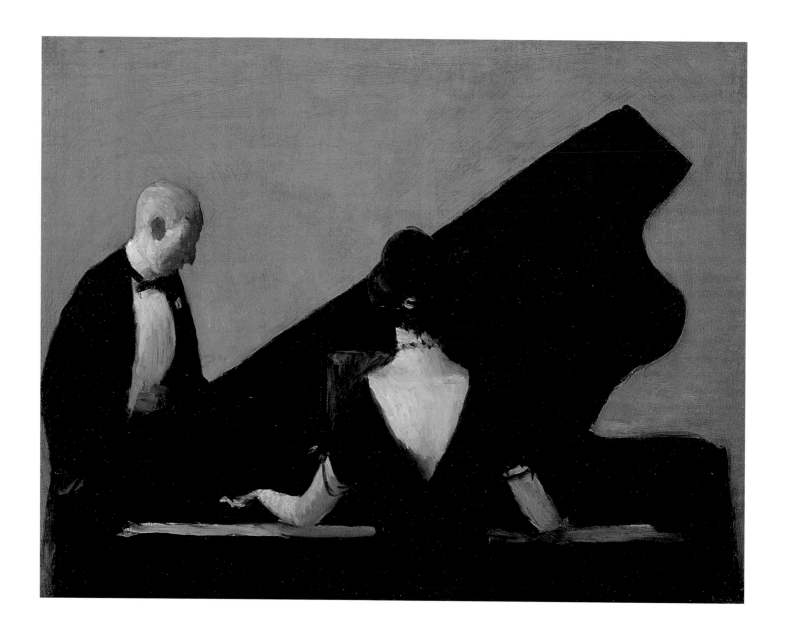

Cat. 23
Guy Pène du Bois
Juliana Force at the Whitney Studio Club, 1921
Oil on wood
20 × 15 in. (50.8 × 38.1 cm)
Whitney Museum of American Art, New York, Gift of Mr. and Mrs. James S. Adams
in memory of Philip K. Hutchins (51.43)

Cat. 24
Guy Pène du Bois
Chanticleer, ca. 1922

Oil on canvas
24¼ × 32 in. (61.6 × 81.3 cm)
San Diego Museum of Art, Museum Purchase
with funds from the Helen M. Towle Bequest

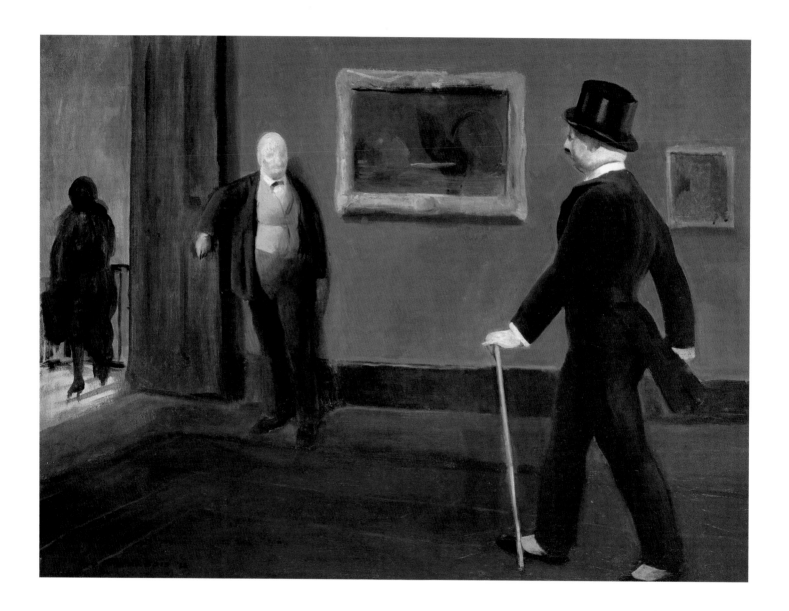

Cat. 25
Everett Shinn
The Orchestra Pit (Old Proctor's Fifth Avenue Theatre), 1906

Oil on canvas
17⁷/₁₆ × 19¹/₂ in. (44.3 × 49.5 cm)
Yale University Art Gallery, New Haven, Connecticut,
Bequest of Arthur G. Altschul, B.A. 1943

(Detroit only)

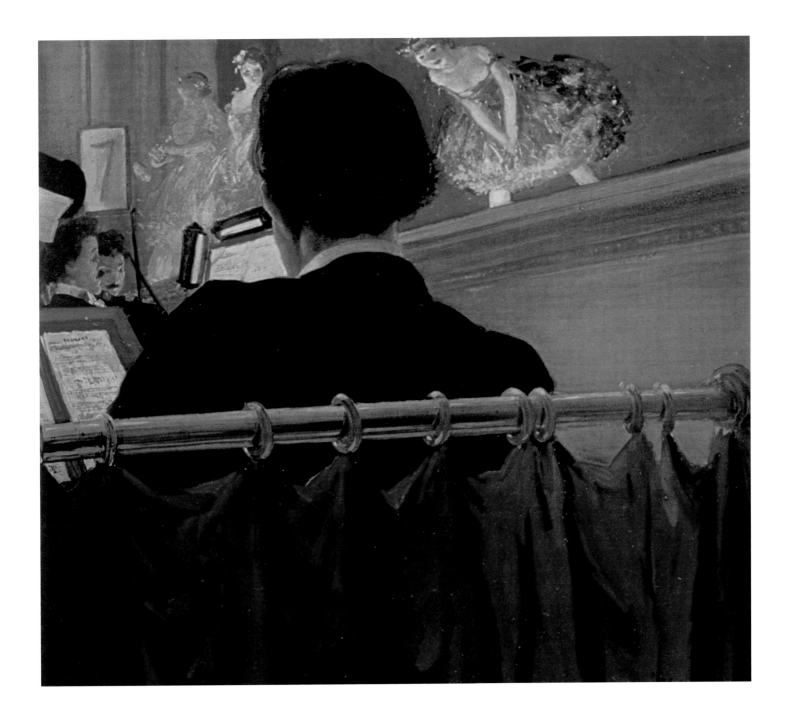

Everett Shinn

Theatre Box, 1906

Oil on canvas
16⅛ × 20⅛ in. (41 × 51.2 cm)
Albright-Knox Art Gallery, Buffalo, New York, Gift of T. Edward Hanley, 1937

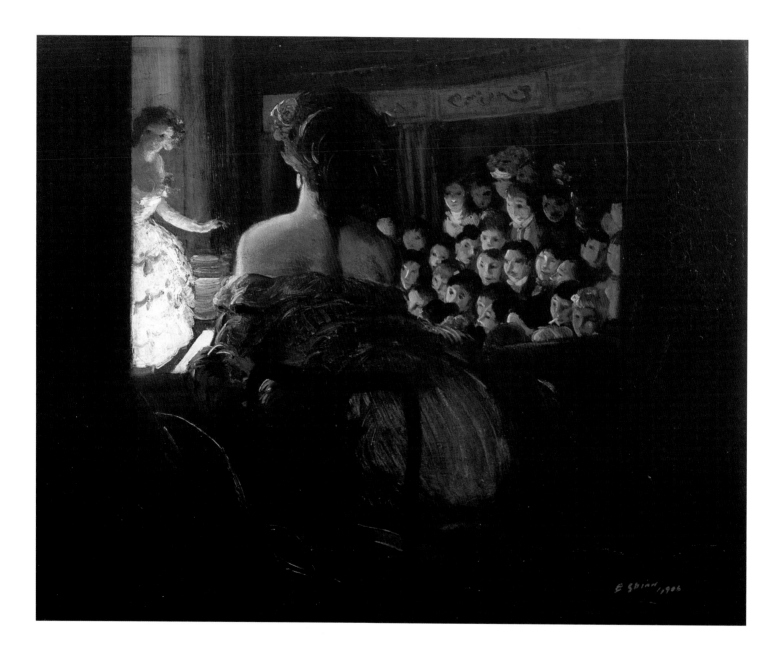

Cat. 27
Everett Shinn
Theatre Scene, ca. 1906–7

Oil on canvas
28³/₄ × 36 in. (73 × 91.4 cm)
Manoogian Collection

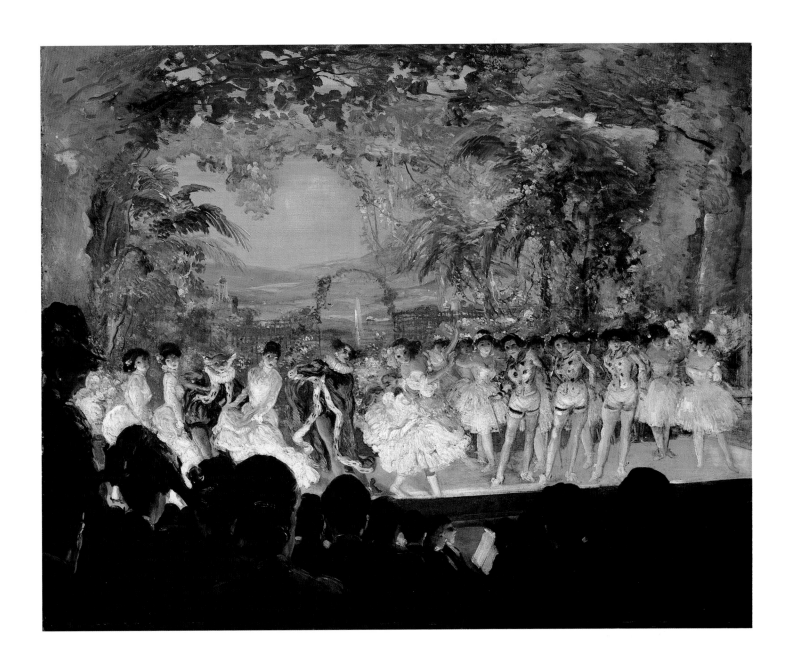

Cat. 28

Everett Shinn

The Orchestra Pit, 1907

Pastel on paper
12 × 8 in. (30.5 × 20.3 cm)
The Westmoreland Museum of American Art, Greensburg,
Pennsylvania, Gift of Dr. Walter Read Hovey

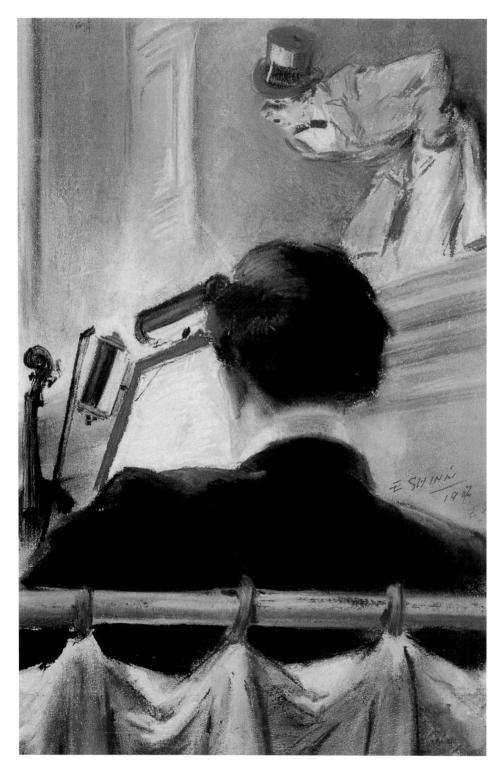

Cat. 29
Everett Shinn
Tightrope Walker, 1924

Oil on canvas
23⅛ × 18 in. (58.7 × 45.7 cm)
The Dayton Art Institute, Ohio, Museum Purchase with funds provided
by the James F. Dicke Family and the E. Jeanette Myers Fund, 1998.7

Cat. 30
John Sloan
Isadora Duncan, 1911

Oil on canvas
32¼ × 26¼ in. (81.9 × 66.7 cm)
Milwaukee Art Museum,
Gift of Mr. and Mrs. Donald B. Abert, M1969.27

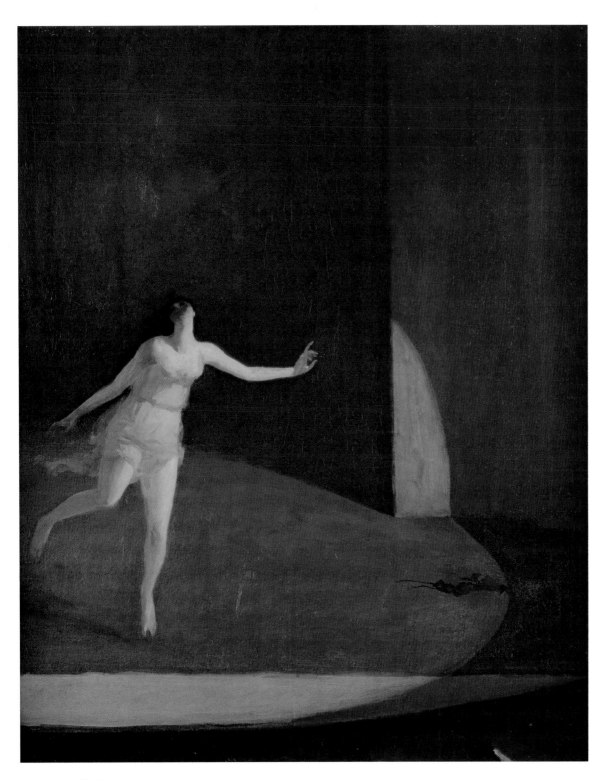

Cat. 31

John Sloan

Traveling Carnival, Santa Fe, 1924

Oil on canvas
30⅛ × 36⅛ in. (76.5 × 91.8 cm)
Smithsonian American Art Museum, Washington, D.C.,
Gift of Mrs. Cyrus McCormick

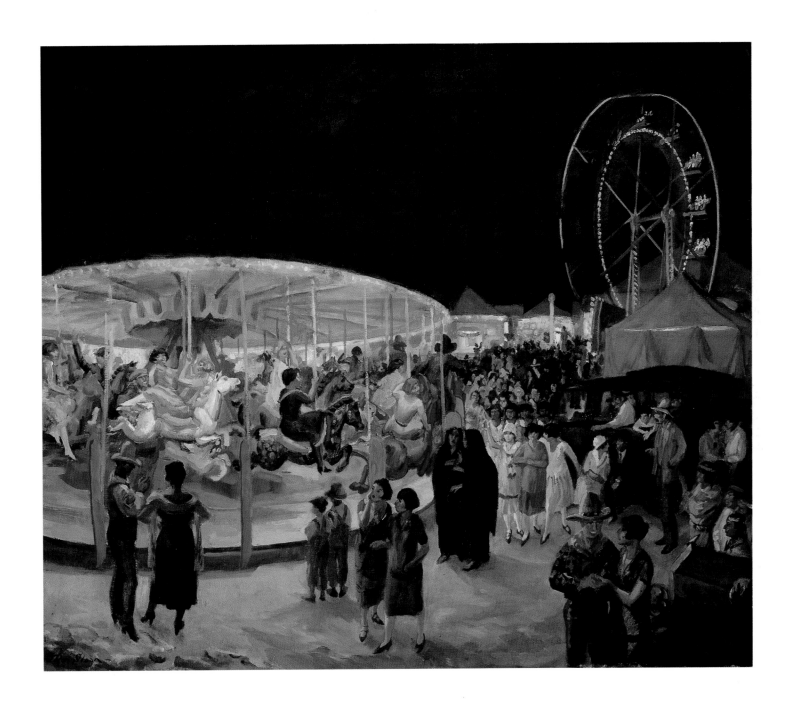

Cat. 32
Eugene Speicher
Portrait of Katharine Cornell as "Candida," ca. 1925–26

Oil on canvas
84¼ × 45¼ (214.7 × 115 cm)
Albright-Knox Art Gallery, Buffalo, New York,
Gift of Julia R. and Estelle L. Foundation Incorporated, Buffalo, 1950

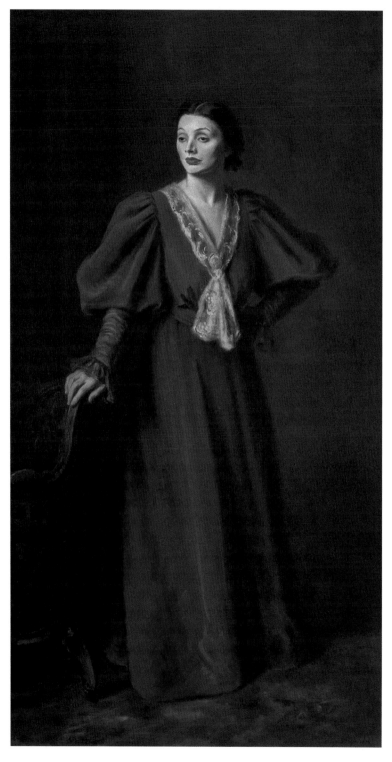

Maurice Sterne

Entrance of the Ballet, ca. 1904

Oil on canvas
26 × 32½ in. (66 × 82.5 cm)
Detroit Institute of Arts, Gift of Ralph Harman Booth

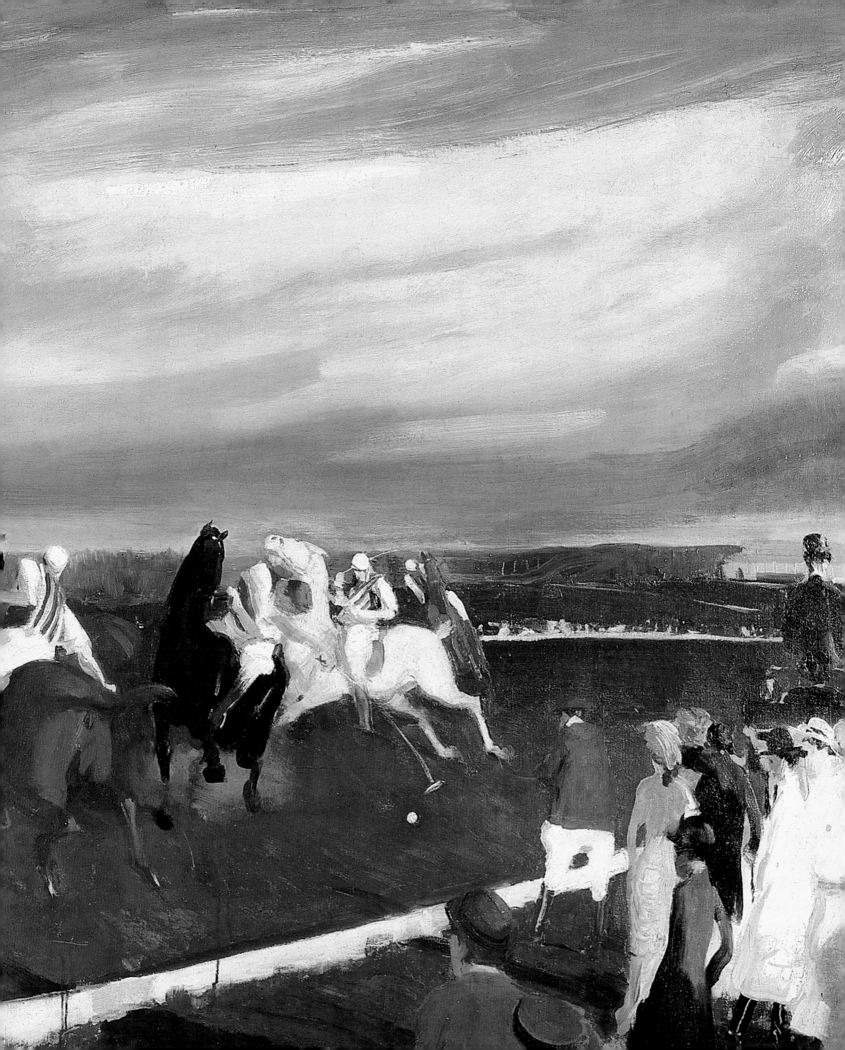

Sports and Recreation

Robert Henri's call to go out and paint what was real encouraged his circle to observe and paint the world around them, which, at the turn of the twentieth century, included the more active lifestyle that Americans were starting to lead. Athletics were believed to build a healthy body, which in turn helped foster a healthy mind. Spectator sports such as prizefights became increasingly popular. Recreational activities, such as swimming and roller-skating, also became more fashionable.

The Ashcan artists were present to view, take part in, and record events in their unique manner. Some sports in this section can be grueling and even brutal. George Luks (see his portrait by Henri, cat. 43), who lived a rough-and-tumble life himself, captured the pure form and competitive nature of sports in such paintings as *The Wrestlers* (cat. 46). George Bellows, an athlete in his own right, visited the theme of prizefighting on several occasions. In his hard-hitting *Club Night* (cat. 34), two combatants are pummeled red with blood and punishment. His classic *Dempsey and Firpo* (cat. 38) depicts Jack Dempsey being knocked out of the ring on to ringside seats and reporters. Remarkably, Dempsey recovered and won the bout in the second round. Bellows, who saw the fight firsthand, shows Luis Angel Firpo connecting with a left, when in fact it was the right that sent Dempsey through the ropes.

A distinct grouping within this section features equestrian sports. John Grabach's *Taking the Hurdles* (cat. 41) depicts fashionably dressed people in the

foreground, seemingly oblivious to the race in front of them. Both Walt Kuhn and Bellows present us with polo matches. In *Polo Game* (cat. 45) Kuhn portrays the players in the foreground against a grandstand filled with onlookers. *Polo at Lakewood* (cat. 35), by Bellows, uses a white diagonal line to separate the action from the standing onlookers; in this case, a dramatic sky acts as the backdrop.

There were some athletic activities in which it was more realistic for these artists themselves to participate. In April 1906, William Glackens reported in a letter that "We have just returned from the roller-skating rink.... I was the first to fall and it was a good one. My whole left hip will be black and blue in the morning."[1] Incidentally, Glackens depicts a fallen skater in *Skating Rink, New York City* (cat. 39) and again in his ice-skating painting *Skaters, Central Park* (cat. 40). Rockwell Kent's *Croquet (The Beach Party)* (cat. 44) depicts a cast of young women enjoying a lazy game. Nineteenth-century women, regarded as much more delicate than men, were encouraged to participate in this type of activity because it did not require much physical exertion. By the twentieth century, it had become more acceptable for women to partake in more rigorous activities, such as tennis, swimming, and cycling; croquet was seen as more of an outdoor parlor game. In *Croquet (The Beach Party)*, Kent uses white and blue colors to depict the women's dresses, which complement the horizontal bands used to express the background body of water and plush sky. Sloan's *Fishing for Lafayettes* (cat. 48) presents a diagonal row of fishermen on what appears to be a pier. Fishing not only served as a leisure activity, but also, when successful, provided a potential meal for the angler. The vast range of depictions within this section demonstrates diverse breadth within the Henri circle.

Note

1. Ira Glackens, *William Glackens and the Ashcan Group: The Emergence of Realism in American Art* (New York, 1957), 64.

Cat. 34
George Bellows
Club Night, 1907

Oil on canvas
43 × 53⅛ in. (109.2 × 135 cm)
National Gallery of Art, Washington, D.C.,
John Hay Whitney Collection 1982.76.1

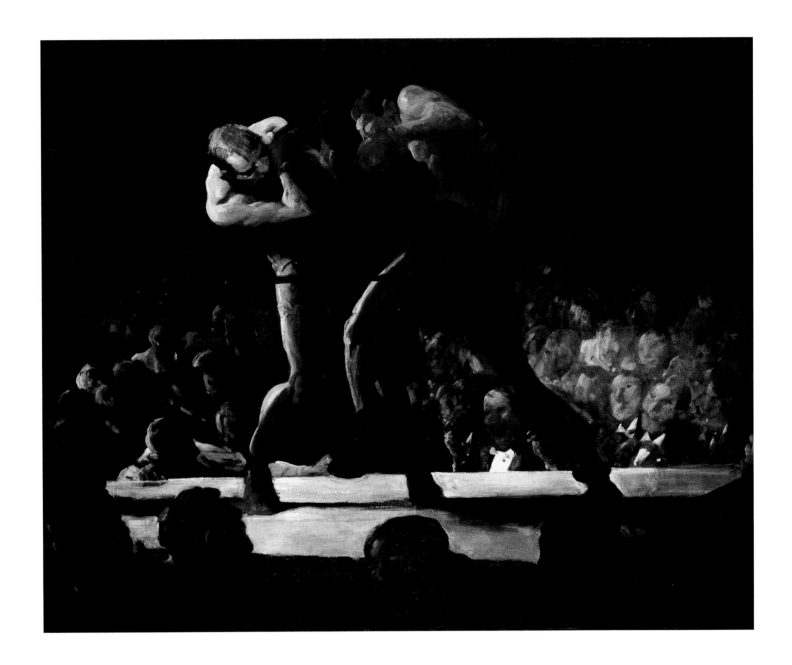

Cat. 35
George Bellows
Polo at Lakewood, 1910

Oil on canvas
45 × 63½ in. (114.3 × 161.3 cm)
Columbus Museum of Art, Ohio, Columbus Art
Association Purchase (1911.001)
(New York and Detroit only)

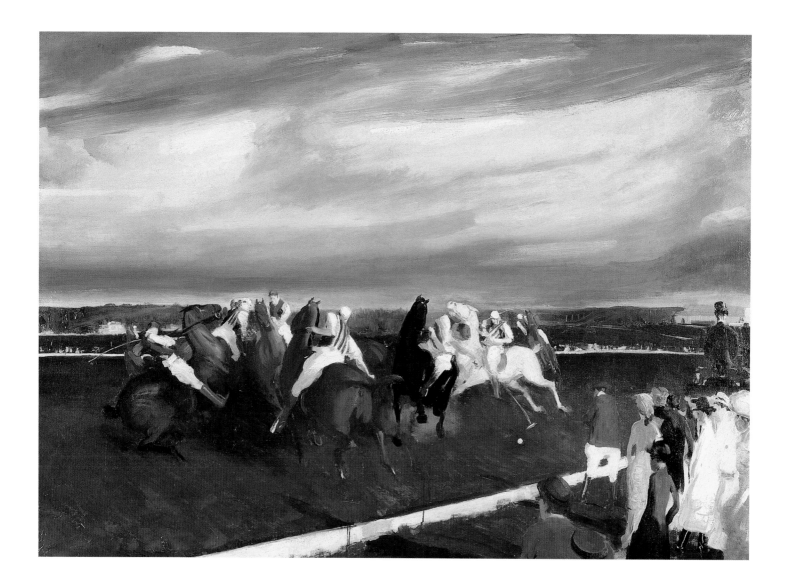

Cat. 36
George Bellows
Golf Course—California, 1917

Oil on canvas
30 × 38 in. (76.2 × 96.5 cm)
Cincinnati Art Museum

(Nashville and Detroit only)

Cat. 37
George Bellows
Tennis at Newport, 1920

Oil on canvas
46¾ × 49¾ in. (118.7 × 126.4 cm)
The Metropolitan Museum of Art, New York, Bequest
of Miss Adelaide Milton de Groot (1876–1967), 1967

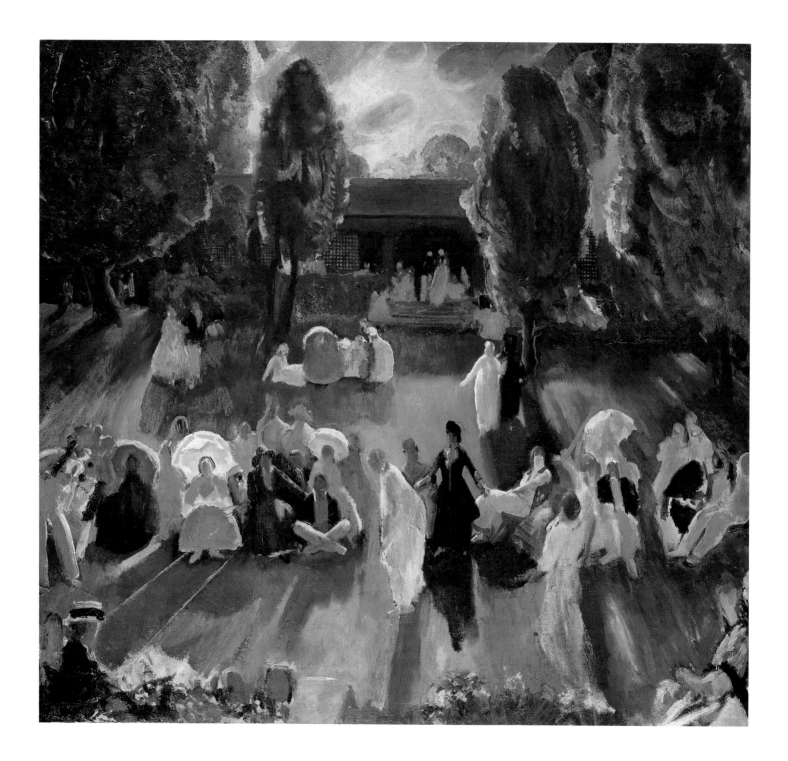

Cat. 38
George Bellows
Dempsey and Firpo, 1924

Oil on canvas
51 × 63¼ in. (129.5 × 160.7 cm)
Whitney Museum of American Art, New York, Purchase,
with funds from Gertrude Vanderbilt Whitney (31.95)

(New York and Detroit only)

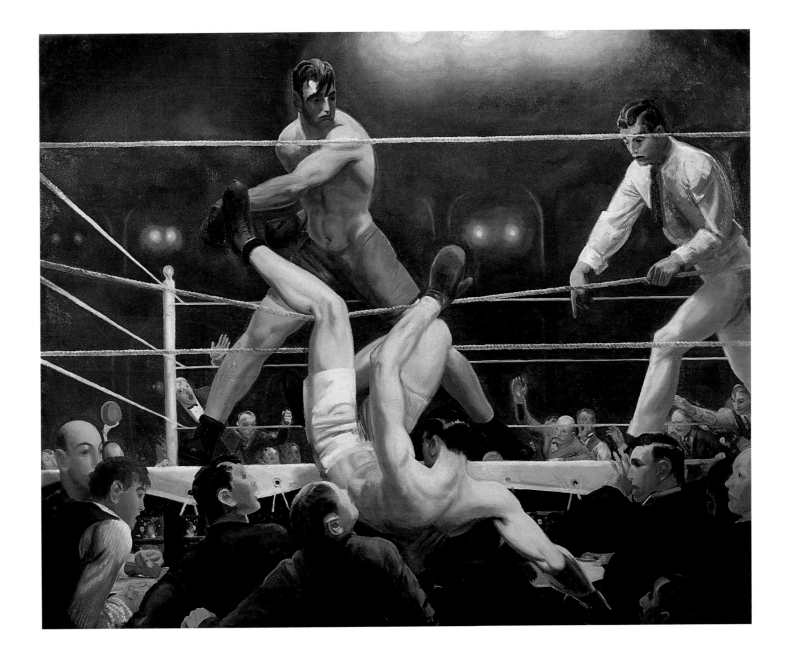

Cat. 39
William Glackens
Skating Rink, New York City, ca. 1906

Oil on canvas
26 × 33 in. (66 × 83.8 cm)
Philadelphia Museum of Art, Gift of Meyer P. Potamkin
and Vivian O. Potamkin, 2000 (1964-116-7)

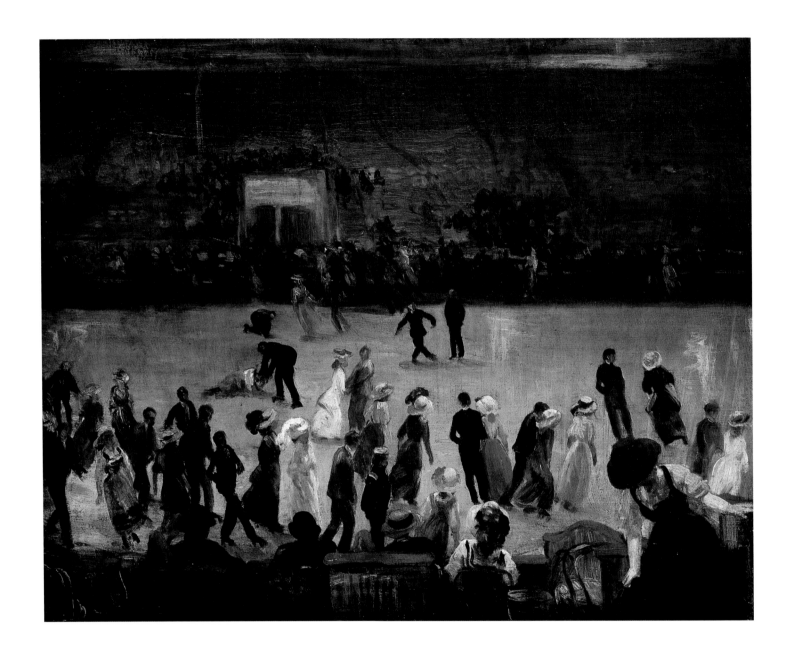

Cat. 40
William Glackens
Skaters, Central Park, ca. 1912

Oil on canvas
16½ × 29¼ in. (41.9 × 74.3 cm)
Mount Holyoke College Art Museum, South Hadley, Massachusetts,
Purchase with the Nancy Everett Dwight Fund

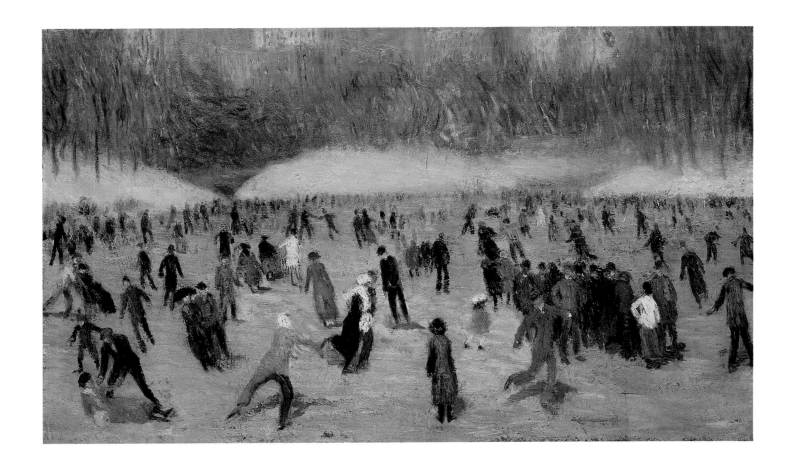

Cat. 41
John Grabach
Taking the Hurdles, n.d.
Oil on panel
42 × 47½ in. (106.7 × 120.6 cm)
Manoogian Collection

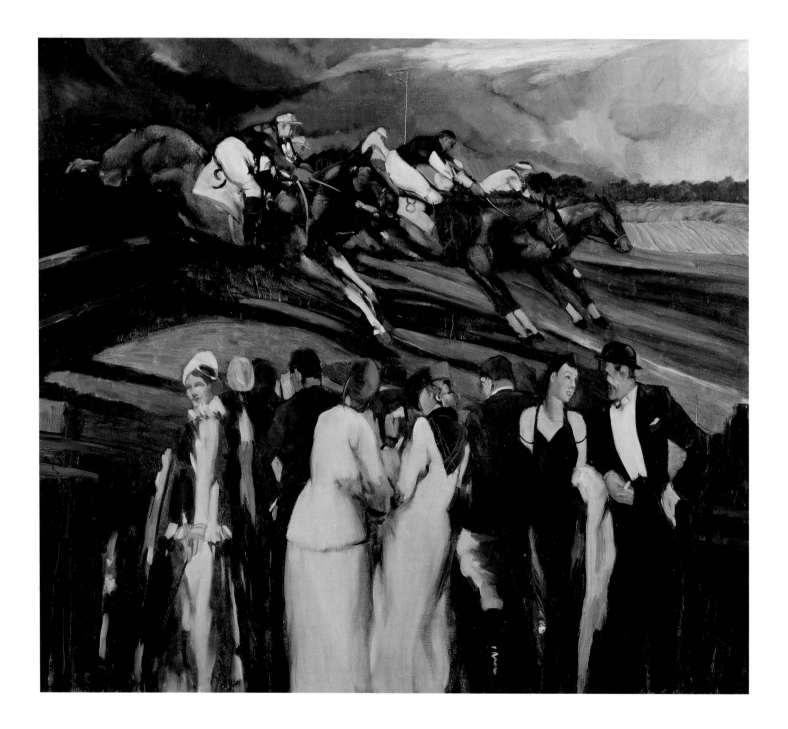

Cat. 42
Robert Henri
Portrait of Miss Leora M. Dryer
in Riding Costume, 1902
Oil on canvas
77 × 35½ in. (195.6 × 90.2 cm)
LeClair Family Collection

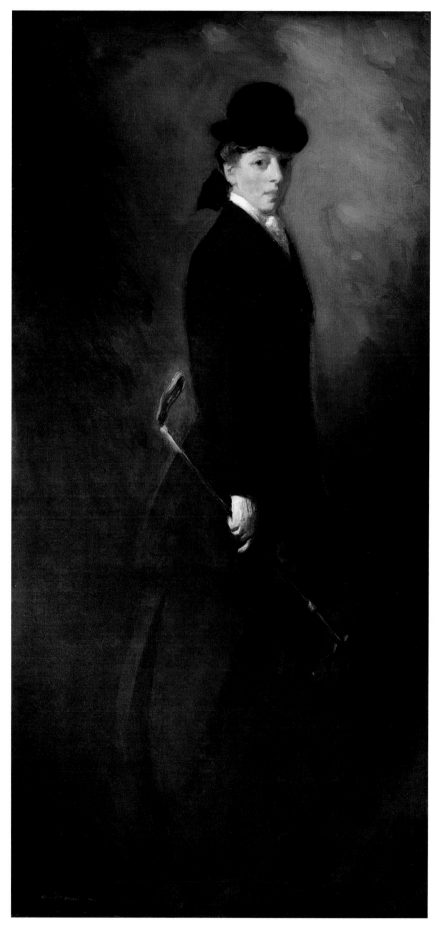

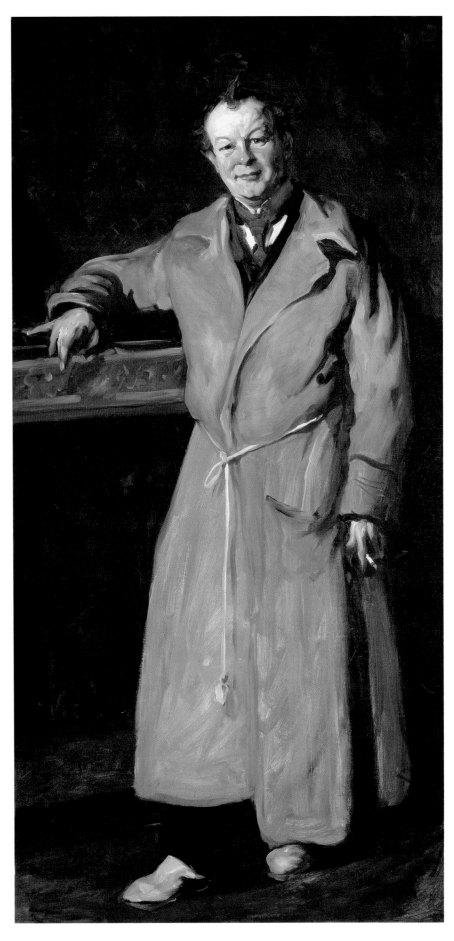

Cat. 43
Robert Henri
Portrait of George Luks, 1904
Oil on canvas
76½ × 38¼ in. (194.3 × 97.2 cm)
National Gallery of Canada, Ottawa

Cat. 44
Rockwell Kent
Croquet (The Beach Party), ca. 1906–7

Oil on canvas
34 × 44 in. (86.4 × 111.8 cm)
Manoogian Collection

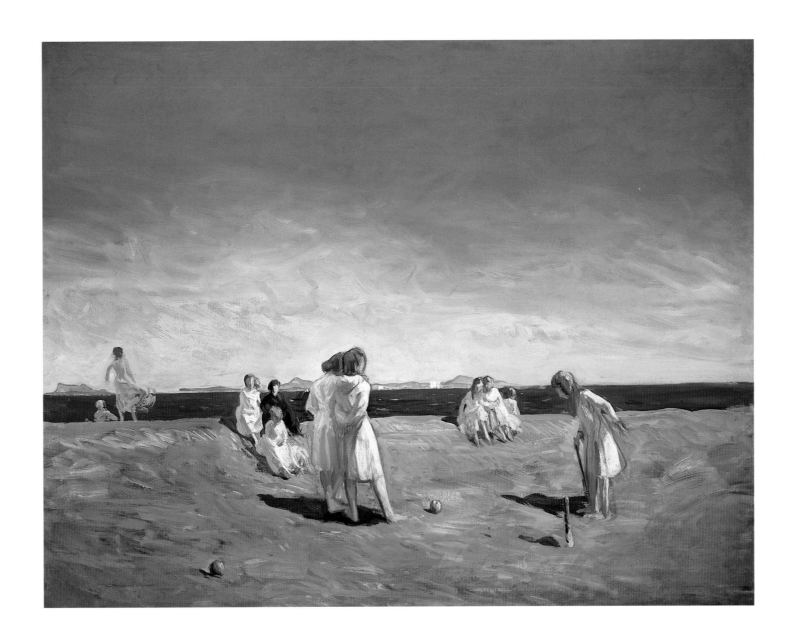

Cat. 45
Walt Kuhn
Polo Game, ca. 1914

Oil on canvas
20¼ × 30 in. (51.4 × 76.2 cm)
Private collection

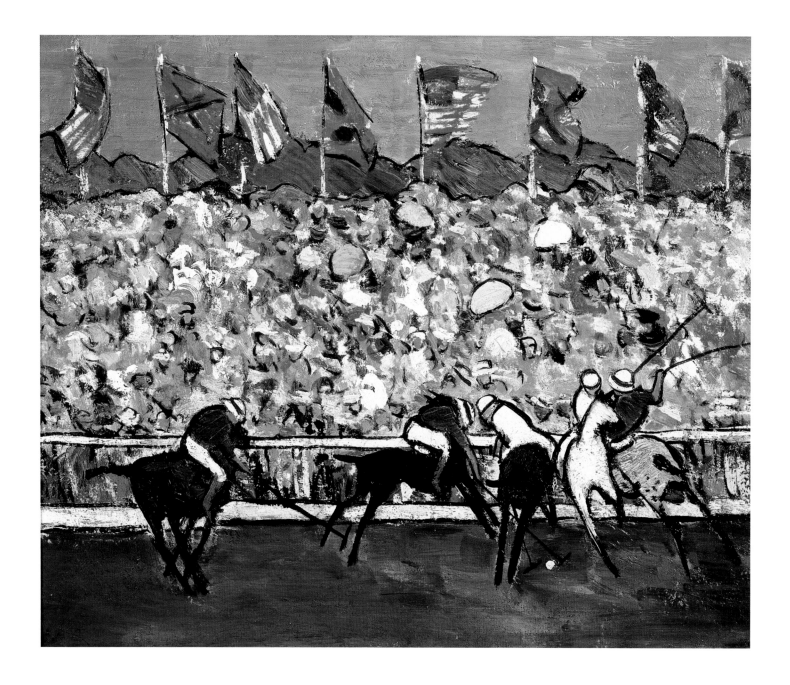

Cat. 46
George Luks
The Wrestlers, 1905

Oil on canvas
48⅜ × 66⅜ in. (122.7 × 168.4 cm)
Museum of Fine Arts, Boston,
The Hayden Collection—Charles Henry Hayden Fund, 45.9

(Detroit only)

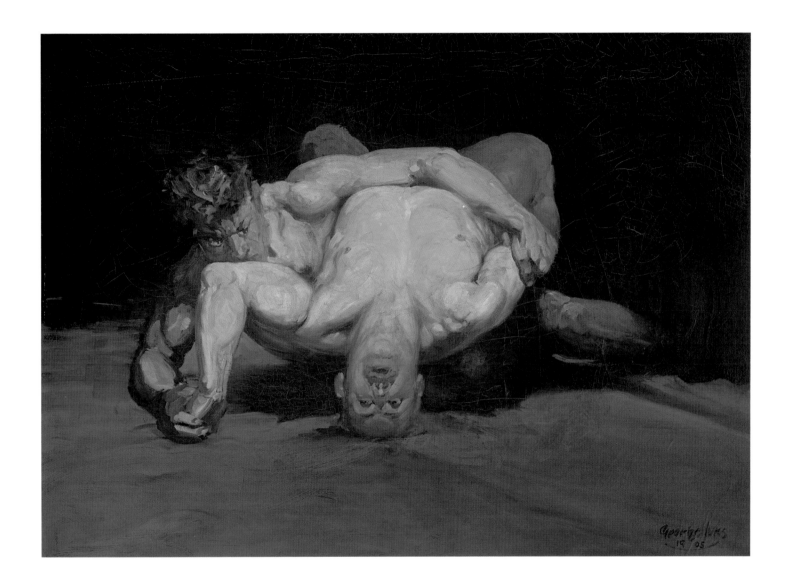

Cat. 47
John Sloan
Gray and Brass, 1907

Oil on canvas
21½ × 26⅝ in. (54.6 × 67.6 cm)
Dr. Karen A. and Mr. Kevin W. Kennedy Collection

(New York only)

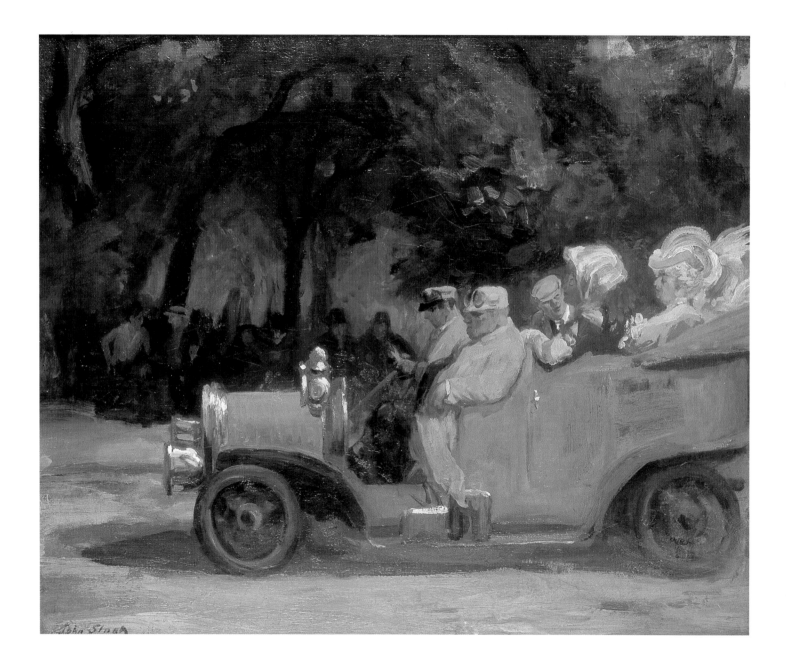

Cat. 48
John Sloan
Fishing for Lafayettes, 1908
Oil on linen
8½ × 10½ in. (21.6 × 26.7 cm)
Collection of Mr. and Mrs. John L. Huber

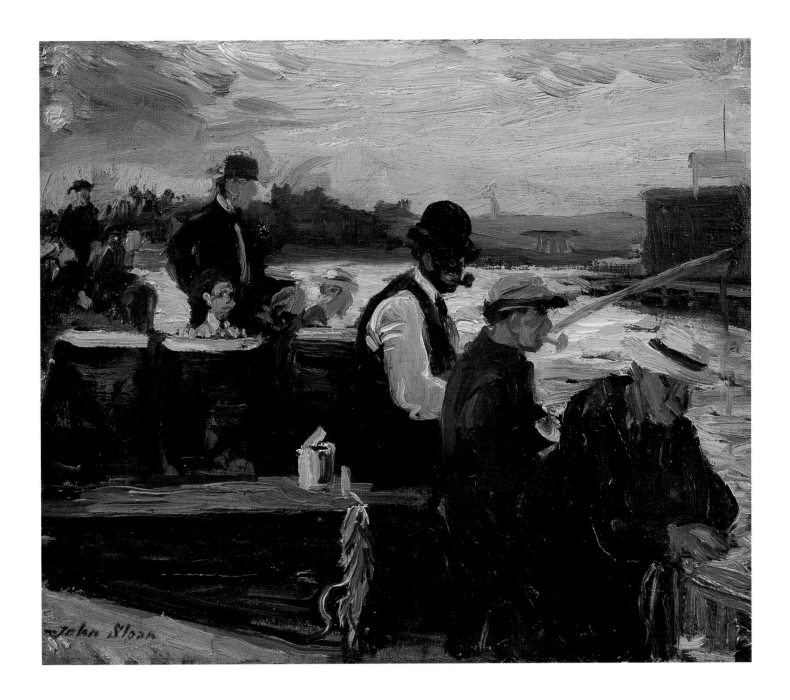

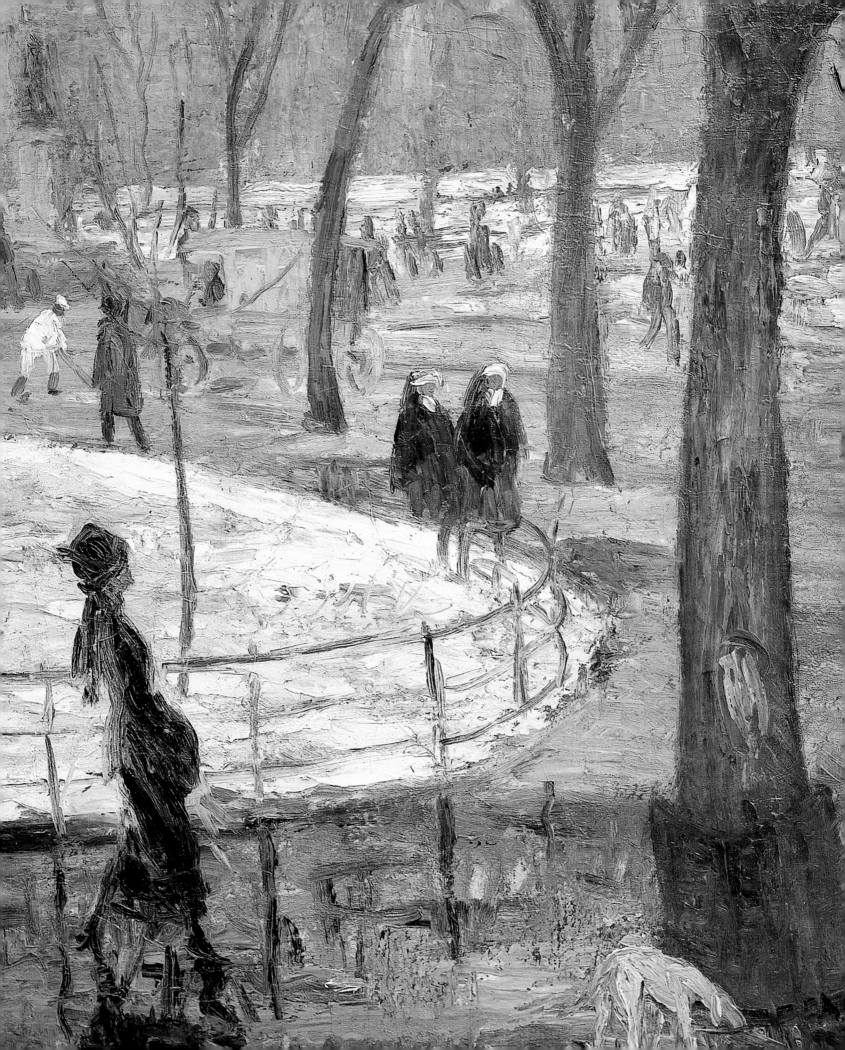

The Outdoors

In *George Bellows: Painter of America*, Charles H. Morgan reported the young artist's first impressions of Robert Henri: "Arrived in New York I found myself in my first art school under Robert Henri having never heard of him before … My life begins at this point."[1] So important was Henri's influence on his circle that such artists as Bellows answered their mentor's call "to paint what is around you." Another example of how Henri's influence affected Bellows is apparent in Leon Kroll's *In the Country* (cat. 62). Bellows had been in an artistic lull for some time. To provide encouragement, Henri asked Kroll to spend time with the struggling artist. The two friends worked together while renting adjoining summer homes in Camden, Maine. This painting is a product of their time spent together; it also serves as a portrait of Bellows's family.

Many artists summered in the country because it was traditionally a slow period in the art world. Escaping the big city, many Ashcan artists found places of refuge, picnicking, playing, and chatting. An example of an affluent park scene, Henri's *Picnic at Meshoppen, PA* (cat. 60) shows a couple in the foreground enjoying a moment together by the side of a large tree trunk that anchors the center of the canvas.

The Ashcan group also painted those inhabitants who were unable to leave the city. Surrounded by buildings, Robert Spencer's *Courtyard at Dusk* (cat. 75) offers a glimpse of a vastly different side of life, where a group of tenement dwellers gather together to escape the summer's heat.

The majority of artists in Henri's circle lived in New York and found Central Park an oasis in the madness of the surrounding city. Maurice Prendergast's watercolor *In Central Park, New York* (cat. 70) shows people enjoying a centrally located water fountain that spouts toward the top of the painting. Kroll's *Scene in Central Park* (cat. 63) offers a view of the park with barren trees and the city's buildings looming nearby. William Glackens's *Central Park, Winter* (cat. 55) depicts adults looking on as enthusiastic children engage in sledding. About eight years later, George Bellows painted *A Day in June* (cat. 50), which shows a loose gathering of people on a plush green carpet of grass. Bellows includes himself and his wife, Emma, in the midground to the left. Bellows is propped up by his elbows, while Emma, seated, looks toward the viewer.

Another popular park with the Ashcan group was Washington Square. George Luks, Everett Shinn, and John Sloan are among those who painted scenes of it, but Glackens is perhaps the square's most active chronicler. In *March Day—Washington Square* (cat. 58), he shows the results of a rainy day, cropping the canvas in a manner that shows only the lower recesses of the square's arch.

Beach and swimming scenes were also popular subjects with Ashcan painters. Sloan's *South Beach Bathers* (cat. 74) shows people gathered on the beach to enjoy a carefree day. Bellows's *Forty-two Kids* (cat. 49) depicts boys escaping the heat of the summer by horsing around on an abandoned pier on the Hudson River. Many of these popular outdoor leisure activities were not only captured in paintings by the Ashcan group, but were also enjoyed by the artists themselves.

Note

1. Charles H. Morgan, *George Bellows: Painter of America* (New York, 1965), 37.

Cat. 49
George Bellows
Forty-two Kids, 1907

Oil on canvas
42³⁄₈ × 60¹⁄₄ in. (107.6 × 153 cm)
Corcoran Gallery of Art, Washington, D.C.,
Museum Purchase, William A. Clark Fund (31.12)

George Bellows

A Day in June, 1913

Oil on canvas
42 × 48 in. (106.7 × 121.9 cm)
Detroit Institute of Arts, Lizzie Merrill Palmer Fund

Cat. 51
Arthur B. Davies
Every Saturday, ca. 1895–96

Oil on canvas
18 × 29¹⁵/₁₆ in. (45.7 × 76 cm)
Brooklyn Museum, New York, Gift of William A. Putnam (12.92)

Cat. 52
Arthur B. Davies
Children Playing, ca. 1896

Oil on canvas
18 × 22 in. (45.7 × 55.9 cm)
Spanierman Gallery, LLC, New York

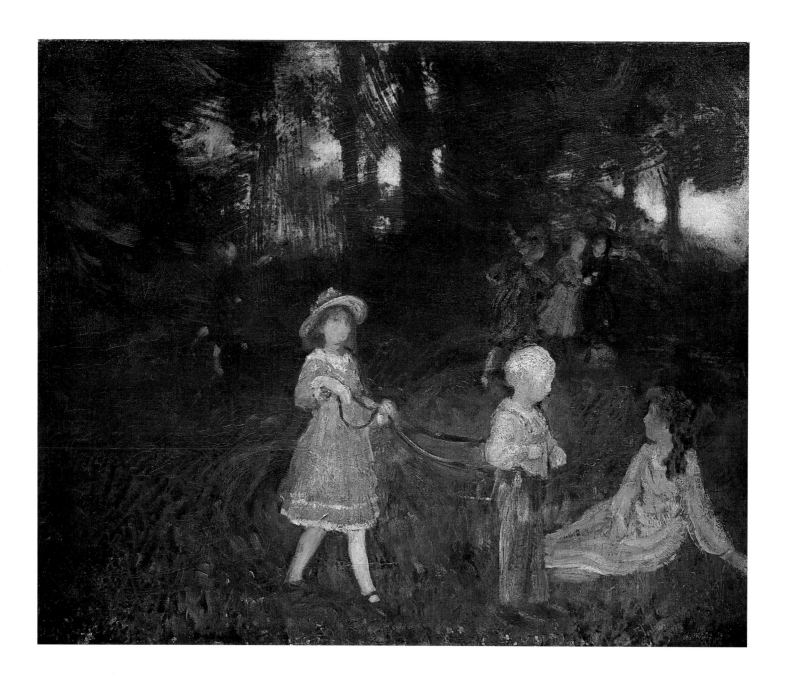

Cat. 53
Arthur B. Davies
Twilight on the Harlem, ca. 1907

Oil on canvas
18 × 40 in. (45.7 × 101.6 cm)
Collection Abby and Alan D. Levy, Los Angeles

Cat. 54
William Glackens
The Battery, ca. 1902–4

Oil on canvas
26 × 32 in. (66 × 81.3 cm)
Collection Abby and Alan D. Levy, Los Angeles

Cat. 55
William Glackens
Central Park, Winter, ca. 1905

Oil on canvas
25 × 30 in. (63.5 × 76.2 cm)
The Metropolitan Museum of Art, New York,
George A. Hearn Fund, 1921 (21.164)

William Glackens

May Day, Central Park, ca. 1905

Oil on canvas
25 × 30 in. (63.5 × 76.2 cm)
Fine Arts Museums of San Francisco, Museum Purchase,
Gift of Charles E. Merrill Trust with matching funds from the de Young Museum Society, 70.1

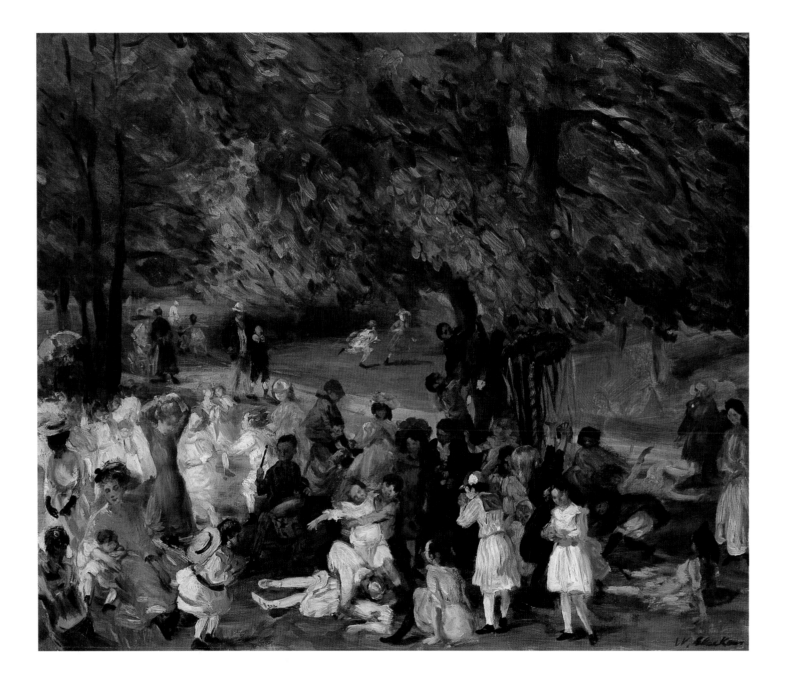

Cat. 57
William Glackens
Chateau-Thierry, 1906

Oil on canvas
24 × 32 in. (61 × 81.3 cm)
The Huntington Library, Art Collections, and Botanical Gardens,
San Marino, California, Gift of the Virginia Steel Scott Foundation

Cat. 58
William Glackens
March Day—Washington Square, 1912

Oil on canvas
25 × 30 in. (63.5 × 76.2 cm)
Collection of Dr. Ron Cordover

Cat. 59
Robert Henri
At Far Rockaway, 1902
Oil on canvas
26 × 32 in. (66 × 81.3 cm)
Private collection

Cat. 60
Robert Henri
Picnic at Meshoppen, PA, 1902

Oil on canvas
26 × 32 in. (66 × 81.3 cm)
The Westmoreland Museum of American Art, Greensburg,
Pennsylvania, Gift of the William A. Coulter Fund

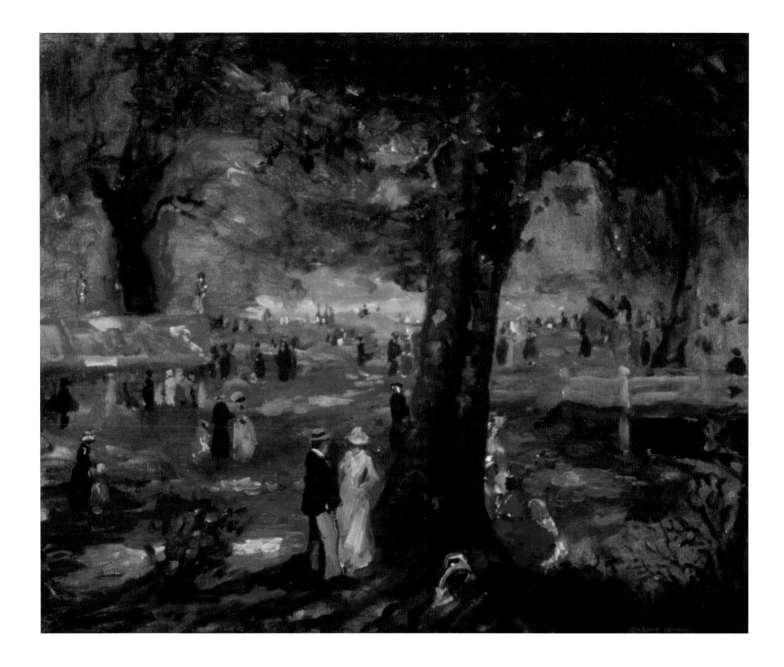

Cat. 61
Robert Henri
Winter Landscape (Central Park), 1902
Oil on canvas
26 × 32 in. (66 × 81.3 cm)
Private collection

Leon Kroll

In the Country, 1916

Oil on canvas
56³/₄ × 62³/₄ in. (144.1 × 159.4 cm)
Detroit Institute of Arts, Founders Society Purchase, Special Membership
and Donations Fund with a contribution from Mr. J.J. Crowley

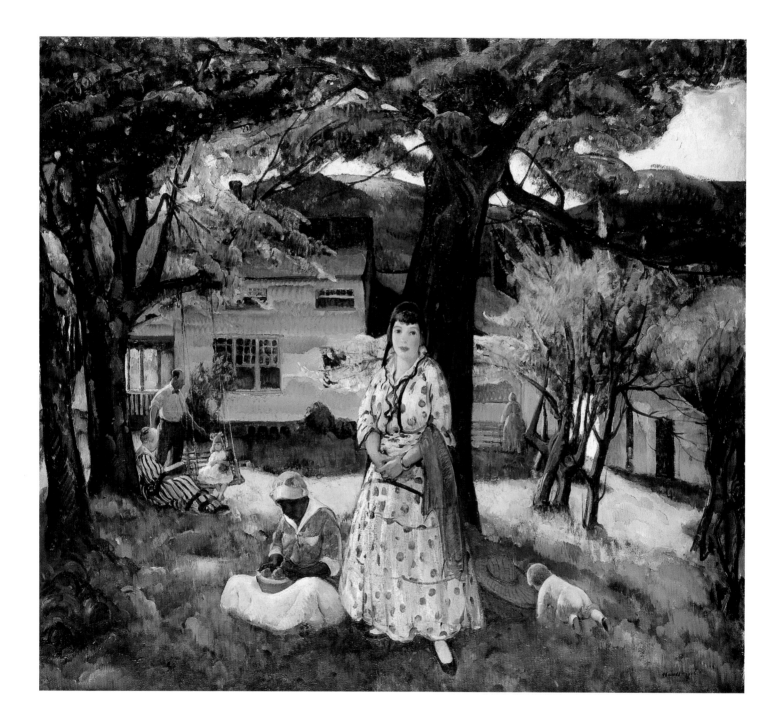

Cat. 63
Leon Kroll
Scene in Central Park, 1922

Oil on canvas
27¼ × 36 in. (69.2 × 91.4 cm)
Smithsonian American Art Museum, Washington, D.C.,
Gift of Orrin Wickersham June

Cat. 64
Ernest Lawson
Boys Bathing, ca. 1908–10

Oil on canvas
25³/₈ × 30⁵/₁₆ in. (64.4 × 77 cm)
Brooklyn Museum, New York,
Gift of Mr. and Mrs. Russell Hopkinson (62.80)

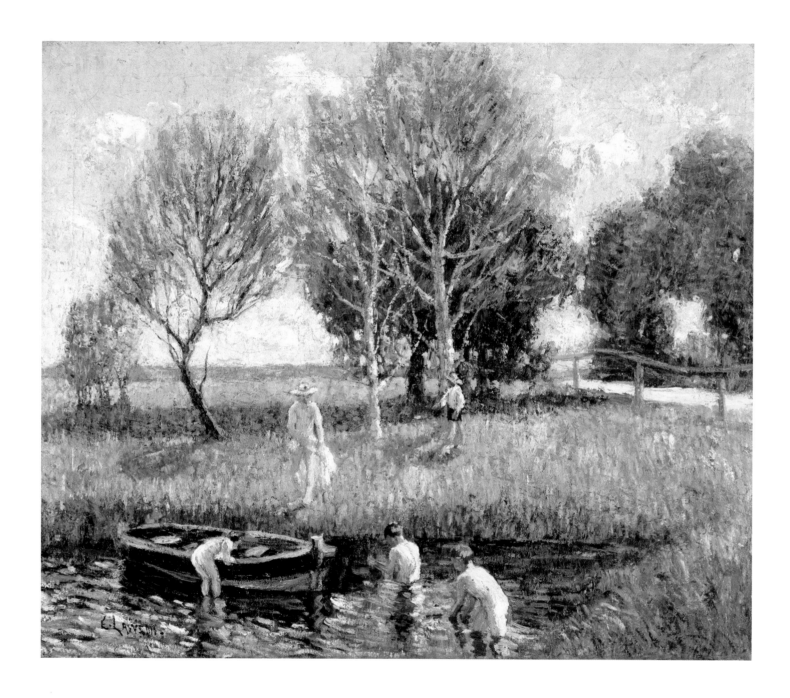

Cat. 65

George Luks

Winter—High Bridge Park, 1912

Oil on canvas
22 × 34 in. (55.9 × 86.4 cm)
High Museum of Art, Atlanta, Georgia, Purchase with
Henry B. Scott Fund and funds from the Friends of Art, 36.8

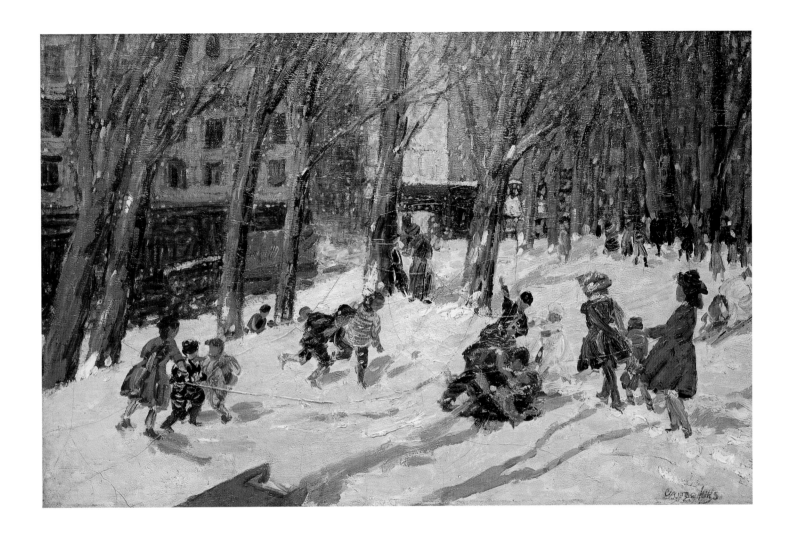

Cat. 66
Edward Manigault
Procession, 1911

Oil on canvas
20 × 24 in. (50.8 × 61 cm)
Columbus Museum of Art, Ohio,
Gift of Ferdinand Howald (1931.208)
(Nashville and Detroit only)

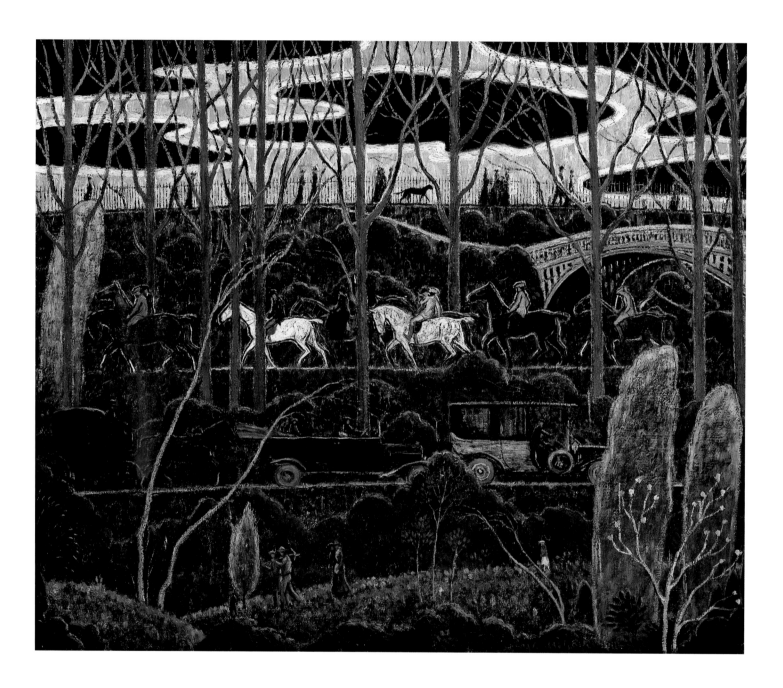

Cat. 67
Alfred Maurer
Rockaway Beach, ca. 1901

Oil on canvas
29¼ × 26¼ in. (74.3 × 66.7 cm)
Curtis Galleries, Inc., Minneapolis

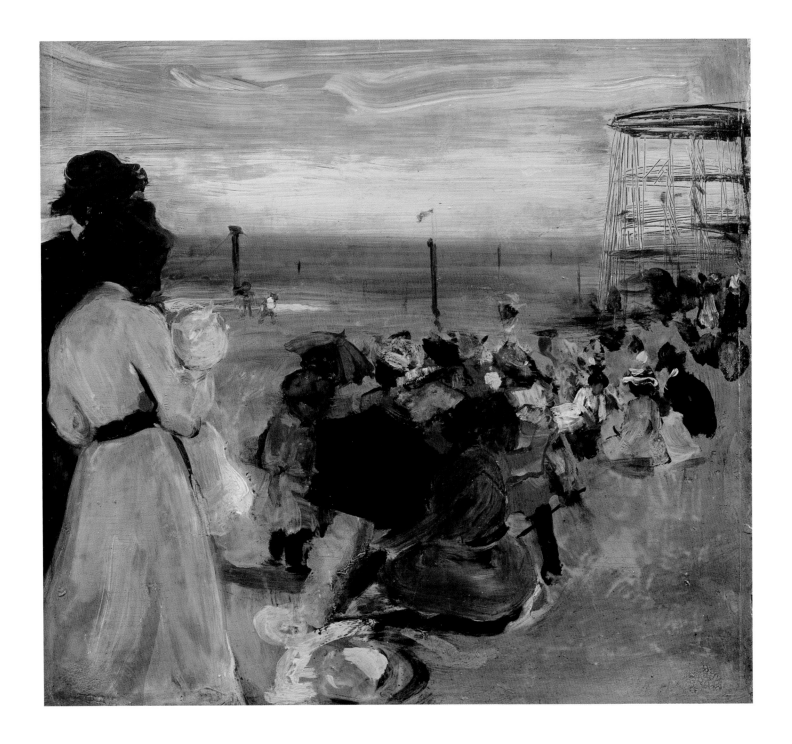

Jerome Myers

Evening Recreation, 1920

Oil on canvas
25 × 30 in. (63.5 × 76.2 cm)
Dr. and Mrs. Stephen Craven

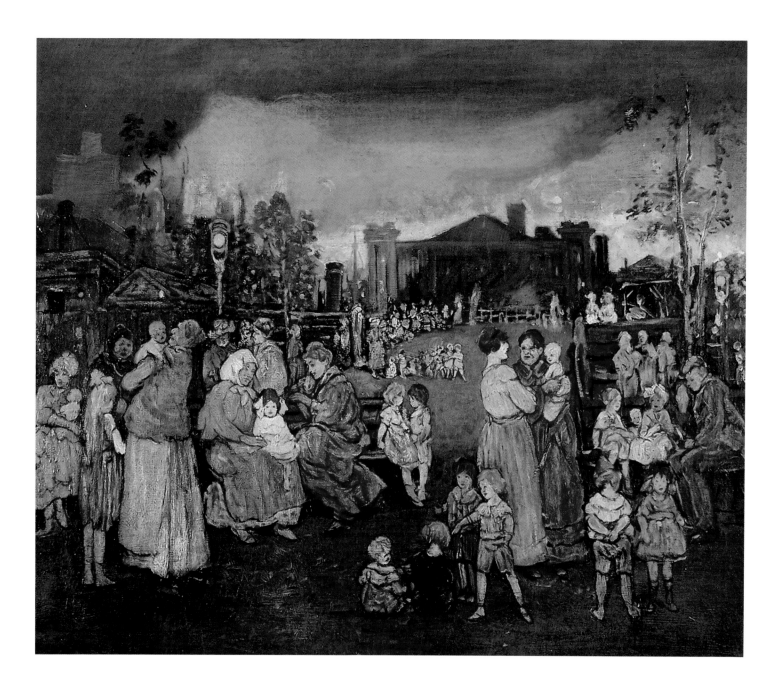

Cat. 69
Maurice Prendergast
Low Tide, ca. 1895–97

Oil on panel
13½ × 18 in. (34.3 × 45.7 cm)
Williams College Museum of Art, Williamstown, Massachusetts,
Gift of Mrs. Charles Prendergast (86.18.40)

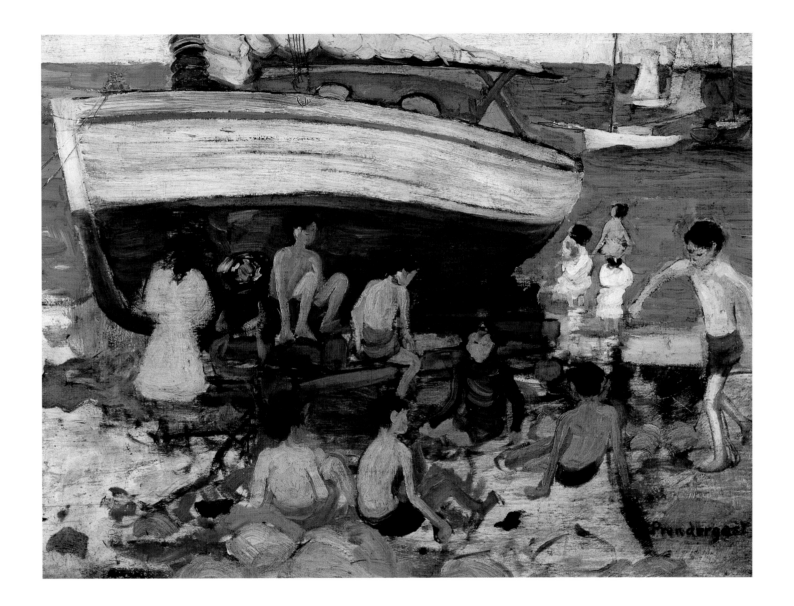

Cat. 70
Maurice Prendergast
In Central Park, New York, ca. 1900–1903

Watercolor and graphite on wove paper
12¼ × 20 in. (31.1 × 50.8 cm)
Addison Gallery of American Art, Phillips Academy, Andover, Massachusetts,
Gift of anonymous donor (1928.48)

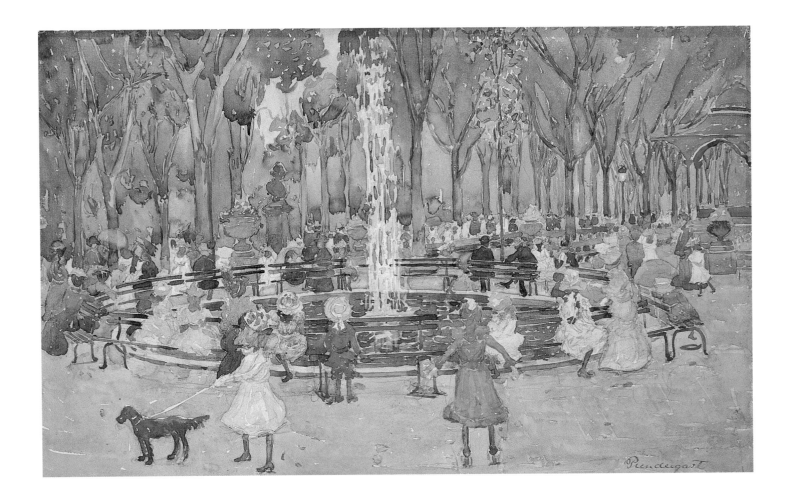

Cat. 71
Maurice Prendergast
Study St. Malo, No. 32, ca. 1907

Oil on panel
10 × 13 in. (25.4 × 33 cm)
Williams College Museum of Art, Williamstown, Massachusetts,
Gift of Mrs. Charles Prendergast (91.18.26)

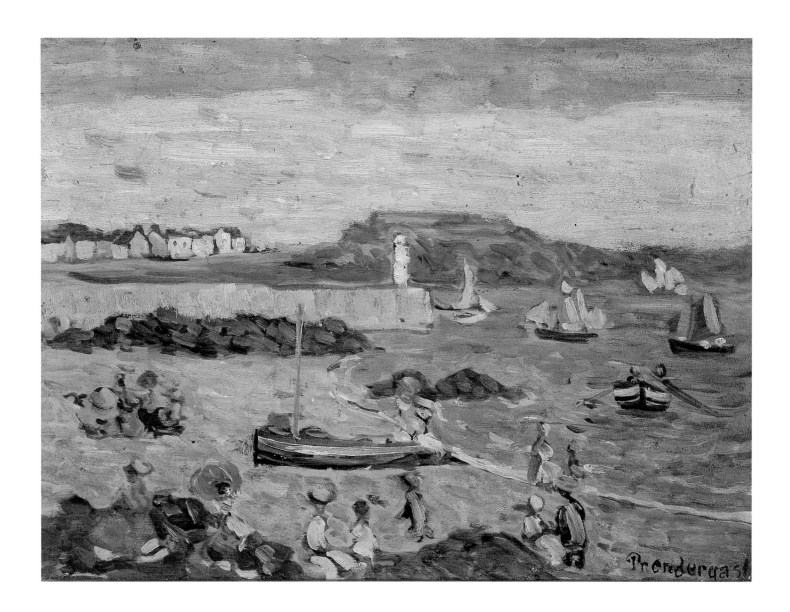

Cat. 72
Everett Shinn
Central Park, 1920

Oil on canvas
17 × 19 in. (43.2 × 48.3 cm)
Mr. and Mrs. John Wallace

Cat. 73
John Sloan
Spring, Madison Square, 1905–6

Oil on canvas
30 × 36 in. (76.2 × 91.4 cm)
Chazen Museum of Art, University of Wisconsin-Madison,
Ruth C. Wallerstein Fund purchase (57.1.2)

Cat. 74
John Sloan
South Beach Bathers, 1907–8

Oil on canvas
25⅞ × 31⅞ in. (65.7 × 81 cm)
Walker Art Center, Minneapolis, Gift of the T.B. Walker Foundation,
Gilbert M. Walker Fund, 1948 (1948.27)

Cat. 75
Robert Spencer
Courtyard at Dusk, ca. 1915

Oil on canvas
30 × 36⅛ in. (76.2 × 91.8 cm)
Fine Arts Museums of San Francisco,
Gift of Mr. and Mrs. Ronald MacDougall

Artists' Biographies

Gifford Beal
1879–1956

Born in New York and raised in a family of artists (his father, William Reynolds Beal, and his brother Reynolds were both painters), Gifford Beal spent most of his life chronicling his environment. Capturing garden parties, circus performances, rocky coasts, Caribbean beach scenes, or street commerce, he developed a personal style suited to the subject matter he chose to depict.

After spending ten years studying with William Merritt Chase in private lessons and as a teen attending Chase's summer school in Shinnecock Hills, Long Island, Beal reflected the lessons of his teacher and mentor in his early work. With deft impressionist brushstrokes, he conveyed popular sporting scenes that garnered critical attention.

Beal spent the summer of 1921 in Provincetown, Massachusetts, where he would repeatedly return for many years. In this period, his style changed from the impressionist palette and sensitivity to light that he had previously employed to a more rugged, realist style, in keeping with the Massachusetts coastlines that constituted his primary subject matter. Yet by 1940, the artist had again modified his approach: to depict vibrant theater and circus scenes, Beal favored radiant color, glinting light effects, and a freer technique, closer in style to the works from his early career.

A dedicated professional, Beal was a full academician at the National Academy of Design and a member of the American Academy of Arts and Letters, the American Institute of Arts and Letters, the Architectural League of America, and the National Society of Mural Painters. A one-time student at the Art Students League, he later served as president of the institution for fourteen years.

George Wesley Bellows
1882–1925

Born in Columbus, Ohio, George Bellows showed early promise as an artist. In 1904, encouraged by the modest sales of several drawings, he left Ohio State University and enrolled in the New York School of Art. There he studied with Robert Henri, whose charisma and teaching approach would have a lasting influence on him.

Exemplifying Henri's adage "art for life's sake," Bellows documented the vitality of his urban milieu: tenements, dock laborers, polo matches, street urchins, and even the evangelist Billy Sunday. His paintings of New York, particularly his series depicting prizefighters in action, received accolades and guaranteed his stature in American art as a representative realist of his time. Although not included in the 1908 exhibition of The Eight, Bellows shared with members of the Ashcan

school the tonal range, urban imagery, and frankness of approach.

A versatile painter and lithographer, Bellows also created intimate portraits and captured wintry vistas and seascapes, such as the breaking swells off Monhegan Island, Maine, a popular summering spot for artists. Contemporary critics appreciated his art for being "rough, frank, original"—attributes that did not change even as he experimented with new compositional and color techniques in his later works.

During his lifetime, Bellows received prestigious awards and showed in both established art venues and independent exhibitions, including the Exhibition of Independent Artists in 1910 and the Armory Show in 1913. In a career tragically shortened by fatal

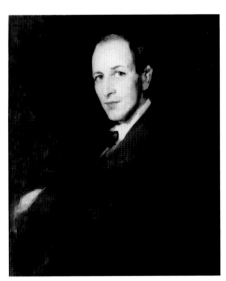

Robert Henri, *George Wesley Bellows*, 1911, oil on canvas. National Academy Museum, New York (561-P)

peritonitis, the prolific artist nonetheless produced more than six hundred finished paintings and thousands of drawings and lithographs.

Arthur Bowen Davies
1862–1928

As an artist and a leading proponent of the progressive movement, Arthur B. Davies was an influential figure in the American art world. His highly individual, poetic style drew on the mythical classicism of Puvis de Chavannes, the landscape tradition of the Hudson River school, and the dreamlike scenes of American visionary painting. Despite his lack of stylistic affinity with Ashcan school painters, he was an original member of The Eight.

Having shown early artistic promise, Davies left his hometown of Utica, New York, in 1881, and pursued his training briefly at the Chicago Academy of Fine Arts, and later when it became the Art Institute of Chicago. In 1888, he relocated to New York, where he enrolled in classes with Augustus Saint-Gaudens and Kenyon Cox at the Art Students League. Like many of his contemporaries, he worked as an illustrator, for *Century* magazine, while pursuing his independent artistic career.

After meeting William Macbeth, Davies received his first solo show at the prominent art dealer's gallery in

1896. In 1904, Davies exhibited with Robert Henri's group at the National Arts Center, and he joined them again in 1910 in the Exhibition of Independent Artists. Three years later, as president of the Association of American Painters and Sculptors, Davies was an integral part of the organization of the landmark Armory Show. The emphasis on progressive European artists in the exhibition of 1913—some thought at the expense of American realists—caused a permanent rift between Davies and Henri.

William Glackens
1870–1938

Although William Glackens is labeled an Ashcan school artist for his works that chronicled city parks and café scenes with a characteristically somber palette and coarse paint handling, his oeuvre reveals a diversity of subject matter and treatment.

A talented draftsman, Glackens began working as a reporter-illustrator for the *Philadelphia Record* in 1891. The following year he joined John Sloan, George Luks, and Everett Shinn at the *Philadelphia Press*. He also befriended Robert Henri, and in 1895, they traveled together to the Netherlands and Paris, where Henri shared his appreciation for the art of Frans Hals, Diego Velázquez, James McNeill Whistler, and Edouard

Robert Henri, *Portrait of William J. Glackens*, 1904, oil on canvas. Sheldon Memorial Art Gallery and Sculpture Garden, University of Nebraska–Lincoln, NAA-Thomas C. Woods Memorial

Manet with the younger artist. After returning to the United States in 1896, Glackens moved to New York, where he earned a living as an illustrator for such publications as the *New York World Magazine*, *New York Herald*, *McClure's*, *Saturday Evening Post*, and *Scribner's*. In 1905, he adopted a brighter palette and impressionist paint handling, a move that was encouraged by his discovery of the work of Pierre-Auguste Renoir during a visit to Europe in 1906. From this point onward, Glackens turned his attention to new subject matter, finding inspiration in studio models, still lifes, and landscapes. The seaside summering spot of Bellport, Long

Island, captivated the artist from 1911 to 1916 and provided a fitting subject for his brighter tones and feathery brushstrokes.

In 1907, the National Academy of Design rejected Glackens's submission to the annual exhibition, sparking Henri's organization of the exhibition of The Eight at the Macbeth Galleries, in which Glackens participated. In spite of this public protest against the academy, Glackens maintained his association with the institution, and was promoted to full academician in 1938. As an artistic adviser to his childhood friend Albert Barnes, Glackens contributed to amassing an impressive array of impressionist and postimpressionist art for Barnes's collection.

John R. Grabach
1886–1981

A painter best known for his portraits and scenes of urban life, John Grabach was a leading figure in establishing a vibrant artistic community in Newark, New Jersey. In subject matter, palette, and the sometimes sardonic treatment of the characters he depicted, his work has been considered in keeping with the Ashcan school of urban realism.

Grabach displayed his artistic talents at a young age. As a teenager, he joined the Newark Sketch Club, where he learned life drawing. In 1904, while working for a silverware

manufacturer in Newark, Grabach enrolled in classes at the Art Students League in New York, where he studied with Kenyon Cox, George Bridgman, and Frank Vincent DuMond.

In 1912, Grabach moved to Greenfield, Massachusetts. Inspired by his picturesque surroundings, his paintings in the years prior to World War I were impressionist in their technique and color scheme. In 1915, after returning to the New York metropolitan area, he encountered the art of John Sloan and George Bellows, which prompted him to adopt a more progressive realist approach. Interpreted as social commentaries, Grabach's depictions of backyard lots, snow-covered neighborhoods, and desolate marine scenes were rendered with thick brushstrokes and often muted tones.

In the following decades, Grabach received considerable attention for his city street scenes, which he exhibited in important venues throughout the United States. He won numerous prestigious awards, among them the Peabody Prize in 1924 and the silver medal at the Corcoran Biennial in 1932. In 1935, he accepted a teaching position at the Newark School of Fine and Industrial Arts, where he had a lasting influence on legions of young artists.

Charles Webster Hawthorne
1872–1930

Both an influential teacher and a painter, Charles Hawthorne was a leading figure in establishing the artists' colony in Provincetown, Massachusetts, in the first decades of the twentieth century. Although many artists visited the New England coast to capture its distinctive shorelines, Hawthorne preferred to paint the area's inhabitants, especially the Portuguese fishing families that had settled on the cape.

After taking night courses at the Art Students League in New York in 1893, Hawthorne studied for two years at the National Academy of Design. In 1896 he attended William Merritt Chase's summer school in

Charles Webster Hawthorne, *Self-Portrait*, n.d., oil on canvas. National Academy Museum, New York (549-P)

Shinnecock Hills, Long Island, and the following year he worked as Chase's assistant. Chase's lessons in *plein air* painting and his treatment of light influenced the development of Hawthorne's naturalist approach.

In 1898, Hawthorne traveled to the Netherlands, where he visited the fishing village Zandvoort and the artistic center Haarlem. There Frans Hals's tonal style captivated him. On returning from his travels in 1899, Hawthorne settled in Provincetown and opened his own school. Modeled after Chase's example, the Cape Cod School of Art (as it became known) trained students in the tenets of impressionism, color theory, and out-of-doors landscape painting. It attracted a number of painters to Provincetown, including George Ault, Gifford Beal, Charles Henry Demuth, Childe Hassam, Ernest Lawson, and Ben Shahn.

Early in Hawthorne's career his art began to be acquired by museums, among them the Metropolitan Museum of Art, the Museum of Fine Arts, Boston, the Detroit Institute of Arts, and the Corcoran Gallery of Art, Washington, D.C. Hawthorne also won a number of prestigious awards, including prizes from the Corcoran; the National Academy of Design; the Art Institute of Chicago; and the Pennsylvania Academy of the Fine Arts.

Robert Henri, *Self-Portrait*, 1903, oil on canvas.
Sheldon Memorial Art Gallery and Sculpture
Garden, University of Nebraska–Lincoln,
UNL-Gift of Mrs. Olga N. Sheldon

Robert Henri
1865–1929

Regarded in his lifetime as one of the
three most important living American
artists, Robert Henri produced an
esteemed body of work, comprising
mainly portraits and landscapes
painted with a piercing eye, thick
impasto, and strong chiaroscuro.
As an educator and progressive
advocate, he espoused philosophies,
many of them compiled in his book
of 1923, *The Art Spirit*, that have
inspired countless artists, among
them Edward Hopper, Rockwell Kent,
George Bellows, and Stuart Davis.

Henri received his artistic
training at the Pennsylvania Academy
of the Fine Arts, where he studied
with Thomas Anshutz and Thomas
Hovenden in 1886. Two years later,
he attended the Académie Julian in
Paris. After numerous trips abroad,
his own painting assumed a darker
tonal range and broader brushstrokes,
reminiscent of the work of European
masters Diego Velázquez, Frans Hals,
and Edouard Manet.

After returning to the United
States in 1891, Henri soon befriended
a group of newspaper illustrators later
known as the "Philadelphia Four":
William Glackens, George Luks,
Everett Shinn, and John Sloan. In
1900, Henri moved to New York,
where he taught at William Merritt
Chase's New York School of Art.

In 1908, Henri established
his own school, where he promoted
the strategy of visual honesty and
painting from life. As a teacher
and mentor, he advocated younger
artists, who struggled to be accepted
by the conservative New York art
institutions. To this end, he organized
several nonjuried, independent
exhibitions, including the show at
the Macbeth Galleries in 1908. This
landmark show drew attention to
The Eight group artists who
participated in it. Although the
content of the exhibition was diverse,
a certain core approach, later coined
"Ashcan," emerged—characterized
by bold, spontaneous paint handling
and an emphasis on depicting the
quotidian aspects of urban life.

Rockwell Kent, *Voyaging*, 1924, chiaroscuro
woodcut. © The Cleveland Museum of Art,
Mr. and Mrs. Charles G. Prasse Collection
1947.149

Rockwell Kent
1882–1971

By the mid-1930s, Rockwell Kent was
one of the best-known contemporary
American painters, and his talents as
an illustrator, writer, and political
activist enhanced his reputation. An
inveterate traveler, he painted rugged
landscapes and marine settings that
captured the relationship between
humanity and nature, and charted
near and distant locations across the
globe, including Monhegan Island
in Maine, Newfoundland, Greenland,
Alaska, Tierra del Fuego, France
and Ireland.

Kent displayed an early aptitude
for art, and studied mechanical
drawing and woodworking at the
Horace Mann School in New York.
His parents encouraged him to enroll
in the School of Architecture at

Columbia University, where he studied for three years before accepting a scholarship at William Merritt Chase's summer school in Shinnecock Hills, Long Island. He also took Robert Henri's course at the New York School of Art, where he met George Bellows and Edward Hopper. From 1927 onward, Kent's Ausable Forks home served as the gathering spot for such New York luminaries as the Pulitzers, John Dos Passos, Paul Robeson, and Pete Seeger.

Kent also applied his skills to a wide range of media and materials. He experimented with ceramic and jewelry design and worked as a commercial artist for such corporations as General Electric, Rolls-Royce, and Westinghouse. His illustrations for a 1930 edition of Herman Melville's novel *Moby-Dick*, are considered by many to be his crowning achievement.

Leon Kroll
1884–1974

By 1920, Leon Kroll was one of the most visible realist artists in the United States, and his status was cemented by his affiliation with a number of professional societies and his garnering of prestigious awards throughout his career. A talented artist of all genres, Kroll created landscapes, portraits, still lifes, and nudes, the latter representing perhaps his best-known work.

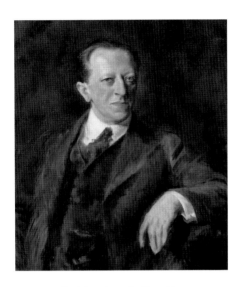

Eugene E. Speicher, *Leon Kroll*, 1920, oil on canvas. National Academy Museum, New York (1189-P)

At age seventeen, Kroll enrolled in courses with John H. Twachtman and Charles Courtney Curran at the Art Students League in New York. In 1903, he furthered his artistic education at the National Academy of Design, and in 1908, he traveled to Paris, where he studied at the Académie Julian. While living abroad, Kroll developed close friendships with Marc Chagall and Robert Delaunay, and encountered the work of Paul Cézanne, all of which inspired him to accept modernist ideas of abstract design and compositional structure.

On his return to New York in 1910, Kroll exhibited his Parisian work to great critical acclaim. That same year, he befriended George Bellows and Robert Henri, with whom he shared a commitment

to realism. Although his artistic instruction was conventional and he taught for many years at the National Academy, he associated with Henri's independent circle and managed to straddle the different art-world camps with diplomacy.

In 1918, Kroll began to paint the New York cityscape, a subject to which he would return repeatedly throughout his career. He also portrayed the Massachusetts and Maine coastlines and the Santa Fe landscape. Kroll often combined different views of the same scene into a composition, eschewing any desire for exact appearances and preferring to capture a mood or tone.

Walt Kuhn
1877–1949

A celebrated painter, illustrator, writer, vaudeville producer, and teacher, Walt Kuhn is also widely recognized for his dedication to promoting progressive aesthetic ideals, especially as a founding member of the Association of American Painters and Sculptors, the group that organized the Armory Show in 1913.

Although Kuhn took evening art classes at the Brooklyn Polytechnic Institute in 1893, much of his artistic education derived from a two-year sojourn in Europe. In 1901, the artist traveled to Paris, where he studied at the Atelier Colarossi and saw

firsthand French avant-garde art. Paul Cézanne's treatment of space and form, in particular, inspired Kuhn, who later adopted in his own painting similar techniques of flattened spatial perspective and geometric shapes. While abroad, Kuhn traveled to Munich, taking courses at the Akademie der Bildenden Künste, and to Italy and the Netherlands, before returning to the United States in 1903.

Inspired by vanguard aesthetics, Kuhn applied some of these newfound approaches to such traditional subject matter as still lifes of wild game or beach scenes and polo matches. In the late 1920s, he began to create piercing and psychologically intense portraits, often of clowns or circus entertainers, a genre with which the artist's name has become synonymous.

In addition to painting, Kuhn gained a reputation as a cartoonist and illustrator, contributing to such publications as *Life*, *Harper's*, the *Sunday Sun*, and *New York World Magazine*. He also taught at the New York School of Art in 1908 and 1909 and at the Art Students League from 1927 to 1928.

Ernest Lawson
1873–1939

Known for his wintry vistas, New York river scenes, and impressionist paint handling, Ernest Lawson was committed to painting out of doors, directly from the motif. He shared this tenet with the realists with whom he exhibited, such as the artists in Robert Henri's progressive circle. Lawson was one of The Eight who challenged the dominance of the National Academy of Design and called for more open exhibition practices.

Born in Nova Scotia, Lawson, after a peripatetic childhood, finally relocated to New York in 1891. In Cos Cob, Connecticut, he took summer classes with John H. Twachtman and J. Alden Weir, who encouraged his impressionist

William Glackens, *Ernest Lawson*, 1910, oil on canvas. National Academy Museum, New York (497-P)

approach to landscape painting, based on capturing the fleeting effects of light with loose brushstrokes.

In 1893, Lawson moved to Paris, where he studied briefly at the Académie Julian under Benjamin Constant and Jean-Paul Laurens, and made the acquaintance of Alfred Sisley, who encouraged Lawson's penchant for painting *en plein air* and the impressionist aesthetic. Having traveled for a couple of years after returning to the United States, Lawson settled in Manhattan's Washington Heights neighborhood in 1898. There the painter trained his eye on the ever-changing landscape of the Harlem and Hudson rivers, capturing with thick impasto and strong contours varying times of day, the changing seasons, and different qualities of light on the docks, bridges, and waters of his environs.

Although he exhibited regularly and widely, Lawson, like many artists, suffered financially during the Depression. With dwindling finances and in ill health, he relocated, in the 1920s to teach in Kansas City and Colorado Springs, and again in 1936 to Florida, where he died three years later.

George Luks
1867–1933

A one-time vaudeville performer, George Luks, one of The Eight, was a charismatic and rebellious artist. His penchant for depicting down-and-out city dwellers with coarse, dark brushstrokes led critics to label him a member of the Ashcan school.

Born in Williamsport, Pennsylvania, Luks trained briefly at the Pennsylvania Academy of the Fine Arts, in 1884. Much of his art education, however, resulted from his European sojourns; from 1885 onward, he traveled intermittently to Düsseldorf, Munich, Paris, and London, receiving some training abroad and studying the Old Masters. In particular, Frans Hals's naturalist approach was an influence on the developing artist.

In 1894, Luks became an artist-reporter for the *Philadelphia Press*, where he formed an informal circle with Robert Henri, William Glackens, John Sloan, and Everett Shinn. After moving to New York in 1895, Luks accepted a position at the *New York World Magazine*, where he illustrated the popular cartoon *Hogan's Alley*.

In 1907, the National Academy of Design rejected Luks's portrait submission to its annual show, sparking Henri's adamant protest of the academy and prompting the organization of The Eight exhibition. In the 1920s, Luks embarked on a new genre—rural landscape painting—in a series of views of Pennsylvania, Nova Scotia, and Connecticut. To supplement his income, he taught at the Art Students League, from 1920 to 1924, then established his own school in 1925. His friend John Sloan assumed management of the school following Luks's death in 1933.

Edward Middleton Manigault
1887–1922

Edward Manigault exemplifies the experimental painter at the foundations of modern art. Throughout his brief but intense career, he worked in different artistic styles and subjects, ranging from colorful postimpressionist scenes and expressionist still lifes to vorticist compositions verging on pure abstraction. He also experimented with different media and formats, including watercolor, pen and ink, ceramics, decorative frieze painting, and furniture, in a quest to realize his artistic visions.

In 1905, the young artist moved from London, Ontario, to New York to take classes at the New York School of Art. His teachers Robert Henri and Kenneth Hayes Miller had a profound effect on his early work, especially his depictions of New York street life. In 1909, Manigault's solo exhibition at the Haas Galleries in New York generated considerable buzz for the artist's experimental approach.

The following year, Manigault joined Henri's students and colleagues in the influential Exhibition of Independent Artists. He also contributed two works to the Armory Show in 1913. His art attracted the attention of several of the foremost patrons of American art, including Arthur Jerome Eddy, J. Paul Getty, and A.E. Gallatin.

During World War I, Manigault volunteered as an ambulance driver for the British Expeditionary Force, an experience that caused nervous breakdowns and exacerbated his chronic depression. In the hope that a change of climate and scenery could improve his ailing health, in 1919 Manigault moved to Los Angeles and joined the loose-knit artists' colony The Hill, in the Echo Park neighborhood. Yet his attempts at spiritual fulfillment failed him. He died after having starved himself, in an apparent attempt to see "new" colors.

Alfred Maurer
1868–1932

In 1950, the artist Hans Hofmann cited Alfred Maurer as one of the forerunners of a "true and great American tradition that is being carried on by the vanguard of advanced modern artists." Maurer's oeuvre reveals a commitment to artistic evolution and exploration, with works that range from impressionistic portraits and genre scenes to fauve-inspired landscapes and fractured cubist still lifes.

Alfred Maurer, *Self-Portrait*, 1897, oil on canvas. Collection of the Frederick R. Weisman Art Museum at the University of Minnesota, Minneapolis, Gift of Ione and Hudson D. Walker

Born in New York, Maurer trained at the National Academy of Design in 1884 before moving to Paris in 1897. There he studied briefly at the Académie Julian, but his real education and inspiration came from the rich Parisian arts scene, such as the legendary salons of Leo and Gertrude Stein. His early paintings, of women in interiors and depictions of café society, reflected the influences of James McNeill Whistler and William Merritt Chase and generated critical buzz for the artist. As Maurer assimilated the vanguard developments around him into his own form of modernist painting, he continued to innovate. In particular, Henri Matisse's bright, nonnaturalistic fauve palette encouraged Maurer to adopt a lyrical and vibrant style.

During the first decades of the twentieth century Maurer received institutional support and considerable acclaim. He exhibited in Paris, at the Salon d'Automne and the American Art Association, and he frequently sent works stateside, including to such New York galleries as Alfred Stieglitz's 291, Folsom, and Daniel's. In 1914, Maurer returned permanently to the United States. His paintings from this period combine a cubist approach to form with a fauvist palette and vigor. In the 1920s, he began to concentrate on rendering solitary or paired heads of female figures, developing a fractured, stylized approach that suggested his own distraught emotional state.

Jerome Myers
1867–1940

Having survived an itinerant and impoverished childhood, Jerome Myers was naturally drawn to the down-and-out members of society. He depicted with compassion scenes of Lower East Side tenements, immigrant neighborhoods, and bustling markets. As he once explained, "Why catch humanity by the shirt-tail, when I could see more pleasant things?"

After moving from city to city for the majority of his childhood, Myers settled in New York in 1886. While working as a commercial artist, he attended classes at Cooper Union and the Art Students League, where he studied with George de Forest Brush and Kenyon Cox. He eventually parted ways with the academic approach of his teachers, choosing instead to adopt a more progressive realist aesthetic. Like the other realists associated with the Ashcan school, Myers painted directly from the motif and chose everyday urban life as his primary subject matter. In 1889, he began to chronicle the unglamorous aspects of his environment, becoming one of the first artists to make such raffish scenes the subjects of paintings.

In 1896, Myers, like many of his generation, traveled abroad to see firsthand the art of the Old Masters.

Jerome Myers, *Self-Portrait*, 1921, oil on canvas. National Academy Museum, New York (910-P)

He exhibited both in traditional forums, such as the National Academy of Design, and in more progressive circles, such as the Exhibition of Independent Artists in 1910. Although never commercially successful, he received a number of prizes during his lifetime. A founding member of the Association of American Painters and Sculptors, he helped organize the Armory Show in 1913. His autobiography, *Artist in Manhattan*, was published shortly before he died in 1940.

Guy Pène du Bois
1884–1958

Artist, critic, and cultural satirist Guy Pène du Bois was an astute observer of modern life. His discerning eye sized up all varieties of social situations, and he depicted iconic scenes of the 1920s—the urbane cafégoers, flappers at a bustling nightclub, the fashionable theater crowd—with a wink and wit.

A high-school dropout, Pène du Bois took classes at William Merritt Chase's school, studying with James Carroll Beckwith, Kenneth Hayes Miller, and, in 1902, with Robert Henri. Henri's teachings inspired the young artist to train his eye on the life unfolding around him, a tenet that served both his art and his writing well.

In 1905, Pène du Bois traveled to Paris, where he studied briefly at the Atelier Colarossi, until his

Jerome Myers, *Guy Pène du Bois*, 1937, oil on canvas. National Academy Museum, New York (913-P)

European sojourn was curtailed by the death of his father in 1906. On his return to New York, he took a position with the *New York American*, sketching courtroom scenes and satirical cartoons; he also contributed art criticism to the newspaper from 1908 to 1912. As the editor of *Arts and Decoration* magazine from 1913 to 1921, he drew attention to new developments in modern art, in particular the French avant garde.

Eschewing the dark tonalities and thick, loose paint handling of his teachers Chase and Henri, Pène du Bois developed his own mature artistic style in the 1920s. His stylized, almost sculptural figures captured the artificial nature of social interactions. From 1932 until 1950, he ran a school in Stonington, Connecticut, where he spent the summers.

Maurice Prendergast
1858–1924

Among the first American artists to assimilate the developments of French vanguard painting, Maurice Prendergast generated a highly individualist and recognizable artistic style. His watercolors, oil paintings, and monotypes of the urban middle class reflect his abiding wanderlust and reveal his lifelong commitment to impressionist and modernist aesthetic ideals.

Born in Nova Scotia, Prendergast moved with his family to Boston in 1868. In the early 1890s, he studied in Paris, first at the Atelier Colarossi under Gustave Courtois and later at the Académie Julian. While abroad, he began to incorporate new artistic developments, such as postimpressionism, into his own work. In particular, the art of the Nabis, James McNeill Whistler, and an exhibition of Paul Cézanne's watercolors inspired Prendergast and encouraged his emphasis on surface patterning and expressive color.

After returning from Europe, Prendergast lived in Boston with his brother Charles, also an artist. He became known for his depictions of middle-class leisure—bustling urban crowds, holidaying beachgoers, brightly adorned ladies with parasols strolling in parks. His concentration on similar subject matter throughout his career allowed him to experiment with color and design, generating

intricate, all-over patterns of brightly colored dots.

In 1908, Prendergast joined Robert Henri's group as one of The Eight. He not only contributed seven works to the Armory Show, but he also was the only member of the Association of American Painters and Sculptors to sit on both the European and American selection committees for the exhibition in 1913. The following year, Prendergast moved to New York, where he quickly attracted the attention of famed art collectors, among them Duncan Phillips, Lillie P. Bliss, Albert C. Barnes, John Quinn, and Edward Root.

Everett Shinn
1876–1953

Everett Shinn was an amateur thespian and lifelong lover of the theater, and his best-known works depict stage performers, often seen from unusual angles. He even converted his art studio into a theater and founded the Waverly Street Players, a theatrical troupe that included fellow artist William Glackens.

Born in Woodstown, New Jersey, Shinn studied industrial design in Philadelphia from 1888 to 1890, before embarking on a career as an illustrator. While working at the *Philadelphia Press* and taking classes at the Pennsylvania Academy of the Fine Arts, he made the acquaintance

of Robert Henri, William Glackens, George Luks, and John Sloan, and became associated with the Ashcan school. Yet Shinn's breed of urban realism often differed from that of his associates; he had a fondness for high fashion and spectacle and depicted elite uptown life, as well as lowbrow subjects.

In 1897, Shinn moved to New York, where he received national recognition for his newspaper, magazine, and book illustrations; in particular, he provided the first full-color drawings for *Harper's Weekly.* He drew on his speed and efficiency as an illustrator in 1901 on a trip to Paris, where he captured life on the city streets in pastel drawings. Inspired by Edgar Degas's paintings of café concert performers, Shinn turned to theater scenes for his primary subject matter.

A participant in the exhibition of 1908, Shinn had only a short-lived professional affiliation with The Eight. In 1913, he turned to set design, art direction, and playwriting, and ceased regular exhibition of his paintings. After a stint in Hollywood as an art director and set designer, Shinn returned in 1923 to New York, where he continued to paint and produce commercial illustrations until his death in 1953.

John Sloan, *Self-Portrait*, 1924, oil on canvas. Palmer Museum of Art, The Pennsylvania State University

John Sloan
1871–1951

A successful commercial artist and supporter of progressive ideals, John Sloan gained recognition as a painter for his unsentimental views of gritty urban life. Largely self-taught, Sloan financed classes at the Pennsylvania Academy of the Fine Arts by working at the *Philadelphia Inquirer*. In 1895, he joined the staff of the *Philadelphia Press*, before moving to New York in 1904.

In Philadelphia, Sloan was part of a lively artistic community that included Robert Henri, William Glackens, George Luks, and Everett Shinn. Henri, in particular, encouraged Sloan to adopt painting and fueled the artist's interest in everyday life. In 1908, Sloan joined

Henri and six other artists in an exhibition to protest the conservative standards of the National Academy of Design in New York. Known as one of The Eight, Sloan was also called an Ashcan school artist because of his palette, thick, dynamic brushwork, and seamy urban subjects.

In the mid-1910s, Sloan contributed to the radical journal *The Masses*, until he resigned from the Socialist Party in 1916. Following the Armory Show in 1913, Sloan turned his attention to formal concerns and away from the subject matter for which he had become known. He began to incorporate the color theories promoted by Hardesty Maratta in landscape paintings, and his travels in the United States encouraged new subject matter, in particular, scenes of Santa Fe, New Mexico, which became his second home. In the 1920s, Sloan focused on the female nude as a vehicle for exploring issues of form. In 1939, he published *Gist of Art*, a collection of comments and aphorisms that summarized his aesthetic philosophy.

Eugene Speicher
1883–1962

Named "America's most important living painter" by *Esquire* magazine in 1936, Eugene Speicher created portraits, floral still lifes, landscapes, and renderings of the female nude, continuing a long tradition of realist painting. He contributed immensely to the growing artists' colony in Woodstock, New York, where he spent his summers.

Born in Buffalo, Speicher moved in 1907 to New York City, where he attended classes at the Art Students League, studying under noted professors William Merritt Chase, Frank Vincent DuMond, and, in 1909, Robert Henri. Henri introduced him to other prominent realists, with whom Speicher exhibited in the nonjuried shows of the MacDowell Club. The artist was also affiliated with the progressive New Society of Artists, another organization devoted to providing alternative exhibition opportunities.

In 1910, Speicher embarked on a museum tour in Europe, where he studied the Old Masters' approach to

Eugene Speicher, *Self-Portrait*, 1913, oil on canvas. National Academy Museum, New York (1188-P)

classical design, composition, and technique. A gifted portraitist, like his mentor Henri, he garnered a number of awards for his work. The first such honor he received, the Art Students League Kelley Prize in 1908, was for his painting of fellow student Georgia O'Keeffe. In 1926, Speicher turned his attention to capturing female figures poised in various stages of undress, a genre for which he became well known.

Robert Spencer
1879–1931

A prominent member of the New Hope Group, a coterie of impressionist painters residing in Bucks County, Pennsylvania, Robert Spencer distinguished himself by focusing on the quotidian scenes that surrounded him: the mills, tenements, factories, and riverfronts that dotted the region. Using a light palette and dappled brushstrokes, he created a hybrid aesthetic, both realist in his depictions of the life of the working class and impressionist in his romanticized treatment of those subjects.

After a peripatetic childhood, Spencer finally settled with his family in Yonkers, New York. He took classes at the National Academy of Design for three years, and later studied at the New York School of Art, where William Merritt Chase and Robert Henri had a considerable influence

on the development of his artistic style and outlook.

In 1906, Spencer moved to the Delaware Valley area, and, four years later, he settled in the picturesque town of New Hope, where he joined Daniel Garber, Walter Elmer Schofield, and Charles Rosen in creating an artistic community and productive dialogue. In the following decade, Spencer achieved critical and commercial success in the New York art world, exhibiting regularly and garnering prizes. He attracted the attention of such museums as the Metropolitan Museum of Art and venerable private collectors, most notably Duncan Phillips, who began to acquire the artist's work in the mid-1910s. Spencer was promoted to full academician of the National Academy of Design in 1920. In 1931, after suffering from mental breakdowns for several years, he took his own life.

Maurice Sterne
1878–1957

A passionate international traveler, Maurice Sterne was responsible for an oeuvre that was as eclectic as his itinerary. He created portraits, landscapes, figural compositions, still lifes, murals, and sculpture, while experimenting with a variety of modernist styles. Drawing inspiration from the world around him, his art was inflected by the sensibilities of the cultures he visited, generating a profoundly individual body of work.

In 1890, Sterne emigrated with his family from Russia to New York, where he initially served as an apprentice to a map engraver. He attended both the National Academy of Design, where he studied with Thomas Eakins, and the Art Students League. In 1904, he set off for a decade exploring much of Europe, including France, Greece, Italy, and Germany; in Paris, he met Leo Stein, who introduced him to the progressive developments in French art of the time.

Sterne was not content to explore only Europe, and throughout his life he visited distant outposts, including Egypt, India, and the South Pacific. Always keen to experiment, he assimilated different approaches, among them expressionist paint handling, cubist distortions, and Paul Cézanne's geometric forms. Dispensing with preliminary drawing, Sterne was a firm believer that the artistic process was a generative one, and he allowed a composition to take shape through the act of painting itself.

The distinct regional topographies of the United States attracted Sterne, and he painted in New York, San Francisco, Maine, Provincetown, Massachusetts, and Taos, New Mexico. During his lifetime, he attained commercial and critical success. In 1933, the Museum of Modern Art launched a comprehensive exhibition of his work, the first retrospective for an American artist at the newly opened museum. Sterne also holds the distinguished position of being the first contemporary American to have a work purchased by the Tate Gallery, London.

Acknowledgments

The organization and implementation of an exhibition require the support and cooperation of numerous individuals and institutions, to whom many thanks are due. First are the lenders, whose generous participation has made this exhibition and publication possible. They graciously provided information and photographs, and, in some cases, parted with their treasure far in advance of the exhibition for necessary conservation work. Among the generous private collectors, there are those who opened many doors in assembling this exhibition, and I am especially grateful to Jonathan Boos, Mary and Stephen Craven, Mary Anne and Eugene Gargaro, John L. Huber, Jane and Richard Manoogian, and Estelle Wolf.

In addition to the lenders, many colleagues gave tirelessly in helping identify and secure the paintings for this exhibition, particularly Carrie Rebora Barratt, Judith Barter, Sarah Cash, Trinket Clark, Mark Cole, Eleanor Jones Harvey, Barbara Haskell, Erica E. Hirshler, Nancy Mowll Mathews, Jessica Todd Smith, and H. Barbara Weinberg.

Many members of the American art world were enormously helpful in providing information, suggesting pictures, and offering encouragement and help, including Warren Adelson, Vivian Bullaudy, Lily Downing Burke, Priscilla Vail Caldwell, Stacey B. Epstein, Stuart Feld, Martha Fleishman, Bernard Goldman, Susan Julig, Frederick Hill, James Berry Hill,

Mary Lublin, Michael Owen, Ralph Sessions, Cameron M. Shay, Ira Spanierman, Hollis Taggart, and specifically Eli Wilner, who extended his gallery for countless meetings.

The exhibition could not have taken shape without the invaluable contributions of the advisory committee, which, in addition to the authors of the essays in this book, included Franklin Kelly and Kenneth J. Myers. These scholars added to the integrity of this project with thoughtful suggestions and excellent advice. David W. Burke III, William T. Kunz, and Peter C. Leonhardt, too, provided counsel concerning the history and development of American athletics, an integral aspect of this exhibition.

At the Detroit Institute of Arts, I would like to thank Graham W.J. Beal, director, for his support of this exhibition. Timothy M. Burns provided indispensable assistance, handling a myriad of administrative duties, from establishing a database for the exhibition to coordinating the required images for this volume. His dedication to this project has been stellar. Kimberly Dziurman managed the countless logistic details associated with borrowing and transporting the pictures. Tara Robinson and Amy Hamilton Foley negotiated with venues and arranged numerous logistical meetings. Serena Urry examined the paintings and recommended the appropriate treatment and handling of each work. Maria Harris was a constant source for research materials, which was an especially Herculean task while her library was packed and in storage. Susan Higman Larsen kept this book on schedule, ensuring that each deadline was met. She was assisted by the always accommodating Tracee Glab. Stephen Robert Frankel also provided superb editorial assistance.

Warm thanks are also due to the staff at both the U.S. and London offices of Merrell Publishers for producing such a beautiful volume to accompany the exhibition.

James W. Tottis
Associate Curator
of American Art,
Detroit Institute of Arts

List of Lenders

Addison Gallery of American Art,
Phillips Academy, Andover,
Massachusetts
Albright-Knox Art Gallery, Buffalo,
New York
The Art Institute of Chicago
Brooklyn Museum, New York
The Butler Institute of American Art,
Youngstown, Ohio
Chazen Museum of Art, University
of Wisconsin-Madison
Cincinnati Art Museum
Cohen Collection
Columbus Museum of Art, Ohio
Corcoran Gallery of Art,
Washington, D.C.
Collection of Dr. Ron Cordover
Dr. and Mrs. Stephen Craven
Curtis Galleries, Inc., Minneapolis
The Dayton Art Institute, Ohio
Detroit Institute of Arts
Fine Arts Museums of San Francisco
Collection of Mr. and Mrs. Eugene A.
Gargaro, Jr.
High Museum of Art, Atlanta,
Georgia
Hirshhorn Museum and Sculpture
Garden, Smithsonian
Institution, Washington, D.C.
Hollis Taggart Galleries, New York
Collection of Mr. and Mrs. John L.
Huber
The Huntington Library, Art
Collections, and Botanical
Gardens, San Marino, California
Dr. Karen A. and Mr. Kevin W.
Kennedy Collection
LeClair Family Collection
Collection Abby and Alan D. Levy,
Los Angeles

Los Angeles County Museum of Art
Manoogian Collection
Mead Art Museum, Amherst College,
Amherst, Massachusetts
The Metropolitan Museum of Art,
New York
Milwaukee Art Museum
Mount Holyoke College Art
Museum, South Hadley,
Massachusetts
Museum of Fine Arts, Boston
Museum of Fine Arts,
Saint Petersburg, Florida
National Gallery of Art,
Washington, D.C.
National Gallery of Canada, Ottawa
Pennsylvania Academy of the
Fine Arts, Philadelphia
Philadelphia Museum of Art
San Diego Museum of Art
Smith College Museum of Art,
Northampton, Massachusetts
Smithsonian American Art Museum,
Washington, D.C.
Spanierman Gallery, LLC, New York
Walker Art Center, Minneapolis
Mr. and Mrs. John Wallace
Ambassador and Mrs. Ronald Weiser
The Westmoreland Museum of
American Art, Greensburg,
Pennsylvania
Whitney Museum of American Art,
New York
Williams College Museum of Art,
Williamstown, Massachusetts
Yale University Art Gallery,
New Haven, Connecticut
and several private collections

Photograph Credits

Index

Page numbers in *italic* refer to the illustrations